The Future of the Museum

The Future of the Museum

28 Dialogues
András Szántó

HATJE
CANTZ

For my sons, Alexander and Hugo

Contents

AMBITION & ANXIETY: REIMAGINING THE ART MUSEUM

This book is a product of the great pandemic lockdown of 2020, yet it points to a horizon far beyond. I had long planned a collection of conversations with museum directors, but I could not find the hook—or the time. Now, in the midst of a once-in-a-century calamity, here we all were, with plenty of time on our hands, staring down a future as new as it was uncertain.

It was clear by April 2020 that this year would go down in history as the biggest global pivot since the end of the Cold War, in 1989—not just for museums, but for all of us. One chapter was closing, another one was opening. Museums worldwide had shut their doors. Their essential way of operating and generating income—showing objects to people in live settings—was put on extended hold. It seemed a natural moment to wonder: What will the museum of the future be like? Whom will it serve? What forms will it take? What needs will it meet, and how?

It has been widely remarked that major crises tend to accelerate changes previously underway. So it has been for art museums at this unprecedented moment. Even before Covid-19, the international museum field was in a period of protracted self-examination, mostly behind the scenes. New approaches to exhibition-making and museum management were being tested. Fledgling institutions were offering tantalizing solutions

to the challenge of what a museum can be. And regardless of size or location, art institutions were questioning the role they were playing in societies where inequality is spiking, social justice is elusive, politics are polarized, and environmental breakdown is becoming a fact of life. These trends were already stirring intense debate about the functions and entanglements of today's art museums. A consensus was crystallizing that institutions need to be brought into a new alignment with a rapidly changing society. But the upheavals of 2020 intensified the reckoning, confronting museums with fundamental questions about their relevance and viability.

That sense of urgency—and opportunity—echoes through the dialogues in this book, all recorded and edited in the spring and summer of 2020, when three seismic shocks convulsed the museum world: the coronavirus epidemic, the ensuing melt-down in museum finances, and, especially in the United States, a confrontation with the historical legacies of racial injustice and structural inequity. Each of them would leave a lasting mark on the museum's future.

Shifting Landscape

In September 2019, a few months before the city of Wuhan, China, diagnosed the first case of the novel coronavirus, the International Council of Museums, commonly known as ICOM, convened in Kyoto, Japan, to debate an updated definition of "the museum." The proposal had been formulated through painstaking and time-consuming committee work. Verbose, clunky, and intensely disputed as it was, it epitomized a new atti-tude gaining currency in the field, especially in emerging econo-mies. It portrayed the art museum as much more than a store-house of beauty and treasure, placing a marked emphasis on serving the needs of society at large. The Kyoto version—which is still being reviewed as this book goes to press—ran as follows:

Museums are democratizing, inclusive, and polyphonic spaces for critical dialogue about the pasts and the futures. Acknowledging and addressing the conflicts and challenges of the present, they hold artifacts and specimens in trust for society, safeguard diverse memories for future generations,

and guarantee equal rights and equal access to heritage for all people. Museums are not for profit. They are participatory and transparent, and work in active partnership with and for diverse communities to collect, preserve, research, interpret, exhibit, and enhance understandings of the world, aiming to contribute to human dignity and social justice, global equality and planetary well-being.

ICOM's arduous effort to redefine the museum was an expression of a disruptive but ultimately constructive tension coursing through the art-museum field today. Institutions are grappling with how to balance their multiple mandates, old and new. Museums have been striving recently to broaden their impact, in particular by engaging younger generations and meeting the needs of marginalized groups. The contrast between the art museum's traditional functions—to collect, preserve, research, interpret, exhibit—and its expanded role as an agent of community life and social progress has intensified in the wake of the coronavirus pandemic, yet it was already felt well before. This tension forms a backdrop to this book, suggesting a mix of ambition and anxiety that pervades museums as they press forward into the twenty-first century.

Bringing together a diverse group of museum leaders from around the world, this collection of dialogues offers a panorama of the current mood and mindset in the museum sector. Together, these directors are responsible for some four dozen institutions and affiliates in fourteen countries on six continents, with a combined annual budget of approximately 900 million dollars, total annual in-person pre-Covid-19 visitation of more than thirty-six million people, and collections totaling well over seven million objects. The oldest institution represented here is 460 years old, five of them are less than five years old, and two of them haven't even officially opened yet. (Technically, two of the twenty-eight leaders are not running a museum presently—one recently stepped down from a directorial post to focus on digital projects; the other oversees an outdoor "museum without a ceiling," as she described it.) The conversations testify to how art institutions and their leaders are feeling their way toward a future that will demand flexibility and resilience.

András Szántó

Perhaps the most striking aspect of that future is its global range. Museums—products of the European Enlightenment that until recently were concentrated in the world's more prosperous regions—have proliferated geographically in the last few decades. Some of the most exciting, paradigm-smashing experimentation now happens in Africa, Latin America, Australia, and parts of Asia. These are the places where the next chapters of the museum's story are being written. Recently formed institutions, as often as not brought to life by private initiatives, are figuring out ingenious ways to support local cultural practices, engage audiences that have not experienced a museum before, and disentangle their art histories from Western cultural narratives. Where museums in emerging regions once mimicked institutional models emanating from Berlin, London, and New York, they are now incubating dynamic offshoots that are at once authentic and less beholden to convention.

Another facet of change has to do with the demographics of museum leadership, which are expected to shift in years to come, opening the door to yet more adaptation in museums' activities and attitudes. The wave of global unrest that followed the killing of George Floyd—as interviews for this book began—has created a heightened awareness of social inequity and insensitivity in museums. As several directors in these pages unequivocally note, tremendous work remains to be done to diversify museums— their executives, curators, trustees, staffs, donors, audiences, not to mention their collections. When it comes to the gender gap in museum leadership, institutions may be trending in the right direction, though by no means achieving parity as yet: it is a hopeful sign that half of the museum leaders in this volume are women.

Young museum leaders are also injecting new energy and a fresh point of view, and there are several in this book—two directors were thirty-three years old at the time of our conversation; one was twenty-one when she started her first museum. Youth tends to correlate with healthy skepticism about received wisdom and, these days, with a digital native's fluency with new technology. But regardless of their years, all the museum leaders in this compendium were invited for their probing outlook on art and its institutions, and for their openness to airing out their views in public.

Speaking of technology, this may be the first book on museums created on Zoom—with the interviews transpiring between the end of May and the middle of August 2020. Each chapter started out as an extended video conversation. Some questions recur in almost every dialogue; others are highly specific. Each exchange has a unique theme that plumbs a particular facet of the museum. These dialogues are not simply transcripts. They are the fruits of editorial collaborations. I adapted each original conversation to a standard length, smoothing it out for clarity and flow. The participants reviewed and updated their texts. After several rounds, the dialogues went through a copyedit to assume their current form.

Inevitably, this book is a reflection of a particular moment—but crucially, it is not *about* that moment. The goal was to investigate the future at a time when we were all sitting still. The directors were speaking under circumstances of duress, when many of their institutions were still closed to the public, or had only recently opened after extended shutdowns, and even then with severe limitations. While the conversations do shed light on how art museums navigated through the Covid-19 crisis, what they are really about is what comes next. Freeing them from constant travel, the "great pause" provided time and space for my interlocutors to step back and think about the larger purposes of their institutions and their professional lives. Stuck in my own house and garden, though in a setting less picturesque than the leafy hills around Florence, I was often reminded of Giovanni Boccaccio's *Decameron*, the masterpiece of pandemic-inspired storytelling born of the 1348 plague—with forced seclusion becoming an occasion for collective reflection.

Work in Progress

So what kind of art museum emerges from these pages? An institution in continuous need of reimagining.

By early 2020, the warning lights were blinking red. The pandemic laid bare the fragility of the museum's business model. Revenues from tickets, shops, restaurants, and rentals evaporated. Staff were sent home, furloughed, and laid off in waves. Large traveling shows, a mainstay of museum programming, were no longer feasible. While museums demonstrated laudable dexterity in pivoting to remote work and free online programming, none of

András Szántó

those measures offset the cratering of their finances. The bleakest industry forecasts augured the permanent closure of thousands of institutions.

Then, on May 25, 2020, George Floyd died under the knee of a Minneapolis police officer. By early June, the largest civil-rights demonstrations in history were roiling American cities. Confederate monuments were toppled. Protests spread around the globe. Cultural institutions faced a new reckoning over their witting or unwitting complicity in the colonial plunder of cultural artifacts and their perpetuation of systemic racial injustice. The new scrutiny revived and intensified long-standing criticism about museum ethics. Notably, long before Covid-19, activists and the press were castigating art institutions for accepting financing from industries and individuals deemed morally questionable. To meaningfully address these compounding challenges would require daunting steps. Just a single example: one director in this book did the math concerning what it would take to establish gender parity in her museum's collection, and found that at the current pace of acquisitions, seventy-two years of buying only works by women artists would be required. For some institutions, it would undoubtedly take longer.

In short, the pandemic exposed both operational and reputational vulnerabilities in art museums. Despite their growing visitation, erstwhile efforts to engage new audiences, and elegant rhetoric about lowering barriers, art museums—more than science and natural-history museums, not to mention libraries— have remained, in the eyes of too many, a privileged and inscrutable domain. The verdict of governments was clear. Museums were not deemed "essential" institutions in the pandemic. My state of New York ranked them in the fourth reopening category, behind hardware stores and barber shops. Public decision-makers, especially in the US, did not see museums as playing an indispensable role in the lives of their communities.

Now the good news. The dialogues in this book offer abundant reassurance that innovation is alive and well in today's art museums. Their leaders understand that reforms and a willingness to try out new ideas will be required to affirm the museum's vibrancy, credibility, and financial sustainability—and they are doing something about it.

Innovation is alive and well in Beijing, where the dedicated entrepreneurial arm of the UCCA Center for Contemporary Art, UCCA Labs, is entering into collaborations with leading brands, mobilizing museum expertise to generate resources for its cultural mission. It is alive in Melbourne, where the Australian Centre for the Moving Image has a laboratory in which designers and artists can test out video games and virtual- and augmented-reality projects with the museum audience. A spirit of new thinking is motivating the Garage Museum, in Moscow, to look to Pixar Animation Studios for how to optimize a workspace for creativity; and the Toledo Museum of Art, in Ohio, to gain insights from Netflix about securing audience loyalty with serialized content.

New thinking about audience engagement is driving the National Gallery Singapore to organize a Children's Biennale, in part to get parents and grandparents to look at contemporary art. A taste for experimentation has led the Fondation Zinsou, in Benin, West Africa, to enlist the country's leading pop singers to sing songs about exhibitions that are broadcast on national radio, and likewise MACAAL, in Marrakesh, to invite people who have never been to the museum for Friday Couscous and Art conversation sessions. Curation and the visitor experience are getting a fresh look, too, from MASP, in São Paulo, where annual survey exhibitions about the histories of topics like childhood and ecology sidestep established art-historical categories; to the Zeitz Museum of Contemporary Art Africa, in Cape Town, where an entire functioning artist's studio was moved into the museum to build appreciation and understanding of the creative process.

A sense of responsibility for community vibrancy lies behind the Pérez Art Museum Miami's Art Detectives series, in which kids from underserved communities look at art together with policemen to understand why they might be seeing it differently. That same out-of-the-box thinking has paved the way for a collaboration between the Brooklyn Museum of Art and the Center for Court Innovation, which allows young people who have committed minor infractions to take classes in the museum to clear their criminal records. A new way of looking at the museum as an organization is reflected in the future Lucas Museum of Narrative Art, in Los Angeles, where strategy and human resources will

András Szántó

be framed, as its director put it, "through the lenses of diversity, equity, inclusion, accessibility, and the sense of belonging."

A spirit of ingenuity and social commitment can be detected in many established institutions. The Serpentine Galleries, in London, have invited thousands of artists to create works as part of a global campaign to mobilize action against climate change. The Dresden State Art Collections experimented with setting up a co-directorship in Ghana to share decision-making and resources. In New York, the Metropolitan Museum of Art is planning a period room dedicated to reflecting the complexity of the present moment. And at the other end of the spectrum, innovation and enterprise can be discovered in a brand-new museum set inside a botanical garden in Lomé, the capital of Togo, where education about biodiversity goes hand-in-hand with learning about culture, where beekeeping is part of the agenda, and where traditional Togolese storytellers sing and dance in front of the artworks to help connect them to local visitors.

The list goes on. Every single institution in this volume is experimenting with new approaches to curation, audience engagement, technology, equity and inclusion, learning, and multisensory storytelling—all in the service of expanding the cultural remit and societal impact of the art museum.

Crafting this kind of responsive, empathetic, public-facing museum is a generational enterprise. The museum leaders in this book, born between 1960 and 1986 and averaging forty-nine years of age, are members of the cohort that is shaping museums today and for the years to come. They have in common certain professional experiences and cultural touchstones. They came of age in a postmodern, multidisciplinary art world, with a taste for artistic pluralism. Their careers unfolded in the large after the Cold War, in a relatively peaceful, prosperous time of globalism and affordable travel. Quite a few were inspired in their youth by the Centre Pompidou, in Paris, which modeled a radically new concept of the art museum under Pontus Hultén. Members of this generation steered museums through the flowering of biennial culture, the explosive growth of the art market, the mushrooming of art fairs, the gentrification of large cities, the dawning environmental crisis, recrudescent populism and authoritarianism, and of course, the upending of all dimensions of life by digital technologies.

It stands to reason that this generation's perspective on museums is different from those that came before. As one reads through the dialogues, a distinctive and more or less unifying philosophy emerges about what an art museum is and what it should aspire to be.

The outlook of my conversation partners is revealed in their answers to a question that came up in almost every discussion: *What is a "museum"?* While all underscored the public mission of museums, the centrality of their buildings and collections, and the meaningful encounters with objects and opportunities for learning that museums offer as places of "culture and education," they also repeatedly emphasized the museum's role as a "meeting place," an "agora" for "a certain kind of communal experience"—a "sanctuary for idealism" and a "place of conversation" where "opinions are given voice" and where art can be a "catalyst" for "raising awareness, promoting critical thinking, and empowering communities." Museums, as "reality producers," can "point the way forward for our societies" and facilitate people's "creative engagement in their own futures," they noted. Particularly in countries where civic institutions are weak, the museum can be "a place where you are free to be right," a "free zone," a safe and welcoming "home"—not just for art and artists, but "in the sense of hospitality, of sharing, of communion." Members of this group place value not only on an institution's academic acumen, but equally on its intangible traits, envisioning the museum as "a place of equilibrium" that is "not sterile" but "inclusive and empathetic"—a "living and experimental" entity, a "platform" that "would not be talking down to you" and "be more like a close friend." Perhaps most important, members of this cohort see the museum as an open-ended undertaking that obeys no single model—"*museums* instead of *museum*."

No less illuminating were the responses to the question: *What should museums unlearn to stay relevant?* My interlocutors did not mince words. Museums "need to let go of this obnoxious idea that they are an authority on all things," to "get off of our own pedestals" and "break our own rules"—to shed "all the protocols" and "stop being so high-minded." For many in this generation, museums have become "too institutional" and "too cautious." The museum leaders decry institutions for "having

András Szántó

a hard time speaking to the issues we say we want to speak to."
They implore them to "unlearn the orthodoxies of the Western
intellectual tradition," to "open up, gradually" and "start to
listen more," to "look and feel different," so they can be more
"artist-led and audience-focused." Museums, in sum, should
"let go of their arrogance" and get rid of "the perception of
elitism." To get there may mean going "beyond the idea that
everything happens in architectural structures and behind walls,
in ever-growing buildings, with ever-bigger staff."

Open Possibilities

What I hope resonates above all from these dialogues is a signal
about the onset of a next stage in the evolution of art museums
worldwide. In this new chapter, not only will the art institution
succeed in telling multiple histories and narratives about art,
society, and individual lives, but the story of the museum itself
will turn more kaleidoscopic—jettisoning its uniformity and
splintering into an array of locally and culturally rooted versions
of what a museum can be.

No longer perceived as an inheritance or imposition from
the West, the museum of the future will have latitude to assume
authentically regional forms and functions. In these diverse and
hopefully surprising future incarnations, the art museum will be
embraced by people of all backgrounds, ages, and occupations,
welcoming and reflecting the full diversity of contemporary
societies, seamlessly woven into the texture of the local commu-
nity, while maintaining an active dialogue with the surrounding
world. If the late twentieth century ushered in a liberating plural-
ism in art and cultural expression, it can only be hoped that the
twenty-first century will do the same for the institutions of art.
This sense of open possibility would be the ultimate guarantor of
the enduring strength and relevance of the museum form.

These ideals draw on a history. In 1851, as preparations began
for what would eventually become the Victoria & Albert Museum,
in London, the German architect and social reformer Gottfried
Semper (1803–1879), designer of the Dresden opera house and
friend of Prince Albert, proposed that collections and public
museums "are the true teachers of a free people." A century later,
in 1944, Alfred H. Barr, Jr., the inaugural director of the Museum

of Modern Art in New York, wrote, "The primary purpose of the Museum is to help people enjoy, understand, and use the visual arts of our time." Around the same time, in 1947, the radical museum director and theoretician Alexander Dorner (1893–1957), among the German intellectuals who fled Nazi Europe for the United States, insisted that "the new type of art institute cannot merely be an art museum as it has been until now, but no museum at all. The new type will be more like a power station, a producer of new energy." In 1967, as prosperity was spreading in postwar Western Europe, Johannes Cladders (1924–2009), the free-thinking curator, museum director, and confidant of Joseph Beuys, envisioned that "the concept of 'anti' in *anti-museum* should be understood as the demolition of the physical walls and the building up of a spiritual house."

Writing some thirty years later, in 1999, the American museum administrator and legal expert Stephen E. Weil (1928–2005) admonished museums to look outward and not inward. In his influential essay "From Being About Something to Being for Somebody: the Ongoing Transformation of the American Art Museum," he wrote: "In the emerging museum, responsiveness to the community must be understood not as a surrender, but, quite literally, as a fulfillment." In the early years of the twenty-first century, the French-Caribbean cultural theorist Édouard Glissant (1928–2011) imagined the museum as an "archipelago," resisting the homogenizing pull of modernity, responsive to cultural context, capable of embracing new spaces and temporalities in what he called *mondialité*—a posture of worldliness that sees difference not as a weakness to be exploited, but as a bonding agent to be applied to bring people and cultures together. And it seems it was only yesterday, in 2017, that Okwui Enwezor (1963–2019), the Nigerian-born poet, art historian, and museum director who opened a generation's minds to the urgency of casting off colonial legacies and embracing global perspectives, forewarned that "we cannot take for granted that museums remain very important sites of judgment; the power of the Western idea of beauty and of aesthetic accomplishment has already been written."

This book adds more voices to a conversation stretching over the decades about the possibilities of art museums, both

András Szántó

achieved and as-yet-uncharted. The notion of a more open and democratic museum—one that is more satisfying and engaged, more community-minded and welcoming, more participatory and inclusive, more pluralistic and diverse, more porous and poly-phonic—is not entirely new. It has evolved by degree, taking inspiration from earlier precedents, and it is already animating the activities of progressive institutions and the people who work in them around the globe. Still, our unusual predicament has given it an accelerating boost. If the tribulations of the year 2020 have created any forward movement in art museums, it is by catalyzing new institutional models and behaviors that can meet the needs of the twenty-first century, so future generations can advance them even further.

SUHANYA RAFFEL
Executive Director, M+ Museum
Hong Kong, China

OBJECTS ARE FULL OF OPINIONS

The future history of the art museum will to a significant degree be written in Asia. Few institutions will be more pivotal to that story than the M+ Museum, a brand-new center for visual culture opening in 2021 in Hong Kong's West Kowloon Cultural District, in a towering edifice designed by the Swiss architects Herzog & de Meuron. The preparations are being led by Sri Lanka–born Suhanya Raffel, who took the helm of M+ after serving in curatorial and management roles at the Art Gallery of New South Wales, Sydney, Australia, and the Queensland Art Gallery/ Gallery of Modern Art (QAGOMA), Brisbane, Australia, where she helped to establish the Asia Pacific Triennial of Contemporary Art. Since 2016, Raffel has assembled a large and diverse international team to steward M+ Museum's growing collection, which is anchored by 1,500 works of Chinese contemporary art donated by Swiss businessman, diplomat, and art collector Uli Sigg. We spoke in June 2020, as Hong Kong was emerging from the Covid-19 pandemic and a sustained period of political strife.

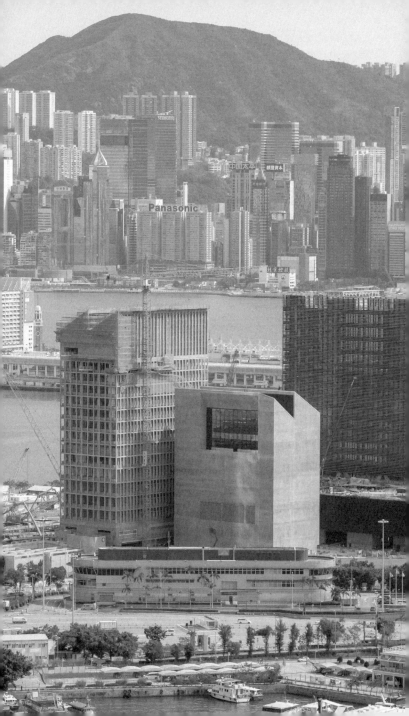

ANDRÁS SZÁNTÓ *We're in a tumultuous moment, and nowhere more so than Hong Kong. Your museum plans to open in March 2021. How has this time tested your ideas about museums?*
SUHANYA RAFFEL I have been thinking a lot about what it means to open a new museum in Hong Kong during a time when the world is changing so profoundly. I think change is actually a good thing. It can bring a level of energy and dynamism that is bracing but important. Change is part of the DNA of life. Change is learning. Change is surviving. So in a situation of intense change in Hong Kong, there is opportunity.

The M+ Museum collections are unique to Hong Kong and Asia. We are building an institution based on visual culture. What does visual culture mean for us? Structurally, it is bringing in collections of design, architecture, moving image, and visual art. Hong Kong has an important history of film, especially in relation to martial-arts cinema, a sophisticated design culture, fashion, and music, often expressed as cross-disciplinary interests. We also see a coherent radical ink practice that intersects with the deep history of ink within East Asian culture. The city is an international cosmopolitan center for the exchange of ideas. M+ is more than a museum of art.

When we look at what is happening in the world today in relation to diversity and voices that need to be heard, I feel as if our institution already embodies a reality that is being sought in other places. We are a pan-Asian workforce, with more than 75 percent of our staff from Hong Kong, working with colleagues from Europe, North America, Australia, and Asia. All of us have our own DNA as individuals. For example, I am Sri Lankan, Australian, now living in Hong Kong. This heterogeneity is incredibly powerful for a new institution in Hong Kong.

You previously served in various roles in Australia. You led the Asia Pacific Triennial in the Queensland Art Gallery. You organized exhibitions in several museums worldwide. How have those experiences shaped the ideas you are testing out for M+?
Crucially. Pivotally. Fundamentally. They underscore the point of view that I bring to M+. When I began working at the Queensland Art Gallery, in the early 1990s, we were embarking on the Asia Pacific Triennial of Contemporary Art. Over twenty years, we built

Suhanya Raffel

a collection of contemporary Asian and Pacific art, when no other institution was collecting contemporary art from that region. It was a blank page. The then-director, Doug Hall, established the triennial as a strategic means of thinking about what could distinguish us. He thought about the region, the neighborhood, Australia's demographics, its history of migration, and its relationship to China and Japan, the long history of exchanges across the Pacific region, which had never been spoken about within the formal canons of art history as established in the West.

I was very young when I joined this museum, and at that time I recall that we had a sense of adventure, as we really had nothing to lose. We roamed far and wide in our thinking, mirrored in the geography we covered. We were unfettered in where our advice came from: architects, filmmakers, fashion designers, performers, curators, and academics—we worked with individuals who had established interests in the places we, too, were interested in. At the time, this methodology was groundbreaking and unusual. Over the course of the twenty years from the early 1990s, a city of two million people that was frankly regional became the home to a museum that was a recognized global contender. The Queensland Art Gallery launched a cohort of professionals who are now dispersed around the world, contributing to the much-needed expanded dialogues in museums today.

As you note, M+ has been conceived as a center for contemporary culture. What will be its most important contribution to society, particularly in Hong Kong?
Hong Kong is an international financial center and business hub. The ambition to build a cultural capital is what initiated the West Kowloon Cultural District, in which M+ sits as a founding institution. There are other institutions devoted to the performing arts: the Xiqu Centre, for Chinese opera; Freespace, for contemporary music and jazz; the Lyric, for dance and drama, which will open two years after us. M+ is pivotal, as it establishes the first museum of twentieth- and twenty-first-century visual culture in Hong Kong, and in Asia.

What will it bring to Hong Kong? In Asia, we need to establish institutions of equivalence to those in Europe such as the Centre Pompidou in Paris, or those in the USA such as the Museum of

Modern Art in New York. I firmly believe that the twenty-first century will be Asia-centered. We need to ensure that we have substantial public institutions in the region that own and deliver the stories and voices from our part of the world: to talk about our histories, our creative ideas and contributions, that are influencing global conversations. We need institutions of substance to ensure that these voices are recognized, along with the deep, complex roots that sustain and provide perspective. Hong Kong is well placed to do this, because it is a nodal point through which so many paths cross.

Can you set M+ against this evolving landscape of institutions in the Southern Hemisphere in general, and Asia in particular? Which parts of the Western museum model translate and which ones do not?
The institutional-structural model itself is the most immediate translation. A museum structured with a collection underpinned with policy, with proper collection management, with established due diligence around intellectual property, with best practice around governance, a museum board—those are important structural tools that we have embraced. That translates well. And it is an important translation, because it is about recognition. Our peers recognize the best practice being embedded into the institution. Governance is an important aspect of our museum's ability to speak with academic and scholarly independence.

What doesn't always translate—and what is often an irritation—are the frequent questions about the ability of this institution, M+, or any museum in this part of the world, to actually express that scholarly, artistic, independent voice. What is happening right now in the United States, with the public protests erupting about race relations, is evidence that such independence is not always to be assumed elsewhere. Black, or for that matter, Asian histories and Indigenous histories that are deeply embedded in the history of the USA have now been recognized as they should long have been. Museums now have to start recalibrating to include these multiple histories.

What have we got here at M+, in this part of the world? Our opportunity is that we have not been burdened with collections and assumptions in the way these more established institu-

Suhanya Raffel

tions have been formed, and they now have to carry forward and redress those histories. I don't have that particular burden to carry. That is enabling.

The word "globalization" is unavoidable in these conversations. What does it mean to you?
A double-edged sword. On the one hand it brings diversity to the forefront. As a species, we are restless. We move. We have always been driven by need or curiosity, or both. That need to journey and explore runs deep across centuries. We have always been global creatures. It is the volume in which that globalization now takes place that distinguishes the twenty-first century. The speed, the numbers, and the economics that support the possibility for so many to move around.

The other side of the globalization debate is the sense that somehow everything is going to be the same—that each institution will somehow mirror the other. I don't believe this will be the case. Our survival is dependent on our not being the same. As soon as we are too much the same, we wither. The challenge is making that difference a positive thing, rather than descending into tribalism and violence.

Up till now, museums were primarily influenced by European and North American models. What will be the biggest impact of the nascent Asian, especially Chinese, museum system on international museums?
Hard to predict. Our community is still an early museum-going community. I need to build an informed audience base here in Hong Kong. In Queensland, we faced a similar situation at the beginning of the triennial. Brisbane didn't have a substantial habitual museum-going public. But within twenty years, attendance went from 30,000 in 1993 to more than 1.1 million by 2012. The local audience had become a hugely loyal interested public. In the Asian context, achieving such a success means ensuring that there is content that is recognized by the local audience as being relevant: "How does it relate to me and my life here?" We have been building a strong collection of contemporary Chinese and more broadly Asian art, design, and architecture that is positioned within a global context and that has yet

to be introduced to the people of Hong Kong, Asia, and beyond. Its relevance will become apparent when people finally see it. Just having this institution will be a transformational change.

Speaking of community relevance, ICOM's museum definition has formed something of a backdrop for this book. What shifts does it portend?
A very important shift. The museum world is a big and diverse world, with voices coming from so many different cultural spaces. There is consensus amongst this community regarding broadening the current definition. We couldn't all agree to the new definition when four thousand delegates met in Tokyo in 2019. But we all did agree that it needed to change. And we agreed that it needed to include a much more dynamic relationship to the communities that museums serve, and that those voices had to have purchase and power. Where we end up will take longer. We are trying to speak across continents and extremely diverse realities. But the value of cultural objects and histories, and what objects tell us about our histories—I think that is now well established and understood as being of principal interest to all.

That 2019 ICOM museum-definition proposal was famously long. How would you sum it all up in one word or phrase, that gets to the essence of it all?
Fundamentally a museum is a repository of objects that relate to people and communities. Material culture is an essential element to be addressed in the definition, including the role of preservation and scholarship that support it.

It is how we articulate these relationships to our communities that needs more expansive, dynamic, and generous expression—because those objects are full of opinions, and the museum needs to be a space where those opinions are given voice.

I also think museums need the protection of strong transparent governance, especially as we commit to understanding our interrelated complex worlds. The institution needs to be able to survive those shifts and changes. Ultimately, institutions that will persevere are ones that rise beyond the dynamics of a particular situation in any given time.

Suhanya Raffel

In this complicated matrix of purposes, one thing we can agree on is that a museum is a place, a location, a site—and it has to have a genuine relationship to its place. Tell me what "location" means to you.

That word allows a sense of palimpsest. You can build on that. You can address so many different communities that form a location. From where we speak informs what we do and how we develop dialogues. If we are alert to our various locations, we will become responsive institutions. How do we manage that? That is a big remit. As a museum director, I am conscious of managing expectations, and this is inevitably a juggle.

At the same time, I see that if one is sensitive to location it brings with it obligation and responsibility. We need to manage points of view that may vary considerably. Our location in Hong Kong brings us an ability to show work that would not normally be able to be seen in other places. Yet our location also allows us to think about a platform—a platform that can be digital as much as it is physical.

How exactly does the digital figure into your sense of location in Asia?

In East Asia, the digital capacity developed early. We live in a highly digitally alert, digitally active community. As an institution, we need to be much more available to people on that platform. We acquired the work of Young-Hae Chang Heavy Industries, an artist duo based in Seoul, whose practice is entirely expressed in the digital space. Some have questioned this acquisition: "How can we even do that, if the work already lives on the Internet, available to everybody?" We had to explain that collections are about longevity, and making sure the works will be available into the deep future.

Similarly, we have begun a schedule of digital commissions, starting with Miao Ying, the Shanghai–New York artist who has been thinking about the great firewall, or "Chinternet," that is a fact of life in mainland China. She made an insightful and playful work titled *Hardcore Digital Detox*, which invited all those outside the firewall to come inside it, if you wanted to get away from the intensity of the World Wide Web in order to enjoy a relaxing online detox.

Location is first and foremost physical. You are overseeing an immense architectural project in which are inscribed various values and ideals. What are they?

In Hong Kong, space is at a premium. Herzog & de Meuron have designed and built an extraordinary piece of public space. As soon as you walk in, the main hall's soaring ceiling invites an immediate physical response. It is an incredibly beautiful and generous space. In Hong Kong, that is a wonderful gift of architecture and space for the public to enjoy.

Elements of our visual-culture mandate are intrinsic to the architecture of M+. The tower that rises above the podium has an embedded LED screen. I believe that many people will first experience M+ via this portal, this digital screen. We also have three cinemas and a *médiathèque* to deliver other aspects of moving image inside the institution.

Herzog & de Meuron responded deeply to the site. West Kowloon is built on land reclaimed from the sea, and the museum sits on top of the airport rail express. The underground metro runs through a floating tunnel that dissects our institution diagonally. The architects realized there were found spaces there, and repurposed these as studio-based experimental display spaces.

Of course, we do have traditional white-box galleries to show painting, sculpture, installation, and video, etc. We will also have a suite of courtyard galleries that are lined with bamboo. Here the architects were responding to East Asian architectural forms. Their expectation was that we would show calligraphy and ink in the bamboo galleries. However, our collection has a much more radical expression of ink, so we will use these spaces quite differently than what the architects may have first envisaged for them. We will install our Duchamp collections, for example, in these bamboo-lined spaces, upending expectations and recalibrating them.

I am sure it is not a coincidence that you are opening with Duchamp. As I recall, Centre Pompidou opened with a major Duchamp show.

We acquired a significant Duchamp collection because of our holdings of contemporary Chinese art, and this relationship will naturally de-center Duchamp when it is exhibited at M+. Chinese artists in the 1970s and 1980s used Duchamp without necessar-

Suhanya Raffel

ily seeing his work, because his practice offered a useful tool or methodology for exploring conceptual possibilities. For M+, this is an opportunity to bring him out of the European-American trajectory of Conceptual Art and re-center him here. We are also looking at his practice as an exhibition maker, thinking about his *Boîte-en-valise* as a "portable museum." All this is by way of saying, "Okay, we are opening a new museum. What are our tools, our guiding principles, our perspectives, that we need to bring as we think about museum-making today?"

Space is also organizational space: the museum's workers, its governance, its institutional architecture. What will the M+ Museum's organization project about the possibilities of the museum in the future?

In this post-Covid environment in Hong Kong, we are thinking about sustainability and community. We also have to think about making ourselves financially viable in a time of deep economic stress across the world. So how do we sustain ourselves into the future? What are the partnerships we need to put in place? It is clear how vulnerable we are as a community of museums. We need to stand together and work to help one another to deliver a more sustainable baseline. Collaboration will be a key aspect of the next chapter of museum work. In Hong Kong, we need to build up an audience that values what we are doing, and that value translates from not only being willing to pay for a ticket but, more important, valuing the museum as an essential civic space for future generations—as an intrinsic part of the soul of a city.

It is hard to measure that value until a crisis comes along. At the Queensland Art Gallery/Gallery of Modern Art, we were faced with the fallout of a very severe flood in 2010 that hit the city. We realized just how much our community valued the museum when the next day many, many people gathered outside the museum with mops and buckets wanting to help clean up. They just showed up at seven in the morning to help.

After a period of convergence that followed 1989, some parts of the world now seem to be pulling in different directions. Huge challenges confront us with alarming regularity, from

pandemics to climate change to political discord. Can museums serve as counterweight to these developments?

I think of the museum institution as a deep resource. We are in a situation of unprecedented economic, political, and social change in which many lives are being buffeted, being pulled and pushed. In this situation, the institution is a refuge, a place for slowing down, for reflection, for challenge and joy. Our civic function is to provide that very important precious space, one we advocate for and protect.

If all goes well, M+ will open its doors next year, in the spring of 2021, and I hopefully will be there to celebrate with you. Knowing the challenges you know now—for this institution and for all museums facing the future—what qualities do you think future museum leaders will need? What advice do you have for them?

It is essential to have patience and persuasiveness. We have to be resourceful and passionate. We have to believe in our project. We have to believe in the meaning of that project for people. We have to be tireless in this purpose.

Suhanya Raffel

VICTORIA NOORTHOORN
Director, Museo de Arte Moderno de Buenos Aires
(Museo Moderno)
Buenos Aires, Argentina

THE CENTER OF THE WORLD

Museum management is not for the fainthearted, espe-
cially in Argentina, a country beset by seemingly perpetual
crises. But Victoria Noorthoorn is undaunted. A curator
who has done stints at MoMA and the Drawing Center in
New York and organized a string of important interna-
tional exhibitions and biennials, Noorthoorn took the
helm of Buenos Aires's modern-art museum at a time
when that esteemed municipal institution, founded in
1956, was a shell of its former self. When we first met,
shortly after her appointment, she was managing a team
you could count on two hands and two feet. On visits to
Buenos Aires through the years, I encountered a museum
that was growing by leaps and bounds. With a new wing,
a comprehensive organizational overhaul, refreshed
branding and communications, and a staff of more than
one hundred, Museo Moderno has been revived—only
to confront yet another crisis. Even so, the Moderno has
launched programs and initiatives that are expanding the
remit of the art museum and striking deep roots in the
Argentine capital's vibrant arts community.

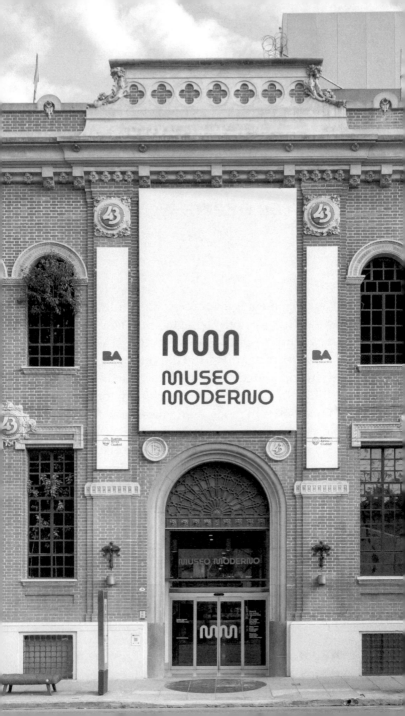

ANDRÁS SZÁNTÓ *Argentina has never been an easy place for institutions. The country came into 2020 with a full-blown economic crisis. Tell me about your experience in these past few months.*

VICTORIA NOORTHOORN A few days after the start of the lockdown, we launched *#MuseoModernoAtHome*, a new online program imagined as an archive of the present. It has reached more than six million visitors in only six months. In weekly or biweekly programs, we explore topics that challenge us as a society going through this monumental crisis. We invite artists (two hundred so far) of all disciplines—theater, visual arts, music, literature, etc., from all around the country—to grasp how Argentine society and the cultural community are responding to the pandemic and thinking about the future. Each artist receives an honorarium.

An important aim during this time has been to remain relevant. We therefore worked at enormous velocity to respond to our diverse communities. We are creating pedagogical materials for teachers, with booklets that have been downloaded twenty-five thousand times and teacher-training programs on Zoom that have reached four thousand teachers from all over the country. We are dedicated as well to serving our mental-health and accessibility programs, as well as those for persons on the autistic spectrum. The immense need for online content creation has resulted in a more dynamic collaboration between areas of the museum that used to work independently. Today, instead of curatorial, educational, and editorial meetings, we have a content working group involving all these departments. We are eager to explore how to translate this new synchronicity back to the new, transformed physical museum.

So, a time of creativity, not just gloom . . .

Indeed. We had to reinvent the museum. Our obsession has been to become a sounding board for ideas developed by Argentine artists at this challenging time, and to provide support to the artistic community, the teachers and families at home, and society at large, during what has come to be one of the longest lockdowns in the world.

You came up on the classic curatorial track: art-history degree from Buenos Aires, curatorial studies at Bard; jobs at the Drawing Center and MoMA, coordinating international projects; curator at MALBA in Buenos Aires; the Lyon and Mercosul internationals; a project in Venice. Did you seek to become a museum director, or were you happy curating?

I loved curating, but I had always desired to lead the institution of my dreams. In my early days at MoMA, I would xerox every document I could find that might help me in the creation of a future institution in due time. The opportunity came years later, when after the 2011 Biennale de Lyon I invited the editors of that catalogue—theater director Alejandro Tantanian and writers Carlos Gamerro and Rubén Mira—to design together a cultural institution for the future, a hub for the creation and presentation of theater, literature, and visual arts. We named it the Center of the World, and presented the concept to the mayor of Buenos Aires, Horacio Rodríguez Larreta. His answer was, "Victoria, can you do this at the Museum of Modern Art?"

In Buenos Aires, I saw a need for enormous change. A more youthful energy and a plurality of curatorial voices were required. Institutions were usually directed by a director who was also the curator, the assistant curator, and the associate curator. This one-person director-curator model was making it impossible for new generations to grow professionally. At the Moderno, the first thing I did was to develop a plural curatorial team, which today comprises eight curators who surprise me at every step.

Can you describe the role Museo Moderno plays in the Argentine art ecology?

The museum was founded by critic Rafael Squirru in 1956, as a house for Argentine artists. It has been able to affirm its close connection to the artistic community ever since, even through the last military dictatorship (1976–1983) and through successive economic crises. It was first closed for renovations between 2002 and 2010, when it was partially refurbished with a design donated by Emilio Ambasz. Shortly thereafter, in 2013, I was invited to lead the museum and tasked to make it once again a leading institution in the city. My goals were to complete the building and to make the museum relevant for the artistic

community again. Museums in Buenos Aires had in the past few decades focused more on international artists and trends, which left an enormous gap in attention to the vast Argentine artistic community. It was imperative to give major Argentine artists their midcareer retrospectives and their first institutional publications. Since 2013, we have presented sixty-three solo and group exhibitions of Argentine artists, and ten international exhibitions. We also produced forty-seven comprehensive bilingual publications covering the trajectories of the featured artists.

Together with Ambasz, we decided to commission the architects Carlos Sallaberry and Matías Ragonese for the last phase of construction. We were functioning at two-thirds of our architectural capacity, and we needed to finalize the building so it could house twice as many exhibitions, a new education lab, and a café. The expansion was completed in July 2018, with the library being the only capital project remaining to be done. If all goes well, we will begin that construction in October of 2020, and it should move very fast—just forty-five days.

Meanwhile, we have gone through an enormous process of organizational development. The budget has increased substantially. The team has grown from twenty-three people to around one hundred. Today we function with all the departments needed in any leading museum of the world, with a diverse curatorial department and teams dedicated to collections, conservation, exhibition design and production, publications, communication, education, fundraising, and so forth. The museum is prepared for a healthy future.

You basically re-created the Museo Moderno in these years. What were your models?
I have three models: artist studios, schools, and hospitals.

Tell me about each one, starting with the studio.
The best ideas and strategies always come from artists. We try to privilege that openness, that state of constant experimentation and research, that attitude of constant discovery, which is so vital to the artistic processes. We have tried to create a working space and working practices that allow for that fresh energy and exchange of ideas, which is flexible and not rigid. I like to think

that some of this energy of the artist studio can be found in what we do, and certainly in what we aim to achieve.

What about the school—how is that a model for a museum?
Art and education provide tools for understanding the world we live in. Artists and curators share the aims of any teacher in any school. Understanding that we are a school of sorts that can reverse methodologies in order to foster the development of the imagination, and therefore multiply the possibilities to create a better world to live in, allows us to think that the museum is a school for teachers, a school for visitors, and a school on its own—a school where we search for new ways of doing and being in the world. Over time, we have come to understand the crucial role of our education department when we build relationships with our diverse publics.

And how is a hospital a reference? That one is especially intriguing.
We are both institutions dedicated to the act of healing. Prior to the pandemic, we had been working on an annual project with ten mental-health patients from the Argerich Hospital, which is just a few blocks from the museum. Our educators go to the hospital, the doctors and patients come to the museum, and at the end of the year, the patients present a small exhibition. And when that group comes to the museum, the hierarchy between doctors and patients dissolves. We are all equal before a work of art. Our minds and imaginations navigate in vastly diverse directions.

Yet of course the pandemic has reminded us of the close relationship between art and health. And as much as we work to offer a space of empathy and reparations before a painful present, we also take strength from the scientific realm, as we incorporate knowledge and working practices that allow us to secure a safer space for visitors and employees.

I know about your love of literature. Argentina is a country of words, perhaps even more than images. You're married to a writer. How do you situate the museum in regard to other disciplines?

Victoria Noorthoorn

This museum was born with a transdisciplinary mission, in line with Squirru's own practice and interests, as he was himself a prolific writer and a lover of literature. Thinking beyond the scope of the visual arts is inscribed in the museum's charter and embedded in the way we work. Yet I must admit that we weren't inviting as many artists from the diverse realms as we would have liked. This moment of confinement has proved an opportunity, and our online program now has plenty of artists working in all disciplines. We are looking forward to fostering this path in the physical experience as well.

What words or phrases would you use to define the term "museum"?
The museum is a meeting place, a place for education, and a platform for the enjoyment of art and culture. The museum is a space for the development of the imagination, which I conceive as the true energizer of a human being and society. The museum is a space for artistic creation. Having artists at the center of any museum is crucial.

In Argentina, where politics permeates life so deeply, and where there is so much inequality and strife, what do you see as the museum's most important contribution to society?
Indeed, there is inequality, strife, and political turmoil in Argentina, probably as much as in the US today.... The museum is a healing agent. It is dignifying. It allows people to understand their past and present and to imagine their future. It provides a sense of opportunity for the true and effective development of freedom; as such, it is a liberating agent for the imagination. It allows you to be someone else in the future, to create that future for yourself.

Argentina is also, as often remarked, the most European, so to speak, of the Latin American countries. European and North American influences are felt profoundly. Yet it is far away from these places. Is there an Argentine approach to museums and art making?
Argentina might seem more European in terms of its cultural heritage, but socially, economically, and politically we are very

much Latin American. In this regard, we constantly seek to respond to our own reality.

One slight symbolic gesture has been to open up windows in our new collection galleries, which enable us to look at the city landscape beyond our walls. Those narrow windows frame the domes of neocolonial churches of Buenos Aires. That image, that presence, anchors our current curatorial narratives.

Our exhibitions reflect and contest our colonial history; they are rooted in our specific locality. And simultaneously, these exhibitions intend to transmit the enormous force of the arts produced in this part of the world. This distance from the so-called centers gives us the possibility of enacting different perspectives—it gives us a freedom that is empowering. Much vitality in our artistic community comes from that. It gives us permission to experiment. Artists can develop their imagination in provocative ways.

I relate to that, as someone who grew up in Hungary. You understand the paradigm, yet you are distanced from it. But let's keep talking about the museum as a super-accessible institution—a museum for everybody, as you call it. How do you create a museum for everybody?
You open it up, very gradually. You undo strict methodologies in order to allow for the creation of a museum as a living organism, one that will be permeable to its context and that will listen to the diverse sounds and voices around it. You identify the key issues—e.g., discrimination—and you tackle them directly; you make them a part, or the script, of your program.

You also reconceive the role of our language. How we speak to our audiences needs to change. We are not an institution apart from our audience—we are our audiences ourselves. There is an enormous amount of work to do to construct an institution for a new world. Artists are essential to this process. They help us look at museums and their role in society in different ways.

I want to touch on some facets of this unfolding. How do curatorial practices need to evolve to be more accessible?
We are working toward a more permeable program that involves more and more artists. Our first exhibition in 2021 will include

Victoria Noorthoorn

one thousand works. We will invite all the artists who took part in our virtual program during lockdown, to thank them for being part of the museum at this critical time. Artists will inhabit the museum. We wish to create a friendlier space, where artists of all generations and backgrounds are closer to the public.

I will never forget visiting the Moderno in 2016, when you restaged Marta Minujín's 1965 masterpiece, La Menesunda, *a delirious installation with screens and tunnels and pillows and rooms with performers doing strange things. It could delight and make you laugh. How can museums balance accessibility and quality? Because we don't want to become the museum of ice cream.*

The capacity of art to deconstruct, to destabilize preconceptions, is something that hopefully could be at the core of a new institutional dynamic. This would give more space to intuition, for getting out of the box, for letting go of the formulas institutions use to present work. How can we use that destabilizing force at the core of artistic practice? How can we bring that shaking of the ground back to the platform of the museum?

Are there lessons to be drawn from the museography of the past that may be relevant in the future?

In Argentina, the Centro de Artes Visuales (CAV) at the Instituto Torcuato Di Tella (1963–1970) functioned as important spaces of creation and experimentation, and also for debate and free expression. I am not sure that happens enough today. We have an unspoken agreement that everything that happens in a museum results from a situation of freedom—but the reality is far from it. There is an enormous amount of censorship inside the art world as to what a museum can be—a sort of *silence macabre* forcing the arts in predictable directions. I believe our role is to try to undo that censorship as much as we can.

Perhaps that predictability and homogenization are the price the museum field has paid for its professionalism.

Totally. All the press releases have the same language. They drain the complexity out of the art. They make it so digestible. It's horrible.

I hear the urgency of adaptation in your words. A museum for everybody is by definition not for a narrow elite.

One of the problems, again, is language: a language that assumes you are in a position of knowledge and the other person is not. It is crucial to make the museum part of its community, not to situate it as a superior entity. Yet there is a fear of open debate today, an enormous fear of culture, especially in the political classes, certainly in Latin America. There is panic about what can come from a human being who expresses himself or herself in a potent way, with all of their desire for a new world.

So with all this in mind, if all these impulses could be translated into the structures of art institutions, what would be most surprising about the museums of tomorrow?

Their vitality. The museum of tomorrow is a space that is invigorating, active, vital, alive. A space for discovering that the fantastic force of art is not something remote or utopian, but close to you. A contagious space. A fun place. A place you hopefully wouldn't want to leave.

If you had the budget to imagine a museum that's more open to everybody, what would be your dream project?

To turn a city into a museum. It would not be a city museum, but a museum-city. It would be a city conceived artistically. Art would inform the whole and in every detail. You would go into a supermarket and your paper bag would be made by an artist. The school system would be conceived by artists. The scientific labs would have sectors for free experimentation. It would be a utopic world, not a utopic museum.

Alas, we do not live in utopia. In the real world, Argentina is in perpetual crisis. What are some of your unrealized projects for the Museo Moderno?

Taking our education programs to a new scale that would reach millions; the creation of a branch of the museum for emerging artists; and the creation of new storage areas in the neighborhood that could become available to the public.

And maybe we should bring back our truck! Back in the 1950s, the museum had a truck that toured works from the collection

Victoria Noorthoorn

all over Argentina. I would like to take the museum out of the building—physically, not just virtually. It would be a kind of national circulation system for art and artists.

The past seven years have reinvigorated the Museo Moderno. They have also been incredibly hard. What keeps you going?
I have always told myself that my job was to give this museum a budget, a diversified financial base, a professional team, a functional building, a collection with all requirements in place, and a strong program of exhibitions and publications and education for the future. And once the institution was at a higher level of development, I would hand it over to the next director. That remains my aim.

Difficulty is part of any Argentine's way of dealing with life. We don't know how to work without difficulties. This pandemic has been a tragedy, but it also gave us a gift. It gave us permission to rethink what we are doing today and for the future, and to adjust any gears to make that happen now and not tomorrow. I have the privilege of working with a team that is enthusiastic about envisioning an institution that is even more relevant for society. That is what gives me the force to fight, to make sure that happens.

FRANKLIN SIRMANS
Director, Pérez Art Museum Miami (PAMM)
Miami, Florida, United States

YOU HAVE TO MEET PEOPLE WHERE THEY ARE

Neither Franklin Sirmans nor I can pinpoint exactly where or when we first met, but our best guess is that it was almost twenty years ago, and maybe earlier, in New York, when we were starting out in the arts. A native of Queens, New York, born in 1969, Sirmans established himself on the art scene soon after graduating with an art-history degree from Wesleyan University. The writer, critic, and editor's first museum gig was at the Dia Center for the Arts, in the publications department. Important curatorial projects followed in Italy and North America, among them a major Basquiat exhibition, and soon Sirmans was curator of modern and contemporary art at Houston's Menil Collection. Next stop: head of contemporary art at the Los Angeles County Museum of Art (LACMA), where he was reunited with his friend and mentor from Dia, Michael Govan. In 2015, Sirmans was appointed director of the Pérez Art Museum, a young institution in Miami—gateway to the Caribbean and Latin America—that occupies a groundbreaking building and serves a diverse audience that mirrors all the demographic frictions and promise of the United States.

ANDRÁS SZÁNTÓ *It's been a heck of a time for this country. As we speak, Covid is peaking in Florida. We've seen protests, a giant reckoning for museums. How has it registered for you?*

FRANKLIN SIRMANS On February 13, we had our second-largest public event, *Art & Soul*, a celebration of our Fund for African-American Art. Around March 7 we had our annual gala. Five days later we started to have urgent conversations among cultural institutions in Miami. We didn't even know what Zoom was. We decided, in the spirit of who we are, that the museum is a place for people to find sustenance and comfort, so we stayed open through the weekend, and then closed on Monday. And, boom, we pivoted to digital.

Then on May 25, George Floyd gets killed, and our worlds collide. We had been talking about equity, distribution of wealth, and health care. Why are Black people dying at these abnormal rates? Why are poor people dying? That was already apparent immediately early on in Covid. When George Floyd happened, it just snowballed the conversation around social justice and systemic racism. And now here we are, living in a moment I thought I would never see.

Have you been surprised at the intensity with which Black Lives Matter has captured the conversation in the art world, at the intensity of the soul searching?

I don't feel surprised. We all knew back in November 2016 that something was going to happen. We've seen things happen along the way—Charlottesville, El Paso. There is just too much hate. I don't know if we knew it was going to be this hard.

How far do we need to go to fully digest the implications of this moment, toward a deeper awareness of racial inequity?

As museums, we have advocated for being arbiters not only of taste, but of humanism. And now we have to question how effective we have been and how much lip service we have paid to actual change, rather than creating real change. We don't look like the things we have been talking about. There is an Instagram account, *@show_the_boardroom*, where they are posting photos of senior staff and board members of major arts institutions. It's a reckoning.

Before we go further, I'd like to get a sense of what got you inter-
ested in art, as a kid from Queens, then Harlem. It's not a typical
path for a Black man of your generation to go into the art world.
It's so simple and clichéd, in several ways. My father was a doctor,
and he wanted to decorate his office waiting room. I don't know
how he came to it, but there is an amazing Romare Bearden print
of a Black Hippocrates or Hippocratic figure. That was one of the
first works we had. We lived in Lenox Terrace, ten blocks up the
street from the Studio Museum in Harlem, directly across the
street from the Schomburg Center for Research in Black Culture,
and down the street from the world-famous Harlem YMCA. Later,
I ended up in openings and situations where artists were around
and museum people were around. It kind of wore off on me a little
in the end, living back in Harlem as an adult.

Eventually, art became something to write about. I got out of
college in 1991. I had already been face-to-face with artists and
curators of the 1970s and early '80s, like Al Loving, Joe Overstreet,
Ed Clark, Nanette Carter, Faith Ringgold, Kellie Jones, Lowery
Sims, Leslie King-Hammond, Kinshasha Holman-Conwill, Vin-
cent Smith. Gallerists like Peg Alston, Corrine Jennings, Alitash
Kebede, June Kelly, Ruth Jett, Eric Robertson, Merton Simpson. It
was all fascinating and interesting, and it allowed me to be part of
a conversation. At a certain point, I had to make that my own.

Again, a cliché. In February 1985 I saw the *New York Times*
Magazine with Jean-Michel Basquiat on the cover. I was halfway
through high school and surrounded by creative folks and just
all-around good people. There was this flowering of creativity
around hip-hop. When I got out of school, I was able to sit around
with people like dear friends Thelma Golden, Greg Tate, Kellie
Jones, Arthur Jafa, Gary Simmons, Lorna Simpson, Glenn Ligon,
Carrie Mae Weems—this amazing group in New York City at that
time. Another important person for me was Christian Haye, the
poet and critic, who ran a gallery on 125th Street, bringing the
Scandinavian artists Elmgreen & Dragset to New York, showing
William Pope.L, Julie Mehretu, Sanford Biggers, and the list goes
on. I was also talking to journalists at *Vibe* magazine, which had
just started. Within that constellation, I knew that writing about
books for *Publishers Weekly* was cool, but not that cool. No one was
writing about art consistently from my viewpoint. That was some-

thing I tried to plug into in that moment, and more in the context of hip-hop, in line with Greg Tate.

The road has led from New York and Dia to curating in Atlanta, Baltimore, Minneapolis, and internationally; then on to the Menil Collection in Houston, to LACMA, and now Miami. You curated Prospect.3 in New Orleans in 2014. What have you taken from those experiences?

I was working at Dia (with Karen J. Kelly in publications and Lynne Cooke in curatorial right next door) from 1993 to 1996, when Michael Govan came there from the Guggenheim and brought with him not only a passion for art, but also a real idealist's sense of communication, which I share. His push with the Internet, as a fledgling tool for greater communication and collective conversation, was insane. We were trying to do art projects on the Internet when it was prehistoric. I worked for Michael again in Los Angeles, many years later. We've always shared an evolving conversation, and I am so grateful for that.

Houston was spiritual. It wasn't just about history and telling stories. They were about art that was in service of something greater than its monetary value or its position in a scholarly discussion. Take Barnett Newman's *Broken Obelisk*, which was gifted to Houston in the name of Dr. Martin Luther King, Jr., and this beautiful pool of water that was created for it to sit in—this incredibly idyllic setting to address the things we are addressing today.

Any other people who left a deep impact?

Yes. We started off by saying there were not a ton of young Black men going into the field at the same time. But the women! Lowery Sims, Leslie King-Hammond, Deborah Willis, Kellie, Kinshasha, Mary Schmidt Campbell—I wouldn't be here without them. They have all been incredible mentors. To think of Lowery Stokes Sims and her presence at the Met—that was a big touchstone. And we can never forget the great impact of Dr. David Driskell (1931–2020) in advancing the academic study of African-American art, in particular.

You were appointed director of PAMM in 2015. Here you are in Miami, one of the youngest cities in America, and one of the most diverse. What drew you to it?

Franklin Sirmans

A desire to bridge, to converse and communicate, has always been the overriding goal for me. When I first went to the Met and MoMA, I felt at times, you could say, alienated in certain ways. I think everyone feels intimidated when they walk up the steps of the Met for the first time. Our building in Miami, by contrast, is surrounded by glass. There are no steps to get up to the building, no Greco-Roman architecture. It has a very vernacular architecture that is connected to this place. It is built on stilts, a reference to Stiltsville, just down the water in Biscayne Bay.

On the other side, as for many Black Americans, the South is important to our history and our trajectory. I had family in Georgia growing up. This space seems so pregnant with possibility. I could not have imagined a better position and place to be in.

The circumstances of our founding are a big part of what drew me here. Our institution was born out of a challenging moment. Concerned citizens and our founding director, Jan van der Marck, recognized the need for it in the events in Miami in the years preceding the opening, in 1984. In 1979 an insurance agent and former marine, Arthur McDuffie, a Black male, was killed by police officers in what is today's Design District. In May 1980, the police officers tried for his death were acquitted, in Tampa, setting off days of protests and violence. A six-month immigration overhaul of South Florida had begun just before. In the Mariel Boatlift 125,000 Cubans fled to Miami, along with 25,000 Haitians. Miami had already been transformed since 1959 by Cubans fleeing Castro. On top of that, the city was the epicenter of the exploding Latin American drug trade.

Not to digress, but that background informs us in the present: this museum was made to bring people together in a time of deep unrest and distrust. This is why, in 1983, when van der Marck, alongside Christo and Jeanne-Claude, realized *Surrounded Islands*, he would say, "For a change, people weren't talking about drugs, riots, or refugees when they spoke of Miami. Christo's melding of contemporary art and nature in a luminous pink motif signaled a change in the perception of the city."

Miami is a city of extremes. Inequities are glaringly in evidence. And it's fair to say that inequality—of income, education, jobs— is a defining issue of our time. How do you tackle it?

This goes back to "What are museums for? Who are they for?" We have made the case for some time as institutions that we are community-centered. We are not just a place for one group to come and look at something on a wall; we want to be meaningful in all people's lives. Our ability to bring different people together and help them learn about each other is now more crucial, and necessary, than ever. Obviously.

We have a program called Art Detectives, which uses art to bridge differences and catalyze difficult conversations. It brings together Miami-Dade police with kids from what we would call underserved communities. They literally go through art learning together. "What do you see? Why are we standing in front of exactly the same thing and yet seeing different things?" It is all about forming bridges.

If we think back to Alfred Barr's MoMA, the exhibitions were not limited to European modernism, but also included African art (1935), Cuban (1944), and shows like *The Family of Man*, in 1955—this anthropological impulse to understand each other was at the heart of the endeavor. We have tried to pick up on that conversation. We need it more than ever.

It seems to me, when it comes to museums, some barriers to entry are visible, some are not. There are invisible walls around museums, even yours—and these are the hardest to topple. How do you convey that a museum is for everybody?
You have to meet people where they are. One thing I learned from the way Michael Govan administered at LACMA is that you can have mobile art labs. We can set up projects in schools, in different neighborhoods. That sense of truly being a part of the entire community is important. We have tried to bring art to people, as opposed to asking them to come to us. Let's at least initiate the conversation on their turf—then maybe we can have a conversation on ours. I think that is crucial.

We are speaking a month after the nationwide protests sparked by the killing of George Floyd. Museums have a lot to learn, and to unlearn. What are the most important lessons?
We have a hard time speaking to the issues we say we want to speak to, and speaking to the communities we want to speak to,

Franklin Sirmans

because in a broad sense we are a monolith. There's not a lot of racial, social, or ethnic diversity in the field. All these conversations really have to embrace a level of diversity that is going to hurt a little bit. It's hard to imagine how there have not been more actions to this point, in line with the conversations that we have been having.

There is a difference between talking the talk and walking the walk.

That's for damn sure. How much are we going to engineer the changing of the guard in terms of staff and board? We have to, if we are going to evolve with this moment. That is real change. Somebody has got to engineer it. We have to set goals to look different in the future. We are all in the process of doing that, to some extent.

Another thing is: *what is art?* Within the context of our museum and value system, the things we have been able to do for people with a work like Arthur Jafa's masterpiece, *Love Is the Message, the Message Is Death*, and the conversations we have had around it, make it way more valuable than any painting that might raise millions at auction. I think we have to collect that way. Maybe we need to think about what a piece does for people, rather than looking at what it means for a more sanctioned, art-historically minded group.

This is where we get to some difficult issues. How do you unscramble the omelet? What do you do with a large museum that has Europe at its center?

Yup. That's where we are. That's the hard part, right. Because now we are talking about, "Oh, shite, do we even still have jobs?" Are we prepared for that future?

What do you make of "cancel culture"? How do you deal with a culture that needs to be remedied, but somehow without obliterating it?

There seem to be ways of both commemorating and constructively conversing about the evils of history and the atrocities of humans. I have been afforded opportunities to think about the Holocaust on my travels, for example, in Germany. Or Senegal, specifically looking through the Door of No Return. There is a way to talk about that now. I believe there are things that are also more

subtle that lead to a conversation, rather than sticking a flag in the ground. Boy, do we have to be conscious about that here in Miami, where we have a population that is very sensitive to the visual imaging of certain historical figures. We should have a leg up on this conversation. Nobody should be talking about monuments to Confederate soldiers anywhere in South Florida. I am not a fan of monuments for the victors.

I grew up in a Communist country. We were not fans of Soviet monuments. When the system ended, they gathered the sculptures, took them to a park, and created an opportunity for reflection. I always thought that was a rather clever idea.
Agreed.

As a director at this time of polarization, how do you navigate between your political convictions and the mission of the museum to be available to everybody?
We certainly try to provide a place for everyone's conversations. Doing that in a time like this becomes more challenging. But if we remain connected to the idea that we are temples of idealism and humanism, then we have to at least be open to the conversation. Boy, is that challenging. The issue goes back to where we started, talking about this current moment. I think a lot of people knew that this moment was coming, ever since the election of November 2016. We have been trying to navigate this space between personal conviction and institutional mission.

Given all that, how would you define a "museum"?
I think of it as a civic sanctuary for idealism, for free thought, and for providing a space and place for conversation and for bringing people together—using art as a catalyst for those conversations. And all the while believing that it is the job and duty of artists to point us in the right direction, and that we're trying to learn from them.

Let's go to the crystal ball. What will be different in museums in the future?
Our job will be to pick up some of the energy of more socially inclined organizations. We are not trying to co-opt what they do,

Franklin Sirmans

but we need to be their collaborators in meaningful ways. What does it look like to collaborate with the Boys & Girls Clubs, or with houses for the homeless? We have to own the space that we have been talking about for a long time—being community-centered and having a part in people's lives that is potentially more meaningful than just entertainment. There's too much hate in the world, and museums should level the field and provide spaces of love—not agreement, but just open hearts.

How does that remit change the curatorial agenda?
You gotta let go. We have to allow for real life to enter into the conversation. It is not just an international art conversation we have to learn. You see it with educational departments over the past twenty years, and the sort of agency they have been given. Now that agency needs to extend further into the public. I don't just mean crowdsourcing. I mean real, meaningful collaboration.

This is good, but it is an expansion of the mandate, and that's expensive. Are you concerned about the viability of museums, especially if they embrace this broader remit?
It just means some things have to be juggled. We have to place more importance on some things than we have in the past. But I am gravely worried about the future of many art institutions.

We also have to deeply consider what it means to be a responsible art institution. If you are supposed to be a temple of humanism and idealism, then you have to treat your staff and the people who work with you every day much better. How important is it for us to value the work of a teaching artist as a thought leader? To have someone like that in your fold is an honor, and it should be valued differently than it has been.

You probably have a good twenty years or more in this field. What will keep you going?
We love what we do. We love the conversation. We appreciate the opportunity to work and talk about art objects and the meaning they have in people's lives. Which is why this is such an exciting moment of opportunity. You can see that it's about to change. Or at least I can feel that things are going to change in some meaningful ways right now. I also play tennis, for balance.

MARIE-CÉCILE ZINSOU
President, Fondation Zinsou/
Musée de la Fondation Zinsou
Cotonou & Ouidah, Republic of Benin

WE REALIZE WE HAVE TO CHANGE EVERYTHING

My conversations with Marie-Cécile Zinsou began in 2015, when she took part in the second Global Museum Leaders Colloquium at the Metropolitan Museum of Art. At thirty-three years of age, she was the youngest in the group of invited international museum directors. She mesmerized her colleagues when recounting how in 2005 she had launched, while still in her twenties, the first contemporary art institution in Benin, one of the world's poorest nations, where her family has been prominent for generations. The Fondation Zinsou, in Cotonou, would be followed in 2013 by the Musée de la Fondation Zinsou, in Ouidah, featuring Benin's most important collection of some 1,200 works of contemporary African art, in well-equipped facilities capable of hosting international loans and exhibitions. For her cultural advocacy work, Zinsou, who was born in Paris in 1982, was made a Chevalier de l'Ordre des Arts et des Lettres and invited onto the board of Versailles and the Institute of Islamic Cultures in Paris. Not content to sit still after starting two institutions, Zinsou continues to explore new models for the museum on the African continent.

ANDRÁS SZÁNTÓ *In the future, more museums will be established in places that never had one before. In fact, you founded not one but two institutions: the Fondation Zinsou, in 2005, and the museum in Ouidah, in 2013. How did they come about?*

MARIE-CÉCILE ZINSOU It really started from scratch. I had never worked in a museum. Benin had post-colonial museums, but no contemporary art museums. In fact, there had never been a museum in the city of Cotonou. I created the museum because of the emergency of culture. There was nothing for art in Cotonou, which is the economic capital of the country. There were a lot of people, especially children, with a demand for culture, but no place to see contemporary creation. The idea was to establish an emergency structure that can give access to, first of all, African art, and more broadly, art from around the world.

I will never forget the story you told a few years ago about the reaction of the children when they first saw the foundation. Tell me about how the community reacted.

I was teaching children in an orphanage. My students were interested in art history, in painting, music. I thought, *If you have eighty students interested in art, there are probably more*. They just hadn't been given the opportunity. So I started the foundation, which meant: rent a building; convince artists to lend to a show; ask people to work with me; and try to explain what the point of it all was. We opened our doors on June 6, 2005.

At first, people didn't come. No one knew what we were there for. Nobody understood. When we explained we are like a museum, they said, "Okay, but why should we go?" They had lived without museums all their lives. First, some adults came; they entered, saw it was empty, and left. Then children came. They said, "Oh, it's empty." We invited them in to stop, look at the walls and the pictures. They found oil cans transformed into masks (our first exhibition was a solo show by Romuald Hazoumè), and so on. They found it very funny. So they stayed and they were really happy. The next day, they showed up with six hundred friends.

We soon had hundreds of children coming every night. After a few weeks, the parents came, because they wanted to understand what the children were talking about.

Marie-Cécile Zinsou

How did the foundation lead to the museum in Ouidah?
We did a lot of exhibitions at the foundation. We did books. We had workshops for children. We started inviting artists in residence. After a few years, people would ask, "We see on TV that every country has incredible museums. Why aren't you a museum?" So we thought that for the permanent collection, maybe we should have a place called a museum. Part of it is about pride. People want to come and see their culture in a museum. A museum means you have a culture. You have an institution. The word was important. That's how the museum started.

Today, everything is changing. When we started, in 2005, I felt we had to do everything exactly as if we were in Berlin or Tokyo. With all the debate about restitution, the fact that we do not have institutions that meet international standards was something we heard often. I wanted to show that we were able to respect every code, so we could have a Basquiat show, or a Keith Haring show. That is how eventually we were able to receive works from the French national collections. I wanted to show that it was possible.

And along the way you had an epiphany....
We were doing our first exhibition with the Musée du Quai Branly when I realized we did not have an archive. It was difficult to learn about our history in books. I knew my French story, but I didn't know my Beninese story. So I started working on Dahomey, the former principal kingdom in Benin. I learned that artworks had always been shown in Dahomey to the population. The kings had a tradition, in the eighteenth and nineteenth centuries, to show each year the art of the royal court to all the people who gathered in the capital. I realized that rather than obsessing about showing everything exactly as elsewhere, we should find our own model. Because trying to look like a Berlin museum is kind of absurd when you live in Cotonou.

Now, after fifteen years, we realize we have to change everything. We have to create the museum in our own way. We have proved that we could do it their way, so now we have to invent our own solution. Maybe we have something to say about another way of showing art.

*Let me into your thinking about what such distinctive ways
of showing art may be.*
I am working on it. I am trying to create a new space. It proba-
bly won't be a "museum." It could answer to the definition of a
museum, but it would not look like what you would see else-
where. We keep a collection. We show it to people. But we won't
do it between four walls. That is not for us.

To meet international standards, you have to maintain
twenty-two degrees Celsius inside the museum, with 50 percent
humidity. These strict conditions are not good for us. I spend
twenty-five thousand euros on electricity each month. I can't
think of being able to spend that much money. The museum
model has not been thought through for a developing country in
a tropical, humid environment, in one of the poorest nations in
the world.

So what is our next step? I can't create the next 250-million-
dollar Smithsonian building by David Adjaye. It's absurd in my
context. Finding a replicable space for developing countries on
our latitude is a real question today. Why should we have four
walls in a building, when every place where people meet in Benin
has been open since the seventeenth century? The marketplace
is where everyone gathers. The king of Dahomey gathered the
population and took his whole collection out of the palace, and
did a runway show on the head of the Amazons, the female army.
You did not go to the artworks; the artworks came to you. This is
the path we are taking.

*I think we often forget how intimidating classic museum
structures can be, even modern ones.*
Even when we rented terrible-looking buildings in Cotonou,
some people thought they were too chic. It's difficult to go
through the door of a museum when you are not used to it. That
is why I decided there will be no walls in my museum. We will
try to make a space with no walls, something that people see
every day, which they can envisage and understand. We need a
roof large enough to show works there in good condition. I'm
thinking we can build a structure like that for two hundred thou-
sand dollars. That will make it the cheapest museum in
the world.

Marie-Cécile Zinsou

We are also thinking about using containers. Cotonou is a port. We think that if we could build a structure out of thirty-five to fifty containers, people will not be afraid of them, because they see them everywhere. It will be a bit radical. And I hope it will work. If it doesn't, we will correct it and invent something else.

We saw in the pandemic that the museum escaped the four walls, digitally, because it had to. That does not sound like a solution to you.
No, because people who go to visit museums online are people who know what they are searching for. And you cannot search for something you don't know. The fact that you are looking for them means you have a high level of education. I don't believe someone from Parakou is going to try on Google terms like "finding contemporary art museums in my country."

Who can help you solve this puzzle?
I speak to artists, because the first thing we must think about is the collection. The artists need to be okay with the project and conceive works that can be shown to everyone in every possible condition. We can't continue to show vintage photos from the 1950s on fragile paper that can be destroyed by humidity. We can print them on vinyl, the kind you put on buildings. We've done that with Malick Sidibé. We presented fine prints of his photos in the foundation, and we put 300 of his pictures in large formats on the street—and we had 1.2 million visitors. Everyone in Benin knows Malick Sidibé now.

This brings us to post-colonialism. The museums on which all others are modeled are kind of machines for showing European art—paintings and sculptures, drawings. It is implied in the architecture, the whole organization. You are dealing with a different cultural tradition and situation.
How do we look at our colonization history? Dahomey was colonized from 1892 to 1960—sixty-eight years. In eight years, Benin will have spent more time being independent than colonized. I think it is weird that we are meant to spend all our time speaking about colonization and what we are doing in post-colonial times, when in fact it was only sixty-eight years. We know it happened.

But we cannot manage our lives always through this lens. The young sponsors of the foundation don't want to hear about colonization. We need to invent our model to move past this situation. We have a thousand years of history.

This still leaves open the question of what sort of institution is a good fit, not just technically, but in terms of its cultural assumptions.
Mediation is one of the things that make African museums different from museums in the rest of the world. We always had dancers dancing the collection, singers singing the collection, rappers rapping the collection. We had people with their own cultural background interpreting the collection. We had traditional dancers, contemporary dancers, all kinds of creative forms, almost every week, since the very beginning. We have people speaking traditional languages, and we are trying to use elements of our culture to explain the artists' works.

Because of the weakness of many institutions in Africa, museums have been on the forward edge of advancing a new institutional attitude. You are not just about objects, but about filling gaps in society. Would you agree?
That's exactly what I was trying to do with the foundation. You have to watch developing countries to see the new concepts. We had a team here from the Louvre, in France, asking us how we used WhatsApp to engage audiences. WhatsApp is something everyone has in Africa. It is almost free. We have WhatsApp groups where we connect, explain what is happening, when we're opening. They came here to see what kind of tools we are using. Because we can try anything, and we are quite flexible.

Your family has been prominent in Benin for generations. You had not worked in a museum before. Why did you choose to make your impact this way?
I didn't decide to do something in culture. I just had to. It was the emergency of sitting in front of thirty kids and asking them, "Okay, explain what your culture is," and these kids not knowing what to say. There was no place to understand our culture. The closest exhibition of the continent's contemporary creations,

Marie-Cécile Zinsou

Africa Remix, was six thousand kilometers away, in Düsseldorf.
An important curator from the Musée du Quai Branly, Germain
Viatte, was visiting Cotonou at the time, and I said to him, "I
think we really need a museum." He said, "Just open it. Take
anyplace and put up a sign that says 'Museum.'" And I did that.

Truly a museum from scratch.
I didn't have a choice. I was twenty-one. I just had to do it.

The next challenge, it seems, was to create your audience. How?
You go and meet every person and you explain why museums are
fascinating. You shake hands, smile, and introduce yourself—
because you are coming with a new concept that nobody knows
they need. That is how you reach the first thousand people. After
that you need a wider concept. You start exhibitions on the streets,
in other neighborhoods. Then you go on TV and explain why this is
so interesting. And most important, you go to every school princi-
pal, and you buy them a beer. After the beer you explain that maybe
schoolchildren should come. And then they come.

We also had people singing. Every exhibition had a song,
and the song would end up on the national radio all the time, so
everyone would know about the museum. I hired almost every
famous singer in Benin in the first five years of the foundation.
We invented different ways of meeting people. After social media
was created, we used it in the same way as TV and radio. But the
first challenge was how to shake the maximum number of hands
and share our message in a minimum amount of time.

*How did you find people to operate the museum? Are there any
unique roles for this context?*
In 2005, it was complex. I started putting ads in the paper about
jobs we were trying to fill. Nobody answered. Nobody knew what a
"museum guide" or a "curator" was. Finally, my uncle helped me.
He went to the church and shared a message after mass, when
you can give a personal message to the community. He said, "If
you have any children, a husband or wife who doesn't work, my
niece is creating a museum." So every unemployed person came
to see what I was asking for. Some of them couldn't read or write.
We tried to figure out who could do what. They absolutely didn't

understand what we were doing at the beginning. But they knew it was different, and they were quite excited about it. And when professors came and looked at them with respect, they felt it was something important. They learned on the job.

How did you go about raising funds?
Today, everyone says, "Why didn't you come to me at the beginning?" But I have never heard anyone say, "Hi, I am twenty-one, I have never worked in a museum, but I decided to create mine, so I would be happy to have fifty thousand dollars." I don't think that would have worked.

At first, we had eighty thousand dollars in a family account, and with that we could rent a space, hire some people, and make a book about the adventure. I felt we needed companies to finance us. But none of them had a budget for sponsorship. So I went to the most important bank in Benin and said, "Will you please become a sponsor? It will cost zero, but you will have to sign a contract and promise you will never tell anyone you gave zero. If you tell anyone, you have to give us a hundred thousand dollars." We put their logo on the façade, the invitation, everywhere; we thanked them at the exhibition opening. By the third show, everyone wanted to be involved. All the other banks came to me and said, "We don't know how much they gave, but maybe we can give more."

So it worked out in the end. With these experiences in mind, what do you think is at the heart of the term "museum"?
I keep my museum open because it is one of the places where you are most free to speak and think. It's a place where you are free to be right. That is why I did the Keith Haring exhibition. Haring wrote in his journal that from the minute he finished a painting, his view of the work and your view were equivalent. I thought it was important for people to feel how free they were in front of an artwork. For me, in my context, in my country today, that is the most important function. To be the only free space in town.

So where do we go from here? How do you imagine tomorrow's museums? Will there be an "African model"?
I am not exactly sure. In Africa, I do think the future is about

Marie-Cécile Zinsou

private initiatives. Government initiatives are not the answer. In developing countries, the answers will come from private citizens and sponsors. Only they can invent things. The model is Naoshima in Japan, or Inhotim in Brazil. These are probably the most amazing museums in the world, and they can only emerge with private funding. The future will not be revealed in the most important hundred-year-old public institutions.

To adapt to this future, what will institutions need to unlearn? What habits do they have to shake to stay relevant?
Museums have become too cautious. And being cautious means not being relevant when it comes to contemporary art—or art in general. If you're a museum, you shouldn't feel like a cupboard. It shouldn't feel like you're putting the works in a cupboard that you close and only open sometimes, and after a while not at all, because all you want to do is protect them.

There is a tension between these roles, especially in museums with large collections. On the one hand, they are there to protect and conserve. On the other, they must engage with contemporary culture, which is moving fast. It can be hard to reconcile these impulses.
It's about risk. I am always questioning myself about certain ancient pieces in my collection. Should we show them to the maximum number of people, even though they are fragile? Or would they be better somewhere in my house, where nobody will touch them? I can take the risk. I can say, "No, the reason we bought the throne of the last Dahomey king is because we want to show it to everyone." I can do it, because it is mine. (Don't worry, it is in good condition.) I feel it is more important for a whole generation of children to have access to their history. A museum curator would never dare to take it out, even if there was only a slight risk.

You are also a social entrepreneur. You follow discussions around development in Africa. Are there any fields museums should borrow from as they evolve?
One of my future exhibitions will be curated by young start-uppers. In Benin, we have identified six successful ones who

want to work with us. When they were children they came to visit the foundation, so I contacted them. They will curate a show about the works that are most important to them. I spend a lot of my time with people who have nothing to do with museums. I look at what is happening in the fashion industry, the music industry, in medical start-ups. I am speaking to those people. And they come to the foundation and sometimes help build the collection with me.

You started two institutions before you were thirty. Do you have any unrealized projects?

We are doing plenty of experiments on the new museum. The other big challenge in West Africa is publishing books and writing about our times. In the past, we depended on the visions of others to understand our story. Right now, we have a team working on publishing books about our artists. It is important to describe what's happening right now, because the continent is so vibrant in every domain.

For this advocacy to have effect, institutions will need to adapt and embrace art from Africa in a different way. What is your best hope for how African art and culture will be represented in museums in your lifetime?

If we manage to find a more innovative model, which goes to people and is more open, then we can try to impact others. For the moment, the codes are European codes, American codes, Occidental codes. We have needed to respect those codes to exist. Now that we have managed to prove that we can respect them, we have to break those codes.

Marie-Cécile Zinsou

ANNE PASTERNAK
Director, Brooklyn Museum
New York City, United States

WE SHOULD AIM TO BE THE PILLARS OF SOCIETY

Anne Pasternak was one of the first people I got to know in the art world. It was around 1990, and I was doing research for a dissertation on the art industry in New York. Still in her twenties, Pasternak had already directed the Stux Gallery, and she was making a name for herself as a curator of ambitious public art projects. She seemed to know everybody. Then as now, she was fully committed to art, a true believer in its potential to transform communities and people's lives. A Baltimore native who is married to the photographer Mike Starn, Pasternak would soon go on to lead Creative Time for more than twenty-one years, initiating memorable projects like the annual *Tribute in Light* memorial honoring the victims of 9/11 and launching a series of global summits on art and social change. A *New York Times* crossword-puzzle enthusiast, she doesn't shirk from complex challenges. As director of the Brooklyn Museum since 2015, Pasternak has been bringing her impassioned brand of entrepreneurship and advocacy to an institution in the heart of one of America's most diverse and dynamic communities.

ANDRÁS SZÁNTÓ *You and I were born in the same year, 1964. It has been wonderful to watch you in your various art-world incarnations. But you had not worked in a museum prior to coming to Brooklyn. How did your previous positions shape your ideas about art and museums?*

ANNE PASTERNAK My entire career has reinforced a simple truth: give great artists an opportunity to be free and realize their dreams, and extraordinary things will happen. My career has taught me to trust artists, to listen to them. Creative Time, in particular, allowed me to help artists realize their dream projects. I had to work with many stakeholders, from government officials to labor unions and community leaders, all of whom have their valued viewpoints. You have to lean in and meet them where they are and listen with great care. And you have to excite them about why they should join you and the artist in a journey that is unfamiliar, even uncomfortable. You have to build trust.

All those skills are important in any job, including museums. We are public institutions and we serve multiple constituencies. Some people think all of our museum staff and visitors have the same political beliefs—that is not the case. So you have to understand the landscape where you are working and welcome people into the conversation with care.

My previous jobs also taught me how to be entrepreneurial. I learned how to work with donors and foundations, to build a board, to be a better communicator and leader. Creative Time, in particular, helped me bridge art and social change. Coming to the Brooklyn Museum was an opportunity to go bigger in figuring out how art and social change can connect.

Were there any artists, apart from your husband, or institutions or events that revealed to you the possibilities of museums?
In early 2015, Glenn Lowry asked me to curate a panel for MoMA one day after the *Charlie Hebdo* massacre. He wanted it done quickly. So I got busy and asked a lot of great thinkers—from artists and scholars to comedians—to help us understand the horrific events. It's amazing how everybody says yes to MoMA. Without much advance notice, MoMA livestreamed the event. Almost ten thousand people tuned in. This spoke to me about the power of large institutions. Many people may like to com-

plain about museums (often with some justification), but at the end of the day they care about them, too. Museums are great democratic spaces to learn, debate, and advance social change. That's a great responsibility, and an opportunity.

I've learned the most about the potential of culture from artists, who have been my teachers. In addition to my husband, there's Paul Chan, Jeff Chang, Judy Chicago, Jenny Holzer, Kara Walker, Mel Chin, and Rick Lowe, to name a few. They are all profoundly moral people and deeply brilliant.

Just after you became director, we organized a meeting at my home, which happens to be opposite the Brooklyn Museum. We invited friends to talk about the museum and the role it has played in their lives. I think we were both amazed by some of the answers. But we never asked what role the museum had played in your life.
When I first moved to New York, I lived near Prospect Park West, close to the Brooklyn Museum. I used to come to the museum quite a bit. My parents met at Brooklyn College. My mother grew up in Flatbush and visited the museum frequently. It felt like I was getting a glimpse of my roots. At the time, in the late 1980s, the museum felt sleepy, yet it was still a place of discovery and wonder. Later, after Arnold Lehman became director and faced a huge controversy over the *Sensation* exhibition, the Brooklyn Museum became a powerful leader, demonstrating the importance of standing up for basic democratic ideals, like freedom of expression. I remember going to the rally to support the museum on my fortieth birthday. The institution's leadership and board took a powerful stand despite tremendous political and social pressure. And they set the bar for me and so many other arts leaders who would later face similar pressures and attacks.

This has not been an easy time. The trifecta of the pandemic, cratering finances, and the eruption of activism around Black Lives Matter has shaken institutions. How has it been for you?
Without question, this is the most challenging time I have experienced as a leader—and I've faced my fair share of tough times. In addition to Covid, we are in a new civil-rights era, and this keeps me inspired, as I feel a strong responsibility to step up—

Anne Pasternak

to go harder, bigger, and faster. It's a time to right historic wrongs, and to learn from past mistakes, including my own. I hope I will look back at this period and be able to say I contributed to this movement in whatever ways I could, that our actions made a meaningful difference. That's my goal and my hope.

How, in a nutshell, do you interpret the mission that you were hired to carry out at the Brooklyn Museum?
I came here with an entrepreneurial spirit, a love for art and artists, and a commitment to community. I wanted to grow partnerships with our neighbors, put a spotlight on untold histories and artists, grow our diverse staff and audience, and create trailblazing exhibitions and public programs. I confess I wanted to pull the center of museum gravity away from Manhattan and toward central Brooklyn. I quickly realized the museum had long been suffering from weak financial foundations. So while I came with a big agenda, I've also had to hustle and focus on building the museum's financial foundations, restructure, rebrand, and improve infrastructure.

Coming from where you come from, what is your definition of a "museum"?
Historically, museums have said they are repositories for humankind's great art—we care for it, we study it, and we share it to educate people. While those are important things, they are not a mission. Fundamentally, we should aim to be pillars of society: public places where you can come to learn, meet other people, share ideas, debate, and even disagree. We should uphold humankind's greatest ideals with truth, dignity, love, and an exhilarating sense of possibility. I do hope we will get better at this. There's a lot to be done in telling truthful histories—histories that are painful and celebratory, told from multiple points of view, histories that reckon with our past as well as our present.

Is there a narrative of museums that you see evolving?
More people are visiting museums than ever. It's a must-do activity, especially when people travel. While it's easy to be annoyed with overcrowding in some museums, overall it's great that more people are being exposed to art and history. But what excites me

is that museums are being pushed to change. Historically, museums, including the Brooklyn Museum, have upheld white patriarchal narratives, but at long last more and more institutions are starting to show and collect more women and BIPOC artists. Just as important, BIPOC people are shaping the narratives of our exhibitions and programs. As a result, the stories we tell are becoming more thoughtful, truthful, inclusive, and exciting. Our field has only taken baby steps, but I am hopeful that fundamental change is happening. It's essential—including for the survival of our field.

Where are the break points in this narrative—the unresolved issues that still need to be tackled?
Institutions like the Brooklyn Museum were founded on the belief that the sharing of world cultures would lead to greater understanding and empathy, and thereby advance civilization. I believe in this ideal. And I believe in the historic role of the museum as a place where we come together to experience great art, learn about our past and the dignity of other cultures. But museums have also played a role in supporting narratives that have led to the pain and suffering of others. We are monuments to a fraught past. We have left out the histories and narratives of so many. We have upheld sexist, classist, racist, colonial, and many other unethical and inequitable practices. So it should not be a surprise that we are facing a major shake-up.

As the Ford Foundation's president, Darren Walker, recently told me, "museums are in a crisis because America is in a crisis." Museums shape narratives that matter, so it's no surprise young people are passionate about pushing for change. It's time now to do better—a lot better. That means looking at ourselves honestly and fixing a whole lot about the way we work as we make authentic commitments toward equity, inclusion, access, and anti-racism.

I started doing these conversations before the killing of George Floyd, and since then the debate about the museum's future has taken on a new dimension.
The imperative is not new, but the urgency is definitely heightened. This is a moment to rethink what we do, where we put our

resources, how we prioritize the work. The horrific murder of George Floyd has given me urgency to look at my own role, to be more reflective and learn. Everyone says, "Anne, you are such a woke museum director." Let me tell you, I'm not woke enough. So I am trying to use this time to enhance my awareness, reflect on my own shortcomings, and learn to be a better leader.

You are known as a community-minded arts practitioner. What exactly does the term "community" mean to you?
I am excited to imagine how the Brooklyn Museum can support community vibrancy. And I am proud that since Covid shut down the museum, we have been partnering with local organizations to provide healthy food for families facing food insecurity and free camps and high-quality art supplies for thousands of local youths. We created a permanent standing committee of the board to focus on our community impact, so we can be a better neighbor.

With that said, the term "community" is bandied about too much. The fact is we serve many communities, and some we serve better than others. It's a time to be more intentional about whom we are trying to work with, how, and why. I am thinking about people who have been historically underserved: Black and brown working families who have faced great challenges due to systemic racism. What does it mean to be a partner and an advocate? What does it mean to be a part of the solution with them? What does an organizing model look like for our museum, as opposed to the service model? The potential is tremendous and exhilarating. I hope we will transform our work with "community" in ways that blaze new, meaningful trails.

When it comes to fostering community vibrancy, what on balance has been successful in the work museums have been doing, and what has been less successful?
Museums have a long way to go in supporting community vibrancy. Since I've been at the Brooklyn Museum, we have done a number of things to move the needle. We have partnered with local Title 1 schools, which have a high percentage of kids living in poverty, providing in-classroom arts training. We have an unusual track record of working with local artists in

our super-popular public programs. We regularly partner with social-justice organizations, nationally and locally. Our exhibitions and collections spotlight histories, artists, and issues that are important to our local audiences. But I ask myself: *Are we doing anything that materially uplifts these people and organizations for the long term?* In my heart, I know we can go further. So we've been inviting our neighbors to speak with us, to tell us about their needs and desires. We are learning a lot. This feels like the beginning of something important at the museum.

As you note, these questions are intertwined with chronic racial and economic diversity and inequity. What other steps could museums take?
There is no road map for our field to follow, but we have to start somewhere, and some things are clear: leaders must take the time to learn and reflect. Boards must be actively engaged in the conversation with staff. We must hire people who reflect the diversity of our city and local community—at all levels, throughout the organization. Same goes for boards, because they cannot steer the institution if they do not reflect our city and nation. We need to rethink our budgeting priorities and curatorial processes. We need to allow greater inclusion of more diverse knowledge.

Obviously, we need to rethink what we show and how. For example, American art collections have long been celebratory of America's past. Why haven't they also been discussing the mass eradication of Indigenous peoples? Where are the truths of slavery and Jim Crow? Where are the stories of immigration? Why do we expect universities to tell fuller histories, but not museums? People will not visit, trust, or love museums until they see representations of people who look like them and stories that acknowledge their many truths, from the celebratory to the painful and everything in between.

What else have you done that could move the needle?
While we have much further to go, I am proud of a number of our new partnerships. For example, last year we began a partnership with the Center for Court Innovation. With their involvement, young people who have been picked up by the police for small

Anne Pasternak

infractions like graffiti or shoplifting can choose to take an intensive class on art and self-determination at the museum—and as a result, their record is cleared.

Are any other kinds of organizations doing a good job with this?
I mostly look outside of museums for inspiration. Libraries are particularly interesting. They have started to think of themselves as places of learning rather than places for books. The Brooklyn Public Library has classes for citizenship, job training, and a whole lot more.

Another cultural model that has been reinventing itself is the Wildlife Conservation Society. The zoo or the aquarium used to be a place to check out a lion or a walrus. Now they support science and advocate locally and globally for the preservation of natural habitats. Museums could benefit from studying how these cultural fields have been transforming themselves for greater impact.

Museums take pride in their collections and academic acumen. Community vibrancy often draws on other forms of engagement— public programs and partnerships. Can a museum find resources to do it all?
For years, institutions like the Brooklyn Museum have been doing more of everything—more exhibitions, more education, more public programs, more donor events, more, more, more. I think we are at a breaking point. It's a time to look at our budget more closely. After all, where we put our money tells us what we value. Historically, resources have been directed where donors are interested in putting them: education, collections, and curatorial. But if we are to become more community-minded and equitable, some things will have to give, because we can't do everything well with limited financial resources.

So what might we change to advance equity? Can we do less of some things so we can divide resources more generously to benefit the people who are paid the least? I wish I had the answers right now, as figuring this out keeps me up at night.

What do museums need to unlearn to be successful in engaging deeply with their communities?

They need to let go of this obnoxious idea that they are the authority on all things, and start to listen more. They need to let go of their arrogance.

Museums also need to look and feel different. You and I grew up in a world where, no matter where you went, all museum installations looked the same, featured the same artists, told the same fake version of history. There must be a radical rethinking of how we tell stories and what it feels like to go to a museum. From wall labels to immersive experiences and new technologies, there's a lot of change on the horizon.

Speaking of what it feels like to visit a museum, the Brooklyn Museum, before your time, moved its main entrance to street level to make itself more accessible. But architecture, it turns out, does not always solve the problem.

The main goal was to be more welcoming and to connect the museum with the life of the street. Whether you like the design or not, it was a step in the right direction. But we have to go further to become a welcoming, inclusive institution. That's why we have been making advances in creating experiences throughout the museum that incite joy and learning. The experience of going from gallery to gallery can be exhausting. Museum flow is ripe for rethinking.

If a philanthropist came knocking to help you realize your goals, particularly as they relate to community engagement, what would be your dream project to propose?

My dream project is the least sexy thing imaginable: I dream a donor will contribute a hundred million dollars to the endowment. We have one of the smallest endowments of any major institution in the United States. Again and again, we punch above our weight, but just imagine what we could do to uplift all of our community if we had solid financial foundations. Frankly, it's an issue of equity. Brooklyn's youth deserve a museum that is as great as the Met, MoMA, the Whitney, or the Guggenheim. The only thing that holds us back is money.

You've been around the art world for some time. Even if we solve these problems around race, inclusion, pandemic response, and

Anne Pasternak

financial viability, we will have climate change and a host of other systemic issues to tackle. This is all quite daunting. What keeps you on the field?

I've sometimes wondered if my skills would be better applied to social-justice causes or politics (god forbid). But I love the arts and I am passionate about their power. They help open the hearts and minds that lead to the social change that leads to political and policy change. Museums have an important role to play. So I hope that when I am old and look back on my life, that my contributions mattered. I am motivated by my desire to do the best I can with the opportunities I have. I feel a profound sense of responsibility.

ADRIANO PEDROSA
Artistic Director, Museu de Arte de São Paulo
Assis Chateaubriand (MASP)
São Paulo, Brazil

THERE IS NO ONE SINGLE HISTORY

The landmark edifice of the museum commonly known as MASP, hovering over São Paulo's Paulista Avenue like a giant magnet, houses the premier collection of European art in the Southern Hemisphere. But since 2014, under Adriano Pedrosa, the privately operated museum has been conducting a bold experiment in de-centering entrenched Eurocentric narratives. It is a fitting place to challenge convention. MASP's Brutalist architecture, by the Italian-born Lina Bo Bardi, wife of the museum's founding director, Pietro Maria Bardi, testifies to the iconoclastic spirit of 1960s modernism. Its norm-breaking display system, also by Bo Bardi, consists of an indoor forest of glass easels on which are affixed Old Master and modernist paintings—part of a ten-thousand-strong collection that encompasses Brazilian, Latin American, European, and African art, along with costumes, textiles, photographs, rare books, and a library. Pedrosa, a veteran curator and avid book collector who usually travels the world nonstop, has helped turn MASP into an incubator for new models of exhibition-making and engagement that challenge Western-dominated discourses, and point to a future in which history is understood to be plural, inclusive, multi-layered, and always speaking to the present.

ANDRÁS SZÁNTÓ *I'm thinking about our last meeting, at MoMA in the late fall of 2019 , when we walked through the museum to see the rehang after the recent expansion. Then everything changed.*

ADRIANO PEDROSA We have seen difficult moments at MASP, as all over the world. We canceled and reduced a number of exhibitions. Yet still we managed to remain excited about certain projects and new possibilities, including on social media. We have always been quite invested in the museum's digital presence, with a strong curatorial direction, and recently we've moved a curatorial assistant to the communications team. With the museum closed, twice a day a curator is writing a post, either about something from the collection or a memory or a recollection related to the museum. In addition, these texts and posts generated through Instagram are being fueled into what we are calling "illustrated captions" for works in the collection display. With Instagram, one can write 2,200 characters about a picture and illustrate it with a carousel of nine additional images. This same material will generate new short texts for the works in the collection, installed on the back of the iconic glass easels, along with small reproductions. It's an updated version of the old "didactic panels" devised by the museum's founding director, Pietro Maria Bardi (1900–1999). This innovation came about during this time of social distancing and deeper engagement on social media.

We also developed a new workshop—a "challenge." Each week, we invite people to draw an iconic work in the collection. We have had a tremendous response. As many as 1,500 people submit drawings on social media. Speaking to our topic of decolonization or de-Westernization, for our Ingres challenge—a nineteenth-century painting titled *The Blessing Christ* (1834)—the most interesting entries turned out to be representations of a Black Christ, a trans Christ, and an Indigenous Christ. People really got involved.

This is the space where we exist right now—through social media, and, at least at MASP, above all through Instagram.

Let us pull back. You studied law, and then critical writing, at CalArts. You spent most of your career as a curator. When you came to MASP, it was your first full-time museum role. What attracted you to it?

Adriano Pedrosa

I live three blocks from MASP. The museum is housed in an iconic building by Lina Bo Bardi (1914–1992), a landmark of international modernism. I am originally from Rio, and lived in Los Angeles in the early 1990s. I moved back to São Paulo in 1997 to work on the Bienal de São Paulo, the famous 1998 edition, under Paulo Herkenhoff. During much of that time, MASP was in a semi-dormant state. In 1996, the iconic glass-easel display system for the collection was dismantled. MASP went through a very difficult financial phase, which of course was reflected in its programming. But it was always an extraordinary machine, in this great building, with a fantastic collection, a rich history, on Paulista Avenue, in the heart of São Paulo, a magnet for political demonstrations of all sorts. I always thought this would be an incredible museum to re-energize, so a perfect opportunity for a curator, and I was invited to work there in 2014.

Is the eminent critic and political figure Mário Pedrosa a family member of yours?
He was my grandfather's cousin. They were born five years apart in the same small city of Timbaúba, in the northeastern state of Pernambuco. They were close in age, but we never met. My grandfather left for the state of Santa Catarina, in the south, to live a different life from the Pedrosa family who remained in the state of Pernambuco.

Even so, like him, you have been a connector of the Brazilian and the international art scene. And similarly, your work is quite political.
Yes, it is. But unlike him, I am not so involved in party politics. Mário Pedrosa was one of the founders of the Partido dos Trabalhadores, the leftist Workers' Party. At MASP, we avoid taking a partisan approach. Yet if you look at our program, it is faithful to our mission, which was reformulated in 2017 and appears at the back of every book we publish: "MASP, a diverse, inclusive, and plural museum, has the mission to establish, in a critical and creative way, dialogues between past and present, cultures and territories, through the visual arts. To this end, it should enlarge, conserve, research, and disseminate its collection, while also promoting the encounter between its various publics and art through transformative and welcoming experiences."

The reference to diversity, inclusion, and plurality provides a cornerstone for all our programming, which always revolves

around different sets of histories. Each year we dedicate our entire program to a particular set of histories, articulating all exhibitions, publications, and public programs in this manner. In 2016 it was *Histories of Childhood*; in 2017, *Histories of Sexuality*; in 2018, *Afro-Atlantic Histories*; in 2019, *Women's Histories, Feminist Histories*. This year, 2020, would have been *Histories of Dance*. In the coming years we will organize *Brazilian Histories* (2021–22); *Indigenous Histories* (2023); *Histories of Diversity* (2024), which are really queer or LGBTQ histories; and *Histories of Ecology* (2025). This program has a strong inclination toward social or political histories, less so proper art history, and it is of course very much connected to present-day issues and concerns, and to a liberal or progressive agenda (in US terms). There is also the notion of plural histories, and in fact *histórias* in Portuguese (as in French and in Spanish) can encompass both fictional and nonfictional narratives. It is not a matter of ignoring art history altogether, but understanding that it is one among many other possible layers of these *histórias*.

You are a prolific visitor to museums worldwide. What have been their most impressive achievements in your lifetime?
I remember a meeting you and I participated in seven years ago in Hong Kong.[*] There was a discussion about future trends in the art world. The idea was that perhaps, if all those relevant players could agree or converge toward a certain topic, then it could very well become the relevant topic of the future. I remember even then suggesting de-Westernization—the term comes up in the work of Walter Mignolo, the Argentine semiotician. I remember writing it down: *desocidentalização*. I believe this is quite a radical transformation that we see many museums going through.

For a long time, we saw connections and exchanges in the art world within the center, in a Eurocentric framework. At the end of the twentieth century we saw this starting to open up very slowly, in parallel to the development of cultural studies, multiculturalism, post-colonialism, decoloniality. Tate Modern was a pioneer in this regard, with a show it organized in 2001, *Century City*, which focused on different cities and moments around the world in the

[*]*24 Hours* was a convening of art-world leaders in conjunction with Art Basel in Hong Kong, in March 2013.

Adriano Pedrosa

twentieth century—Rio, Lagos, Mumbai, London, Paris, and New York. Only very recently has MoMA been able to start to catch up. The work being done in London—of all places, given Britain's violent colonial past—is really progressive.

The show was shredded by some critics, as I recall, but it was influential.
It provided a blueprint for what they would do. It was an acknowledgement that there were many urban cultural centers in the twentieth century, many narratives and experiences of modernity—though I'm not sure if they were able to admit back then that modernity had indeed a violent, colonial, and racist past. In fact, I am happy not to be working at a "modern" museum.

It is interesting to consider de-Westernization at MASP, a museum that houses the largest collection of European art in the global south, that was inaugurated in 1968 by none other than Queen Elizabeth. Those are some strong Occidental roots.
That is very much part of the history. The founding director, Pietro Maria Bardi, was an Italian impresario, critic, journalist, dealer, historian, and professor. He married Lina Bo Bardi and moved to Brazil in 1946. MASP was founded in 1947 by Assis Chateaubriand, a media mogul and one of the most powerful men in midcentury Brazil. Bardi was coming from a background in European art, especially pre-1900s figurative art, and less interested in abstraction. Yet from the beginning, the museum was constantly showing Indigenous art, outsider art, folk art, or what we in Brazil call *arte popular*. The opening show of the Paulista Avenue building in 1969, on the museum's first floor, was *The Hand of the Brazilian People*, curated by Lina Bo Bardi, informed by her travels in Bahia, in the Northeast, researching various types of material culture: tools, textiles, furniture, saints, votive offerings, sculptures, paintings.

Upstairs, on the second floor, was the glass-easels display, with canonic works from European and Brazilian art history—from Raphael and Mantegna, van Gogh and Cézanne, to Picasso and Matisse, Candido Portinari and Emiliano Di Cavalcanti. The friction and dialogue between these narratives of art history on the two floors were part of the museum's DNA, at least as long as Lina and Pietro were around—he retired in 1990. There is a rich history

to draw from here, which can be unfolded. Lina was already criticizing Brazilian history for being "*branca, europeocentrista*" [white, "Europe-centrist"]—in a different framework, yet the idea was there.

Where should the process of "de-Westernization" start? And where does it lead?
I don't think we will ever get to fully decolonize or de-Westernize the museum, because the museum itself is a European construct. Yet you can always take a step further and further—if you, your community, your partners, your board, your constituencies, are invested in that. It takes many conversations. It's a slow process. But it can be done. One could start with developing a more diverse program of exhibitions, with more artists who are not the usual white, straight Euro-American males, and this should be reflected in acquisitions, in the collection display, in the curatorial team, and in leadership in general.

When I came to MASP, there wasn't a single work by a Black artist on display. I recall two works by women, and the only Indigenous representation was by a nineteenth-century Euro-Brazilian academic artist. We thought it was crucial to increase the presence of women and introduce Indigenous and Black artists in the collection display.

Of course, there has been remarkable change in the past decade, which has accelerated in recent years, particularly now, with Black Lives Matter. I remember ten years ago walking around the Pinacoteca in São Paulo, one of our most important Brazilian-art collections, and wondering, *Where are the representations of Black people, of Indigenous people, of slavery, something that was such a strong part of our history?* In 2014, before coming to MASP, I organized *Histórias Mestiças* ("Mestizo Histories") with Lilia Moritz Schwarcz, our adjunct curator of histories at MASP. There were several quite symbolic curatorial gestures, such as the placement of a painting of the Brazilian empress Isabel, who signed the "Golden Law" abolishing slavery in 1888, under a row of photographs of nineteenth-century Brazilian enslaved people, proposing a visual inversion of the hierarchies of the images.

At MASP, after the years of programming devoted to Afro-Atlantic histories and feminist histories, we were able to bring

Adriano Pedrosa

into the collection many works by women and Black artists. In January 2020, we were finally able to hang the first full row in our collection with about twenty works by Black artists. This was a major turning point, but as I said, it is a slow process and there is still much work to be done.

Addressing colonial legacies in museums, particularly encyclopedic and ethnographic ones, is a herculean task. These legacies are deeply baked into their structures and architecture.
Yes. When I came to MASP, there was only one chief curator with an assistant, and not many departments. Over the years I was able to put together a team, and we have hired ten curators. Whereas in major museums you already have people in place, and even if you are interested in de-Westernization, they are unlikely to embrace that agenda. That is one of the reasons why change is often so slow.

Does this re-examination require embracing new notions of art and culture?
At MASP, we are not interested in concepts that are limited or specific to art. We are interested in social history, political history—topics that are relevant for today. We are now putting together *Brazilian Histories*. Each of our curators will organize a section. However, there will be no sections on Brazilian Baroque, or Brazilian Geometric Abstraction, or Neo-Concretism—all wonderful, of course. Yet we are more interested in questions of rebellion, or revolution, or violence, or religion, or festivities, the land, and agriculture. You can look at art history through those manifold lenses—that is why we always use the term "histories," in the plural.

Imagine these lessons are fully absorbed in the field. What then would be the most surprising thing about future museums?
The museum's diversity, plurality, polyphony. But I want to insist that there is always another step we can take. When I came to the museum there were, as I mentioned, no Black artists in the collection display, and no Black curators. Now things have changed. But we still don't have enough Indigenous representation. We recently hired an Indigenous adjunct curator, Sandra Benites. There will be other steps to take.

You and I sometimes walk together at international art events, which I enjoy very much. I can think back to our visits to museums and events in New York, London, and Kassel during documenta. You used to be constantly on the road. How does a curator—or a museum—today achieve a truly global perspective?

Travel will remain important for looking at things in real life all over the world. It is an enormous effort, very costly, and taxing on the environment, yet I don't think it will go away. Even if you only embark on two or three well-planned trips a year. Before I came to MASP, as an independent curator, I was traveling quite a lot through Asia, the Middle East, Africa, Latin America. At MASP, I end up going more to Europe and the Americas. It is important for the museum and to our projects for me to be out there, meeting with people, visiting museums, developing projects, loans, and partnerships.

Beyond de-Westernization, what other urgent issues need to be fixed in museums today?

A general challenge is to develop tools and practices that can make the visitor's experience more meaningful and relevant, and also accessible and democratic—without being elitist. By saying this, I am criticizing two things. On the one hand, many contemporary art exhibitions and museums seem quite elitist in terms of how they display and explain work. Contemporary art tends to require a specific set of knowledge and references, which are not available to everyone. On the other hand, when it comes to social media or Instagram, we see a lot of superficiality. Some museums' Instagrams are just so silly. They are chasing engagement. I don't know if TikTok really adds anything to the discussion. What do you think?

For the right show, perhaps. I feel that when museums use new media, it often feels awkward, like seeing your tipsy uncle dance at a wedding. Generally speaking, museums shouldn't dumb things down.

That is the big issue, I think: How can you develop more meaningful relations and connections with a wider audience, from many generations, without being trivial, or goofy? We are proud of the program we have developed on Instagram. Everything remains

Adriano Pedrosa

meaningful and accessible, and we have seen the ranks of our followers grow. So I think it is possible to develop interesting content and have meaningful engagement on social media.

I want to ask about museography. The clues to the future may be hiding in the past.
Always.

I am thinking, for example, about period rooms and their so-called immersive experiences. At MASP, one of your priorities was to restore Lina Bo Bardi's extraordinary and idiosyncratic glass-easel gallery, a unique feature of this museum.
Interesting that you should say "idiosyncratic"—because I do not think this is a model to be followed by every institution. Perhaps the advice should be: *you should have an idiosyncratic display.* Each museum should develop its own collection and framework, true to its history, and have its own idiosyncratic display.

I remember traveling around Europe in the 1980s and thinking, *Wow, how amazing that everyone has the same periods and systems*—rooms dedicated to Abstract Expressionism, Minimalism, Pop Art, Conceptualism, with the same artists. One aspect that we have been exploring is acquisitions through exhibitions, which then allows the temporary program to leave a more permanent and hopefully idiosyncratic imprint in the collection, which will in turn be reflected in the display.

It is of course wonderful to explore the exhibition display in a more experimental manner, and the two major challenges are related to costs and conservation. In the end, often curators will cut the exhibition display budget to pay to ship or produce more art. So it is easier to develop experiments with the permanent collection, because it is a long-term investment, though that is often the more conservative or slow-moving territory of museums.

Looking further into the future, what kinds of new institutions do you foresee emerging, in terms of function and appearance?
I keep going back to being welcoming and transformative. Conceptually, they should be plural, diverse, and polyphonic. They should be more multidisciplinary and accessible as well. Because today museums tend to be very specific to certain media and

typologies—museums of art, textiles, ceramics, automobiles, design, and so on. Perhaps hybrid museums are in our future. Not necessarily encyclopedic, but with more crossovers. Collaborations can also be a bigger part of our future. One doesn't see it enough, because there seems to be a certain sort of competition between institutions.

You have described a huge agenda, stretching forward several years. No doubt, these years will be full of challenges and difficulties. What keeps you excited?

Even in these difficult past few months, we have been working hard on publications, exhibitions, acquisitions, and conversations with our curatorial staff. All this is still very exciting for us. Just today, we had confirmation that Alex Donis from Los Angeles has donated his work intended for the *Histories of Dance* exhibition, which will now only happen though publications and a digital presence because of the pandemic. It was quite generous of him, and wonderful news to receive. These things keep us excited.

Adriano Pedrosa

TANIA COEN-UZZIELLI
Director, Tel Aviv Museum of Art (TAMA)
Tel Aviv, Israel

WE ARE A MIRROR OF OUR SOCIETY

The Tel Aviv Museum of Art must balance almost paradox-ical tensions: established in 1932 as a museum of modern and contemporary art, it is a worldly institution speaking to Israel's disparate demographic and religious mix. It is located in a Middle Eastern metropolis with deep affini-ties to Western culture, in an artistically and economically vibrant nation that does not maintain an open dialogue with its neighbors. Fraught as those complexities are, they reflect the challenges of art museums today. Tasked since 2018 with resolving these polarities into a coherent insti-tutional attitude and program is the Italian-born Tania Coen-Uzzielli, an art historian with expertise in the art of the Roman Empire whose previous posting was at the Israel Museum, in Jerusalem. Having briefly served as a cultural diplomat, Coen-Uzzielli has a keen sense of how important it is for museums to speak to wider audiences. Under her leadership, TAMA, with its collection of forty thousand objects and its impressive urban campus, is seeking to welcome the museum's eclectic communities and embed the institution into a society and a region riven by persistent cultural and political conflict.

HERTA & PAUL AMIR BUILDING

TEL AVIV MUSEUM OF ART

מוזיאון תל אביב לאמנות

הבניין ע"ש שמואל והדסה עמיר

ANDRÁS SZÁNTÓ *Our first attempt to meet in person in Tel Aviv, in January 2020, was thwarted by biblical rains. It's hard not to think of that as an omen. Since then there has been a global pandemic, an economic meltdown, and a wave of political unrest. How did you experience the first half of 2020?*

TANIA COEN-UZZIELLI I started my second year at the museum in January. We had an exciting exhibition program lined up, but events took a different course. We had to extend our winter program into the summer. And the extraordinary coincidence was that those exhibitions turned out to be very relevant and attuned to current events.

We had just opened an exhibition, *If on a Winter's Night a Traveler*, one theme of which was African-American artists reflecting on their identities. When we opened it, in January, the widespread protests following the murder of George Floyd were yet to happen. All of a sudden, the exhibition became strikingly timely. At the same time, on the same floor, we had recently opened William Kentridge's *More Sweetly Play the Dance*, a procession echoing the *danse macabre* of another pandemic, in medieval times. This took on a new meaning after the lockdown. We still had up Raymond Pettibon's exhibition *And What Is Drawing For?*, which addresses politics and government control—another theme that could be revisited in light of recent events. Last but not least, we had just opened a major solo exhibition, *Jeff Koons: Absolute Value*. Koons's questions about materiality and consumerism became, once again, deeply relevant in this moment.

You did an imaginative project during the lockdown, activating the walls of Tel Aviv's Bauhaus buildings with video projections. How did the public respond?

In recent decades, as we shifted to digital interactions, the museum has remained closely involved in physical encounters, establishing the necessity of "being there." The lockdown caused an immediate disruption of the "museum as a place." We were struggling with how to re-enhance this physicality. During the pandemic, we spoke about social distancing, but that's the wrong word. We were practicing physical distancing, while remaining active socially. The projections felt like the right project to do in this context. The museum screened video works on buildings

around Tel Aviv, which were visible from windows and balconies. This was in resonance with the Italian "songs from the balconies," which developed as a spontaneous response to the lockdown there. It was very well received and appreciated by the public.

You are an Italian who moved to Israel when you were nineteen. How did you end up running Tel Aviv's leading museum?
I grew up in a traditional Italian-Jewish family in Italy. I studied at a public school in a non-Jewish environment and was active in one of the Jewish youth movements. This gave me an interesting status of being an "insider" and "outsider" at the same time. Italian culture is a big part of who I am. Classical studies in literature, archaeology, and art history made up my baggage when I arrived at the Israel Museum, one of the world's great encyclopedic institutions. My role as curator for twenty years, and then as head of collections and exhibitions for six years, under former director James Snyder—whom I consider my mentor—enabled me to understand what a museum is. He gave me significant insights into the essence of the museum. I brought this knowledge and experience to my challenging position leading the Tel Aviv Museum of Art. In a way, I am still an "insider"—active in the local cultural community for more than twenty years—but also an "outsider"—an Italian coming from Jerusalem to Tel Aviv. This gives me a peculiar perspective on the institution and its aims.

You said that working with Jim Snyder helped you understand what a museum is. So what is a museum?
I would say, first and foremost, a cultural institution where people can physically experience art, its beauty and its soul. TAMA in particular is a multidisciplinary cultural platform that functions as a kind of polyphonic system. We display modern and contemporary art, architecture, design, photography—and we host myriad events: concerts, classical music, a jazz festival, a film festival. I do believe that the museum is a meeting place, an agora, where different people from different parts of the world can interact. In a way, it is the most democratic of places. Everyone can experience art equally.

Were there any institutions, exhibitions, objects, books, or people that became touchstones for you in thinking about museums?

Tania Coen-Uzzielli

My first powerful art experience goes back to high school. I had a wonderful art-history teacher. We spent two months studying Raphael's *The School of Athens*. We studied from illustrations. Since we were living in Rome, at the end of the academic year my father took me to see the fresco at the Vatican Museums. I was finally exposed to it: the scale, the colors, the perspective, the composition, the volumes I had studied in so much detail. Nothing can replace this moment of being exposed to such beauty.

Another touchstone, when I truly realized the importance of the physicality of the museum as a place, was the great 2008 show *Picasso and the Masters*, which was presented in several major institutions in Paris. It allowed the viewer to appreciate the works of Picasso together with the masters who had been his sources of inspiration: Titian, Goya, Velázquez, Manet, and others. You could experience firsthand the citation, the unique interpretation, the "dialogue" between artists. It underscored what the theoretical study of art history cannot provide: art must be experienced live.

You suggested we talk about the tension of global and local.
Tel Aviv lies at the intersection of multiple fault lines. It finds itself
in a complicated neighborhood. Within Israel, Tel Aviv is some-
thing of an island, you could say. How to position a museum
in this charged context?
The idea "think global, act local" is attributed to the Scottish biologist, sociologist, and urban planner Sir Patrick Geddes (1854–1932). He created the master plan for Tel Aviv in the 1920s, when Palestine was a British mandate. He described Tel Aviv as a transitional place, a link between the overcrowded cities of Europe and the agricultural renewal of Palestine. He envisioned the iconic Rothschild Boulevard and the parks, and he was responsible for the adoption and local interpretation of the international style.

Tel Aviv started out as a Hebrew town in 1909, founded on the sand dunes north of the ancient Yafo. Today it is a vibrant cosmopolitan metropolis. People from all over the world came here bringing their own visions, which had to be interpreted and fused together to bring forth the local character in this place and geography. This is the model for how we can develop TAMA. We need to think globally in telling the story of modern art, but we also must act locally, by showcasing local art and being relevant to the local population.

The Tel Aviv Museum of Art was the initiative of Meir Dizengoff (1861–1936), the first mayor of Tel Aviv. He came from eastern Europe and could not imagine a city without a museum. He set aside two floors of his own house to TAMA; that's where the museum started. The first exhibition presented artists such as Van Gogh and Chagall, along with replicas of biblical figures by Michelangelo, Verrocchio, Bernini, and others. Past, present, and future could be seen together. Dizengoff, coming from Russia, was founding a museum as a local institution, but looking toward Europe, at Western culture, for a model and inspiration.

The museum has since put aside the biblical figures. But it has remained an institution of crucial importance locally, and one that thinks globally. Almost ninety years old, TAMA has assembled an excellent collection of modern twentieth-century art and created a permanent home for a comprehensive collection of the art of Israel. We present some twenty temporary exhibitions each year. Our mission is to preserve and showcase modern art and to be at the forefront of art in Israel, initiating projects and supporting the local artists' community, while also serving as a platform for international, cutting-edge art that is happening now.

Meanwhile, Israel's geopolitical situation conceptualizes it as an island. It borders countries that are not in cultural dialogue with Israel, making it a sort of isolated microcosm that cites Europe and Western culture as its main points of reference. I think this raises many questions, and as director, I need to examine, to understand better the challenge that this place presents.

I believe museums are faithful mirrors of their societies. And your museum's challenges reflect Israeli society at large. Remain an island, or engage your neighbors? That is the question.
I think that before going beyond our borders, we need to address our own geographic and demographic peripheries. If we want to be inclusive—another key word—we must first acknowledge that the story I just told you is a classic Western, Ashkenazi story, an elite story of hegemony. We are a multicultural society, and we need to address our own diverse population: Arabs and Jews, Ashkenazim and Sephardim, refugees and new immigrants from Russia and Ethiopia, both secular and religious. The people who built

Tania Coen-Uzzielli

this country were creating a melting pot—one reality, one culture. Now, we need to understand that there are a lot of realities.

When we speak about "Israeli art," I believe it is better to say "art in Israel"—two different things. We have to be more precise in our semantics, because semantics matter and have the power to change reality. To think and act locally is to understand our differences, to open borders inside our society. Because, as you say, we are the mirror of our society, which is elitist and hierarchical.

So, with all this in mind, what exactly does it mean to be an Israeli institution today?
An Israeli cultural institution today has to be inclusive. It needs to think strategically about different segments of the population. In Tel Aviv, we confront many challenges as an Israeli institution that seeks to reach beyond its municipal boundaries. On the one hand, Tel Aviv is a fascinating and vibrant cultural arena, and it has become a destination for young, culture-consuming audiences. On the other hand, museums are widely perceived as elitist, and TAMA—in a city that the Israeli public perceives as a "bubble"—is challenged to attract people who are put off by this image. The museum needs to become a central part of Israel's artistic calendar and provide a platform for the local art community. At the same time, we need to be a must-visit attraction for international tourists—an influential player on both the local and international cultural circuit.

People must see themselves in the museum—not just in the objects, but in the stories being told. Yet there are visible and invisible walls around the museum. How do you break them down?
By letting people know that this is not the ivory tower they think it is. Beside our varied exhibitions program, our education department is an important tool to demolish those walls around the museum. This can start in elementary school. We have multiple education programs that address young people and different populations, among them the Art Road to Peace initiative, which brings Arab and Jewish schools together to talk about art and do a lab together. As we nurture new generations, they will come back knowing how to read and enjoy art.

Israel's population and its politics range from ultra-Orthodox communities to people in cutting-edge knowledge industries— it is a mosaic of religions and cultures. Can you offer something for all of them?

Our program must offer a variety of exhibitions that can be accessible to different audiences. We don't have to be a crowd-pleaser, but we need to speak different languages and approach different populations. The fact that we are not only a museum of art, but also active in different cultural fields, helps us considerably. Sometimes people just happen to be in the museum because a singer they love is performing, or there is a festival going on, so they experience art without planning to do so.

What does it mean to be a secular cultural institution in a place so heavily defined by religion?

The declaration of the independence of the State of Israel took place in this museum. It is meaningful that the state was declared in a museum, as a symbol of culture and secularism. The declaration promoted the values of justice and freedom, and I would like the museum to continue to be a bastion of liberal values. On the other hand, there are contradictions in this city, which is open yet closed, accessible yet secluded, a capital of gay people yet a home of the ultra-Orthodox community. These contradictions are peculiar and interesting, and we need to deal with them.

It seems to me, all museums in the future will have to deal with some version of these polarities. What do they need to do differently in the midst of such complexity?

The museum doesn't have to compromise. To use a simple metaphor, I would say we want to maintain a high level but provide ample stairways and many access points. We do need to preserve and keep up the quality of the art, even adhere to a kind of traditional approach to collection preservation and presentation. I will not change our exhibition program just to bring ultra-Orthodox people to the museum. But we do need to provide better means of access. We need more intermediaries. Technology is a means of attracting young generations. In addition, texts and labels must be more fluid and accessible in the local visitors' languages.

Tania Coen-Uzzielli

So, generally speaking, how will museums need to adapt to stay relevant?
In the end, we're speaking about a paradigm shift. Once upon a time, our public consisted of visitors; and then, with the arrival of a consumerist era, they became our clients. Today, we speak of participants. We endeavor to treat our visitors not as a hostage audience, but as participants in a joint venture. This way, we are going to stay more relevant.

What is the formula? I struggle with it. In January, when you were in Tel Aviv and there was this epic storm, our museum was presenting the *Solar Guerilla* exhibition, about climate change and how cities and designers are responding to it. Thinking back, we could have engaged people even more through events that induced people to become active on this front. I do think the museum will have to become a platform for the community—to be active not just culturally but in regard to social issues.

Where do you see new storytelling opportunities?
The curator is first and foremost a storyteller. We at TAMA can tell different stories, since we are active in many fields: modern art, contemporary art, art in Israel, architecture, design, and fashion. A multidisciplinary approach to the visual arts and material culture opens a variety of opportunities when trying to reach as many people as possible. It would be interesting to explore different methods to convey these stories.

Technology helps, but it is only a tool. I do not think we will turn into a realm of new technologies. I have a romantic idea of the museum as an island of "slow experience," just as the movement of "slow food" emerged in response to the proliferation of fast food. We live in a chaotic and tumultuous environment. So when people come to the museum, I would love them to switch to "museum mode." The entrance of the museum should be a buffer zone where you can switch gears. My hope is that museums will continue to be appealing in their old physical dimension and endure as strongholds of genuineness, as places to go to look at the real objects of our material culture—places of contemplation, where we can pause and gaze.

I am all for the slow museum. Meanwhile, Israel is a fast, dynamic, high-tech economy. A lot of new ideas are incubated there. From which fields can museums learn as they evolve?

The "start-up nation"—which is how we now define Israel—is a nice model. Not just because of technology, but because of the courage to innovate—to dare, to engage, to envision the future before it happens. You don't need to be involved in the high-tech sector to adhere to the concept of the start-up nation. A start-up can be a community project, or a collaboration with a sister institution abroad, or an international traveling exhibition, or an initiative to think widely and globally. This is the model I try to emulate.

You once worked as a cultural attaché at a consulate in San Francisco. As a former diplomat, what are your concerns about politics around museums today?

Art clearly involves politics. Usually, museums tend to preserve what the museologist Robert Janes calls an "authoritative neutrality." Public dialogue, certainly in Israel, has become very aggressive, even violent, and I think the museum can be a place where discourse is conducted in a civilized way. The museum should try to maintain a balance, not being offensive, but giving as much room as possible to multiple voices. It is important to restrain ourselves and not to become too involved in the political discourse, while being deeply involved in the social discourse.

Finally, imagine we had a time machine and we could zoom forward to the TAMA of 2050. What do you think would surprise you about it the most?

A nice question. I am not sure I would be so surprised. Maybe it would have another wing, or a department of robotics—but that wouldn't surprise me. I would like to think that if Dizengoff rose from his grave and saw the museum today, he would be proud of it. And because I am an archaeologist at heart, and a romantic, I do think that our future visitors will still find our *Portrait of Friederike-Maria Beer* by Gustav Klimt standing there, still relevant, as a kind of icon—as our *La Gioconda*.

Tania Coen-Uzzielli

EUGENE TAN
Director, National Gallery Singapore &
Singapore Art Museum (SAM)
Singapore

A NODE MORE THAN A HUB

Some museum directors are called upon to advance insti-
tutions that were established decades ago. Others have a
rare chance to leave a mark on institutions at an early stage
of their formation. The Singaporean art historian Eugene
Tan was afforded this opportunity no fewer than three
times: first, when spearheading the development of the
Gillman Barracks, a contemporary art district installed in a
former British colonial military complex in Singapore; sec-
ond, as the inaugural director of the National Gallery Sin-
gapore, the largest art museum in Southeast Asia, which
opened in 2015 in Singapore's refurbished former city hall
and supreme-court building; and most recently, by adding
to his remit the leadership of the Singapore Art Museum,
which opened in 1996 and is undergoing a comprehensive
overhaul. For Tan, who was born in 1972, these roles have
been part of a larger project of institution-building that
has led, over the course of his lifetime, to the rapid prolif-
eration of art museums across the Southeast Asia region.

ANDRÁS SZÁNTÓ *I remember teaching in Singapore in 2010, the year you moved back to Singapore. The art scene was opening up at the time. The supreme-court building had yet to be converted into the National Gallery Singapore. Tell me about the evolution of the art scene in Singapore in the past decade.*

EUGENE TAN I moved back to Singapore to work on the Gillman Barracks project. Exciting things were happening in the art scene on many fronts. The government had recently announced that the National Gallery Singapore was going to be converted from the former supreme-court and city-hall buildings. The commercial side of the arts ecology was also getting a boost from art fairs, as well as international galleries setting up in Singapore. Gillman Barracks formally opened in 2012, after which I joined the National Gallery, which opened in 2015. It is the largest art museum in Singapore, but not the oldest. The oldest is the Singapore Art Museum (SAM), which opened in 1996. In 2017, it was announced that SAM would undergo a major redevelopment. In 2019, I became director of SAM as well. The museum occupies two former secondary schools, St. Joseph's Institution and the Catholic High School, and these will be adapted with new structures to expand the museum, which is currently due to reopen in 2023.

The art scene that we have in Singapore now has been the result of long-term planning and investment by the government to grow the arts, to make sure we have a complete ecology. This includes the public-nonprofit sector as well as the commercial sector, including art fairs and galleries. It is unfortunate that art fairs haven't fared so well in Singapore, partly because they were eclipsed by Art Basel in Hong Kong.

You are now in charge of two major institutions of art. How do you balance their roles?

SAM was the only public art museum in Singapore until the National Gallery opened. In terms of scale and organization, SAM is the smaller of the two. When the National Gallery was established, it was decided that the two museums would differ in their focus. The National Gallery focuses on the histories of art in Singapore and Southeast Asia and its connections to the global, while SAM is a contemporary art museum. However, the term "contemporary" is a complex one. In addition to referring to both

an historical period and to the art of the present, it has other meanings within the context of Southeast Asia that are separate from the paradigm of Euro-American art histories.

As far as I know, you didn't set out to run museums at first. What got you here?
I think of myself as an accidental museum director. After completing my PhD in art history, I started out as the curator and director of a gallery that was part of an art college. Curating was what I always enjoyed—working with artists and on exhibitions. But I was conscious that there was much that could be done to grow the art scene in Singapore and Southeast Asia. I wanted to contribute where I could, and this led me to various roles, including teaching, working for a commercial gallery, and developing Gillman Barracks. When I was approached about the National Gallery, I felt it was something I could do to contribute to the development of the museum scene in Singapore and the region.

What was most challenging in this pivot to directing?
It is no secret that most curators are not particularly good administrators or managers. The National Gallery Singapore was by far the largest organization I had to manage, with a staff of more than two hundred, so it was a steep learning curve. Getting the whole organization as well as our various external stakeholders and board members aligned with a shared vision for the museum was probably the biggest challenge. As the National Gallery was the largest cultural institution ever established in Singapore, we also had to draw on staff from various industries, many of whom had never worked in a museum before. Getting our staff and stakeholders to understand the role of the museum, our mission to society, and how we differ from other types of organizations took some work.

In the course of inventing, essentially, a new institution, what shaped your perceptions about the kind of museum you wished to build? And what are your priorities?
While the initial impetus for the establishment of the National Gallery Singapore by the government was inspired in part by the major international art museums in Europe and America,

Eugene Tan

there was also the acknowledgement that we had to create an institution that was specific to our context here in Singapore and Southeast Asia. As such, focusing the collection on modern and contemporary Southeast Asian art was critical. There is no other public museum in the world collecting the art of this region on a large scale, so we felt that we could play a role to further the understanding of Southeast Asian art globally in this way.

We also recognized that the art histories of Southeast Asia are still a relatively under-researched area. Research had to be at the heart of what we do. I got our curators to focus on research into aspects of art histories beyond our received histories, to areas yet to be uncovered and on the connections between artists in different parts of Asia and beyond. This has helped us build our collection and the programs and exhibitions that we have since rolled out. To foster greater research and scholarship in art history, we established a new art-history program with the National University of Singapore, which has been going very well.

Another area that we worked on was thinking about our audiences. Whom is our museum for, and what kind of impact can it have on our audiences? These were questions that we pondered and considered carefully. Given that this was the first time we were going to have permanent collection galleries devoted to the art histories of Singapore and Southeast Asia from the nineteenth century to the present, we were in a position to cultivate and foster a deeper appreciation and understanding of art among our public, as well as the role of art in our societies at various times in our histories.

Singapore is a tiny territory in a large region on a vast continent. You have a broad sense of how museums are evolving in Asia. This part of the world is a driver of change. How do you see its future?
We are recognizing that the neoliberal capitalist structures that are the foundation of our societies today have also shaped the art-and-museum world in a certain way. When Singapore announced our plans to open the National Gallery in 2015, and that it was going to be the largest art museum in Southeast Asia, with the largest public collection of art from the region to match, there was, as you can imagine, some suspicion from our neighbors in the region. Despite its size, Singapore is seen as one of

the most economically successful and affluent countries in the region. There were questions as to why we were doing this. Was Singapore claiming to represent Southeast Asia?

When I became director, I was very conscious that we should not want to see ourselves as a hub—as something that draws everything from the region to a central point, which then creates a sense of hierarchy. I was conscious that the National Gallery was being established within an already-existing regional ecology. I saw us as a node more than a hub. Our perspective on the histories of art in Southeast Asia was just one among many—because there are multiple perspectives, all of which are equally valid.

Furthermore, there is still so much to be discovered, with the field still under-researched, as I have mentioned. The problem with our neoliberal societies is that the dominance of capital (and spectacle) obscures less visible narratives that are just as meaningful and important. We have seen this in the art market in Asia in the past fifteen years, where capital and the art market have had less-than-desirable effects on its development in the region.

I was determined that the National Gallery Singapore should be not a hub or center, but a node to connect artists, curators, and audiences around the world to the various art scenes in Southeast Asia. As such, apart from collaborating with other institutions on projects and exhibitions in Singapore, we are also working on projects in countries throughout the region. This is an important role that museums now play, giving a voice to marginalized perspectives and narratives.

History, the saying goes, is written by the winners. As a curator and museum director, how do you see your remit in terms of broadening art narratives, making them polyphonic, particularly in regard to Asian narratives?

This is something we have been trying to do since we opened. As you know, ICOM last year came up with a new definition of museums as polyphonic spaces committed to human dignity and social justice, global equality, and planetary well-being. And this has been controversial. In Kyoto last year, the majority of ICOM members voted to postpone the decision. A few days ago, ICOM's president resigned because of dissent over the proposed defini-

Eugene Tan

tion.[*] At the same time, I really agree that museums today have to think of ourselves like this—but in a way that is appropriate and relevant for our local contexts.

That is not exactly happening yet in Asia, where art has been driven by the commercialization and the market. Art has become a commodity and an asset class, a symbol of status and prestige. You see the rise of private museums and collectors displaying their wealth. In this context, people are not recognizing the role museums can have in our society as agents of change.

Cultural institutions, including museums, should lead the discussion about the values of our society, as art is ultimately a reflection of our societies and museums. The new proposed ICOM definition can be seen to derive from the UN's sustainability goals, announced in 2015. I strongly believe that museums have to advocate for these goals as part of their mission, in order to stay relevant to the societies we serve.

The museum is an Occidental construct—a machine built for presenting forms of art associated with Western history, with painting at its center. As the emphasis tilts to Asia, how do you see institutions changing?

Given that museums and art institutions in Asia have relatively less historical baggage, we have an opportunity to rethink what the museum of the future should be. That's something we're actively doing, both at the National Gallery Singapore and the Singapore Art Museum, but more so with the latter as we undergo a redesign. Beyond thinking about what kinds of spaces artists need to present their work and how audiences will engage with art, this is also about looking at some fundamental issues. In Asia, there are discussions about how the concepts of art and museums, as Western constructs, are just two hundred years old. What does this mean for cultural traditions and narratives in Southeast Asia that do not fit so neatly into the received Western paradigm? How can we contextualize these traditions and artistic practices in our museums?

* The resignation of ICOM president Suay Aksoy was made public June 19, 2020, a week prior to our conversation.

How might the future museum be different physically and organizationally?

Even before the Covid-19 pandemic, there has been questioning of the structures that support museums—where their funding comes from. This institutional critique exposed how many museums, as part of a neoliberal capitalist system, are compromised in their ability to fulfill their missions because of their reliance on certain structures and networks of power. Every year, most museum directors have to raise millions of dollars, sometimes hundreds of millions, just to keep operating. This has been further exposed and exacerbated by the current crisis.

On the other hand, state-funded museums are at risk of being instrumentalized by the state. Public institutions have relatively stable funding, but their missions can likewise be compromised due to changes in governments and administrations. In countries around the world, we see this instrumentalization of museums for political reasons.

So neither model is perfect. But in this age of Internet and social media, we get a sense of possible new economic models that allow us to diversify our funding sources. Most museums raise funds through donations and memberships, but I think it has to be something more radical—the most radical approach being a crowdsourcing-funded museum. Such a museum would demonstrate that the community believes in it and supports its work. Or perhaps we can borrow from capitalist structures in another way. For example, could we imagine a museum that has shareholders?

We can and must find a balance between serving our communities and being sustainable. We need to start thinking in these ways, because if museums don't change, we will become dinosaurs. We will become irrelevant and lose our public trust, our most important asset.

Government funding and philanthropy have their limits. The public will only pay so much to see art. Earned-income opportunities are limited. Can Asia offer new models?

I think UCCA in Beijing is an interesting case. They have shareholders in the museum and they generate revenue through projects with commercial entities, which then support the oper-

ations of the museum. It is a model that could work for China. Each institution has to figure out what will work for them in the context in which they are operating, to be open to new models and not rely on the existing ones.

Which institutions in Asia, apart from UCCA, are starting to rewrite the rules?
M+ is due to open next year in Hong Kong, and it will be interesting to see what they do. Until recently, many of the institutions at the forefront of new thinking have been private museums. Even though there are many public art museums in Japan, for whatever reason they haven't been as nimble and visionary as the Mori Art Museum. In Southeast Asia, in recent years we have seen the growth of private museums that are doing very interesting work, such as Museum MACAN in Jakarta and MAIIAM Contemporary Art Museum in Chiang Mai.

New museums bring us to new architecture. Are you seeing distinctive approaches to museum design that you don't find in Europe or North America?
Here in Southeast Asia, our museum design is in some sense restricted by our tropical climate. Our museums have to be almost hermetically sealed boxes to counter the high temperature, humidity, and light levels—which is not environmentally sustainable, due to the high climate-control costs. One of the many crises underscored by the Covid-19 pandemic is the environmental crisis, and museums need to be much more aware of their impact on environmental sustainability in their building design as well as their work.

The National Gallery building is sustainable in one sense: it is a repurposed structure. But it has a complicated historical pedigree. I remember walking through it with you some years ago. There are a lot of ghosts. Is this a challenge or an opportunity?
There is a growing awareness of the effects of colonialism on our societies in Asia. One of the first shows we did at the National Gallery addressed this. We have to acknowledge our past and understand what it has meant for us and our world. In certain countries, some are now trying to rewrite those histories. Here

in Singapore, our sense of rewriting consists of adding to and challenging the narrative that we have been presented so far. One way to do this is by recognizing that our building represents certain things and has come about because of certain histories. Acknowledging this, and examining how we can then use the new opportunity that it presents to look anew at these histories, to address the voices of the people who were ignored previously, are critical.

How would you define the term "museum"? What is essential to it?
History is essential for museums: how the museum tells our histories and our art histories, in the case of art museums. Being aware, as we have discussed, of how these histories have been written, and reflexively re-examining and rewriting these histories from our current perspectives, so that they reflect the epistemologies and values of our present society, to also reflect back and point the way forward for our societies.

You are now charged with thinking creatively about two institutions. Do you look to fields outside museums? Are you looking sideways?
The digital-and-technology world is providing a lot of inspiration for how we can think of the future, not in a way that fetishizes new technologies, but allowing us to understand the changes in how audiences think and behave. For example, our curators are thinking about the implications of increasing gamification. How can we better understand the motivations and intentions of the kinds of experiences that people are seeking through online games, so that we may use these as a way to steer them toward, as well as complement and enhance, the experiences museums can offer?

I detect in your answers a certain skepticism, alongside the optimism.
It is necessary for museums to keep evolving; to constantly be reflexive about our operating models, assumptions, and structures; and to realize the limitations that these have on our work and our mission. At the same time, it is very challenging for museums to effect change, given the kinds of structures that we are. However, if we do not acknowledge this and try to do some-

Eugene Tan

thing about it, I do think museums will eventually become more irrelevant.

If we made a tour of museums around Asia in thirty-five or forty-five years, as two grandfathers, what do you think would surprise us the most?
I would think one of the main surprises would be that "the museum," as we understand it today, has somehow become an exhibit in one of these new museums. The museum of the future would be something unrecognizable to us in the present time. "The museum" as we know it must disappear and be replaced by models that address the problems that confront museums today.

Lastly, as an accidental museum director, what would you say to a young man or woman in Asia whose dream is to run an art museum? What is your advice for them?
You need to have a clear and distinct vision of how you want to contribute to the arts—and just let everything else take its course. For me, it happened by accident, because I had a strong desire to give voice to artists. I believe that artists have important perspectives about the societies and the world in which we live, and that it is equally important for us all to appreciate and understand these different perspectives. This is what led me to where I am.

KOYO KOUOH
Executive Director & Chief Curator,
Zeitz Museum of Contemporary Art Africa (MOCAA)
Cape Town, South Africa

WE WILL HAVE TO TEAR DOWN ALL THESE WALLS

My conversations with the Cameroonian-born Koyo Kouoh have unfolded sporadically over the years in various places where people in the art world gather: from an Art Basel Conversation about new institutions in Africa to a seminar at Pioneerworks, in Brooklyn, for the 1:54 African Art Fair, where she curated the education program. In London, at Somerset House, she included me in a meta-panel about talk programs at art events. At that point, Kouoh was a protagonist, an instigator, a freelance curator, a producer, and a champion of African art and artists whose main affiliation was RAW Material Company, a center for art, knowledge, and society that she founded in Dakar, Senegal. It was only in 2019 that she assumed her first museum directorship, at Africa's largest contemporary art museum, Zeitz MOCAA, in Cape Town, a young institution that was still finding its way after a tumultuous opening phase. Shortly after our exchange, Kouoh received the Prix Meret Oppenheim, Switzerland's leading art prize, for her contributions to advancing art from the African continent on a global scale.

ANDRÁS SZÁNTÓ *How does it feel to be a museum director in a moment like this?*

KOYO KOUOH It is very challenging, I have to admit. The way I think about it, any challenge forces you to rethink what you are doing. It is difficult to be a museum director on a daily basis, as you know, because of the many shortcomings that museums have in terms of needed resources to do the job. What makes it particularly difficult now is that we have to deal with this pandemic—which came upon us as a surprise—and its various adjustments that it imposes. The initial disorientation of this situation demands a lot of rethinking—particularly for Zeitz MOCAA, a museum that was just coming out of a period of crisis.

In the year I have been here, we have done a lot to shift the narrative, shift the programming. And now we have to deal with Covid. But we are embracing the situation in a way that makes our work even more interesting. Because it obliges us to really think through what kind of museum we want to be. At the end of the day, you really have to rethink immediacy, agency, ownership, adjacency. You have to ask: "Who is the audience you are talking to?"

You were born in Douala, Cameroon. You studied business administration in Switzerland and cultural management in France. I assume you had many career opportunities. What got you involved in museums?

I was not initially involved in museums per se. I was involved in art. What drew me to this space of artistic practice and curatorial practice and institution-building was my deep desire and faith in serving artists. I strongly believe in the relevance of the artistic voice and in the narrative of different artistic practices. This is the field where, as a young professional African, I felt we can propose something, where we can be in dialogue with the world in a different way.

The other part is that I felt that in order to develop those voices, it was important to build institutions and make infrastructures available. I believed in setting up an organization that works on a daily basis, in the long term, to provide a space for open debate, for conversation, and for analysis. However, I never

Koyo Kouoh

thought I would end up in a museum. I never saw myself as a museum director.

When conversations about Zeitz MOCAA started, before the museum opened, I was following them closely. I didn't want to be associated with the museum the way it was initially conceived. When things fell apart, under the initial director, many questions were directed to me. At some point it became obvious that if everyone thinks I am the one to do it, I may as well embrace the call.

Your previous posts were with RAW Material Company and 1:54. You have advised biennials, including the Dakar Biennial, and worked in the curatorial teams for documenta 12 and 13. But none of these are museums. How did these experiences prepare you for your current role?
I look at the museum as just another platform to engage with art and artists. Ultimately it is about working with artists and showing art. Zeitz MOCAA is still a work in progress. I think my background has prepared me well, because we all know that a museum is not just about making exhibitions; it's very much about managing an operation. Having studied cultural management and banking administration, I have extensive experience in managing a cultural business. I have sound management and organizational skills that are very useful in my current position.

You now head a nascent museum. Is there a person, an institution, an exhibition, an object that is an inspiration or model?
For many of my generation coming from the African territory, Okwui Enwezor (1963–2019) is, of course, absolutely a paramount figure. I personally benefited extensively from his mentoring. I would not be a curator today if he hadn't taken me by the hand and showed me the way. He is definitely the model that informs what I do as a curator, and now as a museum director.

The inspiration for me comes from close attention to artists and what they have to say, and how they say it. The companionship with artists Otobong Nkanga and Tracey Rose over the past twenty years has been essential in my professional growth as an

exhibition maker. Through their respective practices I came to understand and deal with the political and aesthetic tension of art making. Underlying that is the highly spiritual practice of Senegalese artist Issa Samb (1945–2017). He was the founder of Laboratoire Agit'Art (1973) and one of the most interesting conceptual artists I ever had the privilege of working with. His practice spanned more than forty years. My proximity to and companionship with Issa Samb have informed my work and continue to do so today: my relationship with artists; my understanding of artistic growth, so to speak; and particularly, my understanding of the role of artists in society.

So what is the museum that you want to see evolve? What does it look and feel like?
First of all, a museum that is a site of community. A site of bringing people together around art and artists. Then I am always sort of frustrated on museum visits, because you don't get to see the artistic process. You don't get to be involved in how this work ends up being made. Having worked for so many years with Issa Samb, as well as in the realm of commissioning works, I've developed a liking for process. One of the first things I did at Zeitz MOCAA was to bring in experimentation—not just in terms of the art we show, but experimentation with the museum form itself.

One of the first things I did was to invite Kemang Wa Lehulere, a young, emerging, excellent artist who was questioning where his work has taken him over the past ten years. It became clear in our exchange that it would be interesting to move his entire studio into the museum, to bring the process of art making into the institution. It is not a show like any other show, but it is still a show. These are not installations as such, not finished works. That open experimentation and sense of process are the kind of thing that I miss in museums.

Even the format of the public conversation is not totally satisfactory to me. What does it mean to make visible the artistic process, to make it accessible? There are so many walls erected between different fields at the service of art, so many professional fields that don't really speak to each other. For example, many hardcore museum curators like to distance themselves

from the art market. They pretend to be apart from it, yet at the same time they are also aware of the influence of the market. So my question always is: "If we are all to serve art and artists from various perspectives, why is it that we create so much exclusion?"

Let's talk about museums in Africa. It's easy to focus on the challenges. But what are the opportunities? I am interested in what African museums—nascent as they are—might tell us about the future of the museum in general.
I hope—I wish—that new forms of the museum will come from the African continent. Our context requires us to think outside of the established boxes in the museum field. I strongly believe that the limited resources that we struggle with—because we just don't have the same cultural-support environment that you have in other contexts—demand that we don't necessarily have to apply the same distinctions that exist elsewhere.

As an example, two weeks ago I had an Instagram Live conversation with a colleague, Daudi Karungi, whom I have admired for a long time. He epitomizes what our context demands from us in the future. He founded a commercial gallery, because he needed to build an environment around his practice in his hometown of Kampala, Uganda. After a few years, he launched the Kampala Biennial, to offer a platform to present and discuss art in a noncommercial way. Then he started an art journal—yet another platform, which for me is just another kind of curatorial and exhibition space. And then he started a residency program to support up-and-coming artists. He combined essential formats of the ecosystems of the art industry under one umbrella. Anywhere else, people would scream, "How could you have a biennial, an art fair, a gallery, a journal, and art education all together?" But here in Africa it is possible, and might well be what we need to do.

I really believe that in the future we will have to tear down all these walls. We have to always come back to the question: "What are we doing? Why are we in this field?" I am here in the service of artists and art. Wherever that service is delivered is fine with me.

Necessity is the mother of invention. Working where you do, with the experiences you have had, what do "globalization" and being global mean to you? How are these terms to be understood in the African context?

I like this question, because my work is informed by the past, by history. Up to the early 2000s, the conversation was around "internationalism." At some point, the language evolved into "globalization"—as if globalization was anything new. A lot of people forget that globalization has been an ongoing process. If I had to put a marker on it, it started in 1492, when this man who was heading to India got lost and landed in the Americas, the consequences of which we are still affected by today in many ways.

The other way of looking at it is that in this heightened capitalistic era, globalization means first and foremost an expansion of goods and trade, and unfortunately not the coming-closer of culture and people. We are all still severely handicapped when it comes to cultural understanding and accepting others. The idea of internationalism is closer to my understanding and belief. It is about having international exchanges and conversations from a resolute and unapologetic African perspective.

Much has been said about the broadening role of museums, as reflected in ICOM's expanded museum definition. This orientation applies especially in Africa, where so many civil-society functions are still missing. The museum is a sponge for those roles. What are its most important contributions to society?

First of all, I believe that societies are diverse in themselves, and even more so from the larger geographical, cultural, and historical outlook. Stating that civil-society functions are still missing in Africa is dispossessing the continent of its rich and elaborated systems of societal organization. The so-called absence of organizational systems, as they are developed and understood in the West, does not mean there are no concepts of production, display, and preservation. It only means that they have different cosmologies and stem from different creative epistemologies. I think of the museum as more of an agent of civil society. It is a site of convergence. It is not only an

actor, but also a protector and nurturer of society. Particularly here in South Africa, there are so many topics that demand to be addressed, and that artists have addressed and continue to address in many forms.

We have to address the segregation of the visual arts from dance and from writing and music, and other artistic expressions. In most African societies, art has always been multidisciplinary and communal. Traditionally, you were never just a painter, but could also be a dancer, a writer, at the same time. I don't see why music and performing arts and literature cannot be part of museum practice in the core of the curatorial, and not just as an appendix in public programs. The big disconnect that many institutions on the continent suffer from, in terms of access to larger audiences, is exactly because we fail to embrace this African-inspired radical multidisciplinarity that is so ingrained in our societies. I fundamentally believe that one of our functions is to make art part and parcel of a larger conversation, a larger practice that cries out for reunion.

Can Africa be a laboratory for these new museum models?
In a lab you test things. You find out if something works or not. If it does, you continue, and if it doesn't, you try out other things. In Africa, I am not sure we need to test anything. We have it in our social and cultural and historical DNA. We just need to reclaim it.

Our violent historical experiences when we came in contact with Europeans have stripped out our own imaginary and adopted other people's imaginaries. We have been formatted over the past five hundred years to think of ourselves as lacking something. But we don't lack anything. We have been taught to talk about absence and not about presence. So we don't really need a laboratory. We have to look at what is already there, unearth it, reclaim it, and proudly inhabit that space of multiplicity and plurality.

What does the debate around repatriation look like to a museum director in Africa in 2020 who believes in internationalism?
I very unsuccessfully try to dodge that conversation, and it keeps coming up. Let me take it from a political angle. I think

that when 80 percent of your cultural heritage is outside of your hands, so to speak, outside of your walls, that is a problem. It is a problem on multiple levels. One is that you cannot necessarily connect to it anymore, because it has been taken from you. You cannot build an emotional and historical link, an aesthetic, political, cultural continuation of your human development. If you cannot have access to that knowledge, that is a problem.

Another problem is that a huge body of material that was made in a particular context, attached to a particular lived experience, is now translated in a totally different way than it was meant by those who made it. And finally, I strongly believe that there is a paradox and a contradiction in the fact that the people who for centuries dehumanized you in the worst possible forms, who claimed that you had no culture, and who stigmatized you, are the same people who benefit from your genius and your incredible creativity. These three points alone validate every claim of repatriation.

With these considerations in mind, how would you define the term "museum"? How would you sum it up in one word or phrase?
For me, a museum is first and foremost a site, and a building. Location and architecture, for sure. And also a home. A home for art. A home for art professionals. A home for artists. A home in the sense of hospitality, of sharing, of communion. And a site of contemplation and convergence where ideas and objects intersect to produce meaning and social value.

Much of your work has been devoted to questions of identity, not just in regard to Africa but also to gender and sexuality. Is the museum capable of making a dent in these systems and mentalities that shape identities?
Change or evolution of mentalities comes about through multiple forces. The museum or the cultural field alone can never achieve it. But certainly, the museum participates significantly in expanding horizons, in expanding understanding, in triggering curiosity, in questioning certain realities. Alone, art cannot accomplish that. Let's be honest.

Koyo Kouoh

That's one of my catchphrases: *the exhibition is not a newsroom*. A museum is not a political party. If you look at what people call the Arab Spring, for instance, it was not triggered by an exhibition or an artist. It was triggered by a desperate fruit vendor on a street corner.

When you imagine stepping into the museum of the future, what do you see? You said the museum is a site and a home. But what sort of a site and a home do you imagine?
I am pretty sure that museums will have to cohabit very closely with other forms of presentation. They already do cohabit to some extent. Fifty years ago, museums didn't necessarily have retail; that has moved in. You didn't have restaurants; cuisine and culinary experience are now a fixture in museums. Such cohabitation with different other forms of experiences and presentation will only increase. The museum-goer of the future will demand different sets of adjacencies in terms of the artistic experience and the museum experience. Those cohabitations will be key for the survival of the museum.

Speaking of survival, as a former banking-administration student, and a practicing fundraiser, how do you think museums will survive financially, especially in Africa?
The real financial costs of artistic production are still totally underrated. One should not be blinded by the astronomic figures that certain artists achieve in sales and the huge production budgets that a happy few can work with in their Renaissance-like studio-factories. The vast majority of artists still don't have the resources they need to sustain their practice.

On the other hand, particularly here on the continent, there is a sense that art should not cost anything. I think this comes from the ingrained DNA of communal practice—the notion that art is for everybody, by everybody—which I sense still lives in us in a certain way. I want art to maintain some of that tension, because it is also true that it reflects a certain social value that is more important than any other value art can build. It speaks against a profit-oriented, individualistic lifestyle.

You have just started as director at Zeitz MOCAA—just one short year. The situation is challenging, even precarious, from a financial standpoint. What is your best hope for this institution in the coming years, and for all museums in the future?

I can answer it on the purest, simplest, most basic level. Money. Money. Money, and more money. We need funders who support all these initiatives. We need the whole gamut of stakeholders that can attach themselves to making this institution thrive. We are not short of ideas. We are not short of artists and thinkers. But we are always short of financial resources that we need to make things work properly.

The best thing that can happen to Zeitz MOCAA is this: for Jochen Zeitz, the name-giver of this museum, to endow the museum with a substantial endowment of at least twenty-five million dollars from which we can start working. It's money. There is a saying in French: *l'argent, c'est le nerf de la guerre*— "money is the sinews of war." In English you might say, "Money talks." My main worry—and therefore my main hope—is that we can secure the financial resources to succeed, and live up to the expectations and materialize the so-wonderful projects that we have in store.

Koyo Kouoh

MARÍA MERCEDES GONZÁLEZ
Director General, Museo de Arte Moderno
de Medellín (MAMM)
Medellín, Colombia

WE ARE A TOWN SQUARE

Three decades ago, the city of Medellín was the epicenter of the social dysfunction that had long plagued Colombia. Since then, the former drug-cartel stronghold has re-emerged as a thriving, peaceful metropolis and a symbol of Latin America's creative potential. The striking 2015 addition to the Museo de Arte Moderno de Medellín has been both a catalyst for and an emblem of the city's rebirth. The task of expanding the museum fell to María Mercedes González, a former cultural attaché in the Colombian embassy in Buenos Aires. Born in 1977 and trained in media studies at the New School in Manhattan, González, an avid salsa dancer, has deftly navigated the cultural, diplomatic, and bureaucratic challenges involved in relaunching a museum, reshaping its programming, and embedding it in the surrounding community.

ANDRÁS SZÁNTÓ *Say a few words about your museum in Medellín, the role you have played in its evolution, and what role this institution plays in the ecology of Colombian museums.*

MARÍA MERCEDES GONZÁLEZ MAMM is a nonprofit institution established in 1978 by a group of artists and citizens who saw the need for an organization that could channel the audience's interest in arts. I was appointed general director in 2012 and our new building was inaugurated in September 2015. We then implemented an extensive programming reorientation and its following consolidation.

The collection has more than two thousand works of contemporary and modern art, Colombian mostly. We take on issues that are culturally, socially, and politically relevant, drawing from the landscape of the contemporary arts while maintaining high-quality production and a tight connection to Medellín and Colombia. The museum is a key player within the Colombian cultural ecosystem. It is a critical space for thought and debate. We listen to the expectations of the more than 130,000 people who participate in our activities each year.

We're having this exchange in June 2020, as the Covid-19 pandemic crisis is peaking in your country and throughout Latin America. How has it forced you to adapt?

As we speak, we have been in lockdown for almost three months and are now preparing to reopen. It has certainly been one of the major challenges of my life. Adaptation has been required on all fronts. From the beginning of the crisis, it was clear to us that one of our priorities was to preserve employment for the MAMM team. There has been commitment and solidarity from everyone.

We have had to adapt quickly and creatively to work from home, reschedule the programming for the rest of the year and part of 2021, and design a virtual agenda with the tools we had at hand, that could endure beyond the coronavirus pandemic. Financial projections indicate a 40 percent decrease in income, especially our self-generated income, which has forced us to slash expenses and look for bailout options in the public sector. Every day, we oscillate between pessimism and optimism. We have made an enormous effort to ensure that the crisis does not

take up all our energy, and to be able to think about the future and some changes that we hope will materialize.

Of all the projects you have realized in Medellín, what are you most proud of?
Being a part of the comprehensive development of the city is one of my greatest satisfactions. I am proud of our teamwork, particularly around the museum's expansion project, which took approximately six years. More than a physical expansion, it was about the renewal of the artistic and cultural project of MAMM as a whole. Today, the active and enthusiastic presence of artists and people fills the museum with meaning.

Among the people of Medellín there is a strong sense of belonging to the city and its affairs, which has enabled transcendental changes in a city that was so battered by violence and drug trafficking in previous years. Without a doubt, MAMM is today an expression of that social transformation.

Rarely has a museum had such a transformative impact on its community. What in general is a museum's most important contribution to society?
Constructing and preserving the creative action of human beings—and offering the possibility of knowing and enjoying the world through the lens and work of artists, which contributes to strengthening our connection to humanity and to ourselves.

Contemporary museums have a fundamentally educational mission, because our work can contribute to broadening the horizon of formal education and to fostering more open, critical, empathic, and sensitive communities. This can be achieved through raising awareness, promoting critical thinking, and empowering communities in relation to the city and its affairs, and also, of course, through the plain and simple enjoyment of art.

Your museum is a Latin American institution. Latin America has a long tradition of museums, but on this continent, as in some other parts of the world, museums have been proliferating in recent years. What is different about operating a museum in this context? And where are museums in Latin America going?

María Mercedes González

All museums exist within wider social, political, and economic systems—hence the many differences. In Latin America there is a lot of social inequality, and this has repercussions on our work, in terms of the official budgets allocated to art and culture, and also in terms of the issues and priorities that mark our agendas.

For various historical reasons, the Colombian heritage and the management of this wealth have taken place outside the public sector. As a result, the landmark art and culture institutions are today run by nonprofit institutions that are financed through sponsorships and donations from the private sector, their self-generated income, and, to a small degree, contributions from the state. In Colombia, there is a dearth of public policies to support museums and the visual arts. Individual and corporate philanthropy is not as deeply rooted as in other countries. Many of our visitors are attending a museum for the first time. Culturally, the habit has not been encouraged in the family or at school. In 2018, only 11 percent of Colombian respondents said they had ever visited a museum.

Another difference has to do with our audience. We are not a major tourist destination. Seventy percent of MAMM's audience comes from local communities. Unlike with museums in the United States, for example, the participation of board members is understood here as an exercise in civic responsibility, not in the form of significant donations. Finally, and perhaps because of this, the market plays a less prominent role in the dynamics of Colombian museums.

Thinking about museums in Latin America, or beyond, what needs to be fixed in order for them to evolve? What worries you about their future?
Economic sustainability has always been, and continues to be, one of the main concerns. The pandemic has made more evident the fragility of the system in which we exist, and thus our own fragility as well. The inclusion of the museums in public agendas and budgets is subject to the vagaries and interests of whoever is in power. This results in a logic of management that is short-term and oriented toward mere survival.

Add to this the absence of a culture of philanthropy and the scarce tax benefits encouraging the private sector to invest and

donate more, and you see how difficult it is to imagine projects with a longer and more lasting vision.

For Latin American museums generally, transportation, insurance, and taxes on international exhibitions and projects are extremely expensive. The exchange rate is always a constraint. The economic crisis resulting from the pandemic will have a major impact, not only on the sustainability of our institutions but also on our programming. We will need to work more as a network together with other museums in the region. This crisis has also revealed a lack of digital connectivity in a large part of our population. This will further restrict access to culture and widen social gaps.

What does Latin America tell us about the future of museums around the world? Are there any models from here that may be relevant elsewhere?
Latin American museums have much to contribute to social and community practices. We know about working with local communities. We have experience with the inclusion of diversity in our practices and programs. The shortcomings of our countries have led us to become much more than art museums. We are a town square. We promote debate on political and social events. We are civic leaders. Many museums have also tried to become more aware and accountable regarding the sponsorships and donations we receive from the private sector. I believe that we have achieved a more harmonious relationship with the art market as an element that is part of the art ecosystem.

Without doubt, these times will demand we do much more, especially regarding the local, the participation and defense of Indigenous communities in our countries, our relationship with our regional neighbors. How can we be a more active and exemplary voice for environmental sustainability? Against all forms of discrimination, against violence? These are and will be priority issues on our agendas.

Politics is an inescapable part of running museums everywhere, and especially in Latin America. How do you navigate the complexities of managing institutional independence? Do you worry about nationalism, xenophobia, authoritarian governments?

María Mercedes González

These issues have not been a barrier to the operation of our museum, fortunately. We are a private institution. Our internal governance has preserved our autonomy and independence, although we have been a close partner of the Medellín Mayor's Office in multiple projects. In recent years, city hall has played a more active role in the life of the museum, and the secretary of culture has been invited to participate in our board of directors. The museum's income comes from a variety of sources, and this does not compromise our freedom and independence: 40 percent is sponsorships and donations from a variety of corporations and foundations, 39 percent is self-generated, 18 percent is from Medellín City Hall, and 3 percent is from the Ministry of Culture.

We are aware of the danger posed by these threats that you bring up. That is why we have promoted constructive conversations for our country around themes of peace, overcoming war, and the cultural change that our democracies require at a time when autocracy and xenophobia are on the upswing in the world. Of course, we can do more on other urgent issues, such as Venezuelan migration, the new role of ex-combatants in society, and the social conflicts that the pandemic is sure to unleash.

You run an institution that seeks to maintain the highest international standards, yet is also very much about Medellín. How should museums like yours seek a balance between their local cultural roles and their position inside the international arts system? We are a museum firmly anchored in Medellín, but with a cosmopolitan view of our work and what we should offer the city. Working on these two dimensions simultaneously has been a strategic choice that responds to the museum's current moment, but also to the nature of a city that for many years was isolated and has only very recently opened up more to the world. We are committed to being a space where local artists can grow, but at the same time a space for exchange and connection with artists from other latitudes. It is a good thing for the public to get to know the history of art in this region, but it is no less important for our audiences to access global artistic production without the need to travel to another country—that is, ultimately, to access other ways of thinking and seeing the world.

How can Latin American institutions be different going forward? What exactly does it mean to be "local"?
Speculatively, I would venture to say that being local will sort of gain a new legitimacy in the immediate future—the local, firstly, as the full awareness of the place of enunciation, as the need to know our communities better, their demands and expectations, in order to act in full harmony with their needs. But the local cannot be synonymous with hermeticism, inbreeding, or parochialism. In parallel to the local, we must promote a cosmopolitan practice at our institutions on the Indian-English critical theorist Homi K. Bhabha's terms: namely, as an ethical and cultural practice based on the convergence of diverse and fully human cultures and interests.

What is the promise of institutional collaborations in realizing this agenda?
One of the few positive things that this planetary crisis has brought us is the realization of something that we know all too well but seldom practice: unity is strength. Colleagues, artists, and cultural professionals have met, talked, argued, cried, and imagined together. I am convinced that this collective momentum will be maintained, and it will result in collaborative projects between our museums, and even between cultural organizations and other types of institutions in the city, the country, and the world. More than ever, it is a question of combining efforts and capacities.

So how, with all your experiences in Latin America and in Colombia in mind, will tomorrow's museums be different from the institutions we see today? Think ahead thirty or fifty years.
It is healthy to take advantage of the illusion of change that this crisis has brought to speculate about the future. I would like to think that we will continue to be spaces for learning about and enjoying the world, with an essential public and educational vocation. But I also hope that we will work more closely with the education sector, for example, and that we will be an essential part of the habits and lives of more people.

I am excited to imagine that economic sustainability will not be a daily struggle because, by then, we will have achieved public policies that translate to support and budgets that allow us to

　　　　　　　　　　　María Mercedes González

project our work into the long term. Increasingly, we will be recognized as safe places, to which entry is regarded as a relief and not as a chore (as has been the case)—places to meet, places to say things that cannot be said in the streets due to fear.

Of course, there will be new developments in art and artistic practice, and my aim is for us to be able to keep up with and support the work, creativity, and thinking of artists.

You have been extremely purposeful in building a fully community-facing museum in Medellín, a city with a complicated recent past. How will this aspect of the museum develop in years to come?
Medellín has always been part of MAMM's DNA. Forty-two years ago, our founders envisioned a living, urban, modern museum, and that spirit is continually renewed with thoughts and actions that have allowed the institution to update itself with the times. The pandemic has forced us to think about what more we can do for the city and how we can be closer to our surroundings and our communities. We are at the tail end of a process of transformation that began ten years ago, when we moved to a new area of the city, a process that took place at the same time as the urban and social transformation of Medellín.

This city continues to face enormous challenges: social inequality, new forms of criminality that co-opt young people in particular with the promise of easy money, gender violence. How can we contribute, from our capacities and our mission as an art museum, to these common purposes? Finding an answer to this question will be crucial, especially for the new generations who have found in MAMM a meeting place and an alternative for socializing in a city where shopping malls have typically performed that function.

If you had the funds, what is a major unrealized project you would like to add to your museum?
Five years ago, we opened a 78,000-square-foot building in which we feel wonderfully comfortable. However, if I had the resources, I would like to have more conventional (white cube) as well as unconventional exhibition spaces to present other kinds of artistic practices. Surely, we would also make new acquisitions that are needed in our collection.

You have already spent many years working in museums, and you will likely be in this field for a long while to come. What will keep you excited and energized? What is your best hope for museums in the future?

I am fully persuaded about the importance of museums and of art as crucial spheres of human development. I look forward to seeing this understanding arrive and materialize in public-policy agendas, so that we museum professionals will be able to work more smoothly, without day-to-day economic concerns.

I know you are a role model for a next generation of young Latin American museum professionals, particularly women. How would you advise a young woman seeking to be a museum director in your country, or any country?

Assume the role with the utmost professionalism, not as a job that is done for charity. Listen constantly and be perpetually in tune with your surroundings. Exercise human and balanced leadership. Maintain an excellent dialogue with the board of directors, the team, the artists, the allies. Understand the limitations you are working with and prioritize your key objectives. Be open to change, and always seek quality and rigor in content and actions. Last but not least, enjoy the work and always be willing to learn.

María Mercedes González

PHILIP TINARI
Director & Chief Executive,
UCCA Center for Contemporary Art
Beijing, China

A WIDE-OPEN FIELD

My first encounter with Phil Tinari was in 2010, on a trip to Beijing to write about the reopening of the National Museum of China. The Pennsylvania-born Tinari, just over thirty back then, was freelancing for art publications, teaching, and advising organizations seeking a foothold in China. He took on the directorship of the Ullens Center for Contemporary Art, a trailblazing *Kunsthalle* in Beijing's 798 Art District, in 2011. Over the course of a decade, as we have collaborated on various projects and dialogues, he has been an astute guide to the world's fastest-growing art ecology. In 2017, when the Ullens was put up for sale, Tinari together with a group of investors relaunched the organization, embarking on an ambitious series of expansions and initiatives. Today, with a revamped Beijing headquarters, a seaside outpost, a satellite in Shanghai, a foundation, and subsidiaries for retail, education, and brand collaborations, the renamed UCCA Center for Contemporary Art is China's preeminent contemporary art organization and a lab for emerging museum practice.

ANDRÁS SZÁNTÓ *You opened one of the first art exhibitions post-Covid, in May 2020. Let's memorialize this moment. What does it feel like to be in Beijing right now?*

PHILIP TINARI China was the first place to experience the coronavirus, and one of the first to bring it to heel. The system of social control here, for better or worse, ends up being rather well-suited to managing a pandemic, compared to a more open democratic society. For me, having been here during SARS, in 2003, the playbook of the Chinese response was quite familiar at first. When we learned that we would be able to reopen, I was incredulous. Someone from the state-owned company that owns the land under UCCA called me in mid-March to say with great confidence that Gallery Weekend Beijing would happen May 21 and things would be back to normal by then.

We are seen as an anchor of the Chinese contemporary art scene, and certainly of 798, and I felt strongly that if some portion of the Beijing art world was going to reopen, we would have to be right there with everyone. Things move fast here. A lot of my work has been about making us more professional, extending timelines, implementing new processes, aligning with international best practices. But in this moment of crisis, what served us best was this ability to turn on a dime. I put six curators in a room for a week, and we came up with a twenty-six-artist international group show in five sections that looks at this situation from different angles. I was proud we were able to put together an honest and urgent response.

Is this how things are going to happen from now on? Where are we in the larger narrative?

If you go back to the late eighties and early nineties, it is possible to see contemporary art in China as a space of experimentation and openness. From an American perspective, it is easy to see it as a proto-democratic space. Unfortunately, what I have taken to calling the "great teleology"—the idea that economic development would necessarily bring political reform— ended up being misguided. This has required a massive recalibration.

So how does a kid from the Philadelphia suburbs end up running a museum in Beijing?

There is no short answer. I found myself at Duke in the late 1990s, an undergraduate in the program in literature assembled by Fredric Jameson. It was that late-Clinton, pre-9/11 moment of maximum American global influence, but also self-scrutiny. I had come out of a humanistic tradition, educated by the Jesuits. But I also wanted something more tangible than Derrida and Foucault. Studying Chinese seemed like an interesting thing to do, a way of expanding my horizons.

I went to China on a Duke program. One day soon after my semester in Nanjing, a professor of mine, the literary scholar Jing Wang, told me there would be a major Chinese artist coming to campus. It was Xu Bing, a key figure of the 1980s avant-garde who had relocated to the US after Tiananmen. I was sent to bring him from the airport. He was commissioned by Duke to make an exhibition and he decided to plumb the archives about the Duke family's tobacco enterprise and its history in China. The Duke-owned British American Tobacco Company had been headquartered in Shanghai, helping to create the largest smoking population in the world. Xu Bing's father died of lung cancer. He did this whole meditation on cigarettes, desire, material culture, and colonial history. We showed pieces of this in our Xu Bing retrospective at UCCA in 2018.

Amazingly, the department had its office in what was the Duke University Museum of Art, and one of DUMA's shows each year was curated by seniors. I applied, and they took me and another student. For a show titled *Made in Asia?*, we invited the likes of Takashi Murakami, Mariko Mori, Huang Yong Ping, and Do Ho Suh. That was my introduction to the art world. I found it so compelling. I knew that was something I wanted to do.

I ended up getting a Fulbright in Beijing. I started an intensive language program at Tsinghua University on September 10, 2001. On the weekends, I dove straight into the art scene, which was completely unstructured back then. Lu Jie was running *The Long March*, which was a trip along the route of the Red Army's Long March in the 1930s, staging artistic interventions in towns along the way. I ended up traveling with them for a while. Back in Beijing, I apprenticed with Feng Boyi, a senior independent curator who was working on the first exhibition in 798. Through him, I got involved in the first Guangzhou Triennial, in 2002, living

Philip Tinari

inside the Guangdong Museum of Art for two months, editing the English catalogue. By that point, I had met all kinds of artists and curators, getting a sense of this still small but fascinating art scene, which was struggling for recognition.

In 2003, I went back to the US to do a master's in East Asian studies at Harvard. When I finished, I got a contract to work for Sotheby's on the catalogue for their first sale of contemporary art from China, Japan, and Korea. In the spring of 2006 I moved back to China, and I have been here ever since. For a few years before and after the Beijing Olympics, I was working independently—writing for *Artforum*, consulting for Art Basel, making some independent publications, taking museum groups around, flying around with Ai Weiwei to translate for things.

And the rest is history…
I remember when UCCA first opened, in 2007. Like most people in the Beijing scene, I viewed the place with a lot of respect, but also as a spaceship that had just landed, with all the trappings of a European *Kunsthalle*, just outside the Fourth Ring Road.

I like to talk about the history of UCCA Beijing in terms of the entrances. There are three distinct periods. In the first, before my time, you entered by going down a dark corridor. Suddenly there was a rotating door on your left, and you were magically transported into another world, invisible from the street. In the second period—which began in 2011, with me as director and May Xue as CEO—we moved the entrance to the front of the building, so you could at least see us when driving by. Still, there were vast swaths of UCCA that were not immediately apparent.

It was only after the sale and restructuring that we could bring in OMA to build a proper façade and finally realign our visitor experience. We took over a building at our entrance for offices, and it looms bright and red, with banners flying from its center. On the ground there is a gradient of light to dark tiles that draws people in. Once you get to the deep gray shade, you cross the threshold and you enter. It tries to represent the ideal of being open and transparent.

You got to author the main contemporary art institutions in China. What were you emulating? Where are you taking inspiration from?

I am not convinced that the existing models apply directly. This place began as a love letter to China at the moment of China's peak openness and optimism, around the Olympics. It was not about changing China, but it was rooted in a vision of a global civil society that has since destabilized. We are still articulating the sensibility of a world where China has a major voice, and, closer to home, of what a global China might feel like. It is a deeply cosmopolitan project, in a place where that is not necessarily the obvious aspiration.

This project began years before China was as powerful or assertive as it has become, but I think the ideals remain relevant. I do think we have peers. The Garage, in Moscow, occupies a similar position in another post-socialist society. The Mori Art Museum, in Tokyo, functions as a major contemporary art institution for its city and country, despite its private origins. More recently, Koyo Kouoh at Zeitz MOCAA, in Cape Town, has brought a regional/national scene into the global dialogue. Of course, we all owe a lot to Harald Szeemann, in the 1960s, and Alanna Heiss, in the 1970s, or Hans Ulrich Obrist in the 1990s and 2000s, all of whom expanded the notion of what the museum can be.

We are the institution of record domestically for the careers of major Chinese artists. One staple of our programming has been these periodic large-scale surveys and retrospectives of key figures. We try to put their achievements into a global context. We also mount exhibitions that introduce global artists to China, and others that spotlight and support younger artists working in China. All of this has allowed us to be artist-driven. We have a team that knows how to listen and learn. Our flagship space is the column-free, 1,800-square-meter Great Hall, which functions like a blank canvas. The museum can be remade in the image of whichever artist is showing at that time. I believe in that flexibility and vulnerability, that ability to give the space over so completely to an artist's or a curator's vision.

China will play an important role in the next century of the museum, just as Europe and North America did in the last century—that's just a matter of economics and global power. How will the future be different because of China's greater role in it?

Philip Tinari

I obviously cannot speak for China. But what we see at UCCA is a kind of hyper-refined, accelerated version of a lot of trends that museums are reckoning with all over the world, specifically in regard to user demographics and digital convergence. China has completely redefined e-commerce. You have digital-shopping hosts who can convene tens of millions of people and get them to buy something, through livecasting. For all the restrictions and censorship, people's digital lives here are all-consuming. This manifests in this insatiable desire to document one's existence and declare it to those around, using whatever channel or network is in vogue at any given moment. So for example, this idea of the museum as photo backdrop arrived here early. We spend a lot of time thinking about how to turn this inexorable urge into something productive, even educational. At the very least, we need to think about how, in a place where "traditional media" are even less influential than elsewhere, this kind of transmission by individual accounts and users can create excitement and understanding around our program.

You are mirroring a different kind of society onto the museum.
Let's zoom out for a moment. I grew up in Philadelphia, with its great museum, a temple framed by staircases—a place that ultimately exists to educate citizens and to foster a vibrant democracy. There are places where that architectural language persists in China. But when you go to the National Museum of China, even though you enter a cavernous atrium that feels like a grand civic space, your route will be circumscribed by velvet ropes and scissor gates. It is the opposite of, say, the plaza at Lincoln Center. As much as we at UCCA are working to build a public-facing institution that has an empowering view of art and its place in people's lives, and of art's role in connecting China and the world, we do this inherently in the context—and in some cases, against the confines of—an entirely different political system.

How does Chinese society now relate to museums? What are people's expectations?
There are things that the government will build itself, things it wants to happen, and things it will allow to happen. The high-level policy rationale is about fostering the creative industries

and China's capacity to innovate, coupled with the idea that China is a place of culture and civilization, which runs deep in people's understanding of their country. Even so, most of the work of building contemporary art infrastructure has been left to the private sector. And in the past few years we are finally attracting a significant audience.

From UCCA's opening in 2007 until 2016, our tickets cost ten renminbi (about $1.30), and we were free on Thursdays. Yearly ticket revenue was less than our water bill. In 2016, when we were planning a Rauschenberg exhibition, we asked ourselves, "Why aren't we charging more?" We raised the entry to sixty renminbi ($7 to $8), and we had more people come than for the William Kentridge exhibition in the year before. It was like a switch flipped. In 2019, ticketing was our single largest revenue stream.

In China, having a solid commercial logic behind what you are doing is considered a source of authority. People are suspicious if it doesn't add up. They assume there is someone behind it who is up to something. The most common question I still get from people in other fields is an incredulous "So you don't sell the art that you show?" (We don't.)

In the West, if you are a commercial entity, you are considered guilty until proven innocent. What sort of opportunities open up when you think differently?
A lot of museums around China are running a crass version of the pay-for-play scenario. Many are run by a founder who is not necessarily a professional. One phenomenon you see often is dropped-in content produced by a third-party commercial entity, usually a (mega)gallery. There is what you might call a content deficit. There has not yet been time for great collections to be built and filter down into the society, or for robust curatorial staffs to take shape.

The upside is that we have what you might call a wide-open field. Our exhibition *Picasso: Birth of a Genius*, organized with the Musée National Picasso–Paris, was not excessively complicated from a curatorial standpoint. People came in droves because this is a famous artist and someone they need to know about, and we were showing 103 of his works. They left with a sense of who he is and the contributions he made. At the most basic, that's

what museums are for. For hundreds of thousands of people, that show may be a cornerstone in their artistic awakening and cultivation. That is enough to make me feel excited about doing things here.

Given the more matter-of-fact attitude about money and commerce, what are some things you can do, for example, in working with brands or other IP initiatives?
From the beginning, we were registered as a company that was 100-percent-owned by Guy Ullens. A foreigner simply couldn't register a nonprofit museum in the early 2000s. Despite this commercial status, we were able to attract corporate sponsorships and, from 2012, to introduce a patrons group and an annual gala. People were making a donation to a money-losing company. There were no tax benefits; it was purely an act of support. They believed in our role. That all came crashing down when Guy Ullens decided to sell UCCA. When we went up for sale, these people felt betrayed. So when finally a group of partners—including a number of our previous patrons—came together to resolve this situation, the first thing we needed to do was think about how to set up the institution. The biggest asset of UCCA was its public profile and its artistic credibility.

You had to look for a new model. How does it work?
The overall entity is now called UCCA Group. Under that, you have UCCA Beijing, the museum, which is now accredited by the Beijing authorities and operates as a nonprofit. We have something even more sacred than the museum, the UCCA Foundation, our philanthropic arm, which does outreach to underserved communities throughout China. Additional museums are being added in other cities in China, often with new partners—for example, UCCA Dune, in a planned seaside vacation community three hundred kilometers from Beijing; and UCCA Edge, which will soon open in downtown Shanghai.

Then we have three operating entities, which are registered as separate companies, wholly owned by the group. The UCCA Store is an online and offline boutique for art- and design-related products. UCCA Kids offers art classes, in line with our values and sometimes even based on our exhibitions. The most interesting,

and the largest by revenue, is our UCCA Lab, which has become a platform for art-driven collaborations with all kinds of brands. In Beijing, it is a physical space on the south side of the building, with a separate entrance. But it is also a team that can curate and execute projects, strategies, and activations for corporate partners anywhere in China, or for that matter abroad.

Under this division, we have worked with China's leading tech companies, from Baidu to Xiaomi to Huawei. We have done projects with global brands, such as COS, Budweiser, Airbnb. We have even made exhibitions with pop stars. These partners are generally art-curious, and they are open to learning something along the way. We brand these as UCCA Lab projects. And everybody gets paid properly. It can be liberating when you approach something in a straightforward commercial way, and it often paves the way for deeper collaborations later.

Other people in this book have spoken about the rarity of monetizing the intellectual expertise of the museum staff. In China, it seems easier to do.
Absolutely. UCCA Kids is probably the most mission-aligned, because it is about cultivating the next generation of China's art audience. But UCCA Lab is the most organizationally aligned, because it mobilizes the expertise we have developed—from lighting design to press-release writing. A huge number of people here don't know who we are or what contemporary art is. In working with these companies, which are so prominent in people's lives, we can deliver artistic content to new audiences.

The history of museums is inscribed with the assumptions of Western art: picture galleries, for example, are for hanging oil paintings. How will the Chinese influence change that equation?
In a way, China's participation is what makes it possible to construct a notion of a global contemporary art. This was the secondary thesis of a show that I co-curated at the Guggenheim in 2017, *Art in China After 1989: Theater of the World*. When I first started working in China, circa 2002, I used to think of "contemporary art" like an operating system. Even if Windows or Mac OS is American, that doesn't imply much about the kinds of documents a computer might produce. There is a range of

Philip Tinari

commonly used media, or rhetorical devices, or conventions, from Conceptualism to Pop and forward, that may be part of this Western history, and of other histories as well, and that doesn't inherently have to deny the validity of different perspectives or subjectivities.

On this June weekend, we would typically both be on our way to Switzerland, to attend Art Basel. Your life has been shaped by the possibility of a global art world where it's easy to move around. Now, you haven't left Beijing in a half-year.

The funny thing is, I came into the global art world through China. To be regrounded is strangely liberating. Institutionally, it has made us think about what we are best suited to do. I don't want to think of it as a shrinking back or a standing still. Rather, it's more of a doubling down, or a thinking through. The challenge now is going through that catalogue of resources that we have available—the staff and their talents, our protocols and ways of working—and cooking from the pantry, in a sense. Having limitations is actually quite a relief.

With all these experiences and observations in mind, how would you define the "museum"?

We at UCCA are not a repository of objects. We are not a citadel for a collection. There is actually a better Chinese term for an institution that mounts works and exhibitions by mainly living artists, a *meishuguan* (美术馆), versus an encyclopedic, collecting institution, a *bowuguan* (博物馆). We are certainly the former. The English "museum" is not what we are necessarily striving to be. But it is definitely an efficient way to signal our overarching commitment to our public.

Put yourself in a time machine. What is your mental image of a museum in, say, 2060?

I think of the museum increasingly as a community of interest, conversation, and participation. The ritual that most potently sustains that community is being together in shared space, face-to-face with objects and images. As much as the dematerialization of art will have continued through many cycles by then, I want to believe that this convening, this creation of collective

experience that becomes part of social memory, will always be at the heart of the museum enterprise.

I am probably not the only one to refer to you as "our man in China." If you want to connect to the Chinese art world, call Phil. Will this role become obsolete if you are successful?
It already has. If I once had some special ability to function on both sides of the China binary, that has long since been matched or exceeded by the generations born in the late 1980s, 1990s, and now 2000s, who have grown up toggling back and forth. Many of them work at UCCA. They are a constant source of hope as the art world here comes into its own.

I am enduringly grateful to the artists and curators who embraced and encouraged my interest in those early days. And I only hope that we can repay that generosity by lending depth and nuance to a conversation that lately seems to become more fraught and difficult by the month. I persist in the belief that there is value to creating connections between China, on its terms, and the rest of the world, on theirs.

Philip Tinari

RHANA DEVENPORT
Director, Art Gallery of South Australia (AGSA)
Adelaide, Australia

ASK PEOPLE WHAT THEY WANT

One of the most critically acclaimed installations of the
57th International Art Exhibition at the Venice Biennale,
in 2017, was Lisa Reihana's panoramic video *in Pursuit
of Venus [infected]*. Presented as New Zealand's pavilion
in a historic maritime building inside the Arsenale, the
stunning 23.5-meter-long work broke new ground with its
experimental use of video and with its retelling of complex
eighteenth-century encounters between European explor-
ers and Pacific Islanders. It was curated by Rhana Deven-
port, then serving as director of the Auckland Art Gallery
Toi o Tāmaki. In New Zealand, the Australian-born
Devenport honed her commitment to thoughtful and
sensitive engagements between the art museum and its
communities, Indigenous artists and visitors among them.
She has extended this commitment to the Art Gallery of
South Australia, founded in 1881, where she assumed
the directorship in 2018. For Devenport, a trained artist,
former teacher, and self-described cultural producer who
has held leadership positions with the Asia Pacific Trien-
nial and the experimental Govett-Brewster Art Gallery, in
New Plymouth, New Zealand, the ethics, tools, and norms
of art museums are in need of constant re-evaluation and
reinvention.

ANDRÁS SZÁNTÓ *Tell me a bit about your work as an artist, which is how you started out. How does it shape your outlook?*
RHANA DEVENPORT I am a cultural producer in the broader sense of making events happen. I exhibited my work, but that was a long time ago. I quickly worked out that my contribution to the world was through making situations happen and being a catalyst for bringing people and cultural scenarios together. I went to art school, and I have worked with some great artists. And that just means I can understand the process. It gives me empathy and faith and a strong belief in artists, and a lack of skepticism. And, especially, a sense of taking risks.

Looking back, I am surprised decision makers supported me in taking those risks—the Asia Pacific Triennial was very much a shared collaborative project. There has to be a lack of fear about what might happen, because failure is a healthy process in itself. We did several amazing projects with Cai Guo-Qiang in the triennial; two major projects failed. But through that process the relationship with the artist was deeply embedded in the organization, and the museum went on to work with him in different ways. When you are working with ambitious artists, that's part of the journey.

What shaped your thinking about museums? Were there pivotal moments or touchstones?
I had a fantastic year in the early 1990s on a scholarship at the New Museum and doing internships at Oxford MoMA, the Arnolfini, and the Walker Art Center, with John Killacky, looking at performance in museums. When I came back, I was given the role of producing the performances for the first Asia Pacific Triennial. That changed my life. Working with Doug Hall and Caroline Turner, the directors of that project at the time, and experts and curators from the region was transformative.

I remember Filipino artist Roberto Villanueva's *Ego's Grave*, for the first Asia Pacific Triennial. That project involved digging a massive hole in the elegant courtyard at the Queensland Art Gallery, filling it with clay, and making a sunken fire pit, for a performance with several dancers. A raku pit fire requires you to stay with it, so we tended it for some days. We slept on bales of hay on the courtyard, with the dancers and the artist. I woke up the next

morning and I knew that was it for me. I knew these were the artists I wanted to work with, and this work mattered.

You are from Brisbane, and your career has unfolded in Australia and New Zealand. During this time the art world in the Southern Hemisphere expanded exponentially. What are its strengths?
There are three trajectories in Australia for art institutions. The small, experimental contemporary art spaces, like the Institute of Modern Art in Brisbane and Artspace Sydney, and others, are sites of raw practice. There is a parallel world of the state and national art museums. And the Biennale of Sydney, from 1973 onward, and the Asia Pacific Triennial from 1993 have been tremendously influential.

In Aotearoa New Zealand, there were small pockets of experimentation with artists looking outward, determined to build international reputations and relationships. I had extensive curatorial freedom in New Zealand. So throughout our region there are experimental projects and institutions that have legacies of bravery, and alongside them are strong state art museums or city-based museums, such as the Museum of Contemporary Art Australia, working in parallel.

The two years you've run the Art Gallery of South Australia have included a pandemic, an economic crisis, and a reckoning around race and inequality. How do you manage in this environment?
The pandemic raised important questions about the value of art and artists. At AGSA we were identified as "essential" workers because we worked for the government. But artists were considered "nonessential." So we felt a strong responsibility to support artists directly. We did something we would never have imagined doing, which is offering six ten-thousand-dollar bursaries to artists in South Australia, without any outcome expectations. This was fully supported by philanthropists, and we relaunched the South Australian Artists Fund with an annual appeal to our members, which attracted a record response.

We have a magnificent collection of forty-five thousand works. As traveling exhibitions are curtailed, we are focusing on the collection even more. It is strong in Australian, early British, and European art, decorative arts, and historical Asian art, and

Rhana Devenport

growing in the areas of contemporary and Aboriginal and Torres Strait Islander art. We are engaged in a constant renewal and refreshing of the collection spaces. Last year we received a major bequest, which has allowed conscious planning around collection development and exhibition-making. This and our flagship projects, such as Tarnanthi Festival of Aboriginal and Torres Strait Islander Art, the Adelaide Biennial of Australian Art, and the Ramsay Art Prize, will be a major emphasis in coming years.

With these experiences in mind, what is a "museum" for you?
Museums are spaces of wonder, encounter, and empathy, and sites of experimentation and formation of tomorrow. I like Olafur Eliasson's distinction between museums as reality producers and museums as reality containers. He has talked about a future in which museums become co-producers, with artists and the public, of new models of reality.

Great art museums have artists at their heart—otherwise, they wouldn't exist. And since all great art was once contemporary, contemporary practice is the basis of all art museums. Furthermore, museums should present meaning as not something in stasis. They need agility and nimbleness. The kind of art people want to experience today might be different from three months ago.

Objects are starting points for conversations, stories, and ideas. I always talk about museums as catalysts for art and ideas—never one without the other. Great objects generate great conversations. Collections are portals to recalibrating and renavigating the past, negotiating the present, and imagining the future.

I like how you see the museum as this constantly moving, shifting entity.
Now, with the heightened focus on social justice in the flow of Black Lives Matter and the #MeToo movement, it is more important than ever for the museum to respond to issues of diversity and inclusiveness, social justice, and gender equality. When one is in a position of influence, one has to constantly critique what one does.

I worked with many women artists in New Zealand. For a project with the Guerrilla Girls at AAG, we collaboratively did an

analysis of the gender mix in our collections and exhibitions. It turns out, despite all those shows and acquisitions, the balance didn't really shift at all—a reminder of how much diligence is needed. I worked out the math for AGSA, my current institution: it would take seventy-two years of acquiring only women artists to achieve parity across our collections. That is probably true for every encyclopedic collection.

What is a museum's most important contribution to society?
Being an open and communal space—a site of discourse and contrariness, yet in a supportive environment. I used to say "a safe place for unsafe ideas"; however, "safe" has new meanings now, doesn't it? It now also means physical well-being, not just intellectual safety. A space to slow down as well. And given the absence of travel right now, the notion of artworks being portals to another imagination and another way of thinking and being human, and of museums being homes to thousands and thousands of these portals, is prismatic in terms of how museums allow people to journey into themselves and into this communal space.

What needs to be made better about museums today? What do institutions need to unlearn?
The perception of elitism. I like the quote by Gottfried Semper, the architect and social reformer behind the Victoria & Albert Museum, proclaiming that "museums are the true teachers of a free people." Too often you hear, "Oh, the gallery is not for me."

Museums should be artist-led and audience-focused. They are scholarly, but they can be seductive and sensual at the same time. Museums have to offer memorable experiences that matter to people who have given us their time. Because time is so short—every minute counts.

We must ask ourselves: *How useful are we to society? Are we contributing to new models of reality? Are we imaging the future?* It is wonderful to reflect and reassess the past, as long as we learn about it in terms of where are we now and into an unknown future. We just put up a work by the fantastic Aboriginal artist and activist Richard Bell. It is a painting drawn from a historical photograph from 1960s Aboriginal land-rights protests, in

Darwin. Senior Aboriginal leaders are holding up a sign that says, "Ask Us What We Want." We can extend that statement to conversations with all our audiences.

Let's talk more about Indigenous voices in the museum. A place to begin is the work you curated for Venice in 2017, by Lisa Reihana, an artist of Māori descent. Tell me about what it means to advocate for the Indigenous voice.

I hadn't worked closely with Indigenous artists before the Asia Pacific Triennial. In 1993 there were Indigenous artists working across the Asia Pacific region, creating exciting and urgent work. Its political and social urgency made a difference to a sense of art's agency, a sense of presence, and a sense of the future.

In New Zealand, I was presented with a different scenario. It was an interesting position being European-Australian. I was not *Pākehā*, European New Zealand, and this gave me freedom to ask questions that would have been harder to ask if I had been born there. I had life-changing experiences with Māori culture and conversations with incredible Māori philosophers and artists that entirely shifted my perception of the world. Supporting Māori artists felt entirely natural, logical, and necessary.

One of the first artists I worked with was Ngaahina Hohaia, whose father was a great activist and musician from Parihaka, a revered community and a site of passive resistance. She made a beautiful piece of about 360 *poi*, which are small spherical cloth sculptures used by Māori women during *kapa haka*, or dance rituals. The fictive idea, of course, is that *poi* are purely decorative. In fact, they were also used as fitness training in practicing for battle. It was a magnificent installation at Govett-Brewster Art Gallery. The people of Parihaka came and performed in the presence of the work. It was a homecoming, because the museum stood on the street where their ancestors were repeatedly imprisoned in response to a concentrated program of passive resistance to land seizure by the British colonizers in the late nineteenth century. So this event was a tremendous reclamation of space for Māori.

I worked with photographer Fiona Pardington on a series, *The Pressure of Sunlight Falling*, that reclaimed images of life casts of Pacific peoples taken by phrenologist Pierre-Marie Dumoutier

in the mid-eighteenth century. And of course I worked with Lisa Reihana, whom I first worked with in the 1990s through the Asia Pacific Triennial. It was Lisa who first provided the platform for me to curate in Aotearoa New Zealand. In New Zealand, I collaborated on projects with Australian Aboriginal artists, as they had rarely been seen in New Zealand, and there appeared to me to be an urgency to set up new conversations. I initiated group exhibitions and worked on major solo projects with artists Brook Andrew and Jonathan Jones. Interestingly, in Australia at that time I might not have worked so closely with Aboriginal artists, as opportunities for Aboriginal curators are rare and need support. Also, during my time in New Zealand the First Nations Curators Exchange emerged, involving curators from New Zealand, Canada, and Australia working collaboratively over several years.

In Auckland, we toured AAG's amazing portraits of Māori by the nineteenth-century Bohemian-New Zealand painter Gottfried Lindauer. We presented the exhibition at the Alte Nationalgalerie in Berlin and the de Young Museum in San Francisco. It generated tremendous discussion about contemporary Māori culture and living traditions. Simultaneously, I was working over ten years with Lisa Reihana on her astonishing *in Pursuit of Venus* project. Great projects take time. It was an amazing process, in terms of both Lisa's technical experimentation and her conceptual play, to take the fictitious decorative wallpaper *Les Sauvages de la Mer Pacifique*, from 1804–5, and flip it around as an act of Indigenous and imaginative reclamation. I admired her lack of cynicism and her generosity in that process.

I saw it again in January, in Tel Aviv, powerful as ever. But back to your museum. Recently, you acquired a nineteenth-century Murlapaka *shield, attributed to the Kaurna people of the Adelaide Plains, as a reminder that the gallery sits on Kaurna land. Can you walk me through the decision-making?*
In Australia an Acknowledgement of Country occurs on all public occasions, in which respect is paid to the Indigenous owners of the land, and an acknowledgement is often made that the lands were unceded. Here in Adelaide, our South Australian Museum, next door to us, has a vast collection of Aboriginal

artifacts, arguably the largest and most important collection of Aboriginal artifacts in the world, some thirty thousand objects. The complexity, of course, has to do with how these objects came into the possession of the museum. These are questions for all museums. This is tremendously fraught and requires constant recalibration and assessment.

It's important to note that the circumstances of First Nations within Aotearoa New Zealand are radically different from those in Australia. In New Zealand, the Treaty of Waitangi of 1840, the country's founding document, was signed by the British Crown and five hundred Māori chiefs. In Australia there is no treaty; this establishes a fundamental difference in terms of the initial relationship with the colonizers and ongoing assumptions about sovereignty. In Australia it was not until 1962 that Aboriginal people were acknowledged as citizens. For New Zealand Māori there is one language, whereas in Australia there were more than 250 languages at the time of European settlement, in 1788. Keep in mind that New Zealand was settled after the abolition of slavery. I have read the texts from King George III to Captain Cook, and they made clear how the Pacific was considered in a completely different light from Australia, a penal colony.

In any event, we were the first state art museum in Australia to acquire Aboriginal art as art, not as artifacts—and we are proud of that. When the opportunity to acquire the *Murlapaka* shield became apparent, we engaged two researchers, one Aboriginal, one non-Aboriginal. There are seven *Murlapaka* shields in the world, a couple of them in England, of course. Thinking about having that shield as a welcoming presence, something that will never come off the wall and will be in constant dialogue with what we are doing, was a really interesting process. The acquisition was in part funded from the federal government, and of course we worked with the local Kaurna community. Even though scholars verified the shield's history, it was equally important for the Kaurna community to be comfortable with what we were doing.

On a related note, AGSA repatriated a stolen idol last year to India, six months after I began as director. That claim had been brewing for some years, and I really wanted to resolve it. The idol was a beautiful Dancing Shiva, *Shiva Nataraja*, and it was

returned to its temple in Tamil Nadu. Our curator and registrar returned it, and thousands of people came into the streets in celebration of the long-overdue return. I see all this as an extension of what we are talking about.

So how can museums feature Indigenous voices in ways that are culturally sensitive?
Ask people what they want. And listen. Caroline Turner, cofounder of the Asia Pacific Triennial, once said to me, "Rhana, you are there to listen and only speak on rare occasions." That was her guiding principle. Listening and not being afraid to not know. It's also about talking to a lot of people, listening, and not to just one advisor. And allowing artists the space to explore their ideas in new ways. Just give them the platform and support new work.

The museum is a machine made to feature a Eurocentric form of art—paintings and sculptures. How must it adapt to embrace different definitions of creativity?
I suppose the machine must adapt. It's the whole white-box, black-box, glass-box flow—the physicality of the museum must change. But the museum has also got to be a machine for making sense. It has to adapt and shift. And that's up to us.

The work I did earlier in New Zealand for the Len Lye Centre, associated with Govett-Brewster Art Gallery, was about creating a twenty-first-century museum for a twentieth-century artist who was a radical pioneer of kinetic art and moving image. What a fascinating project that was—with a boutique cinema and a new exhibition space that could be totally reconfigured. So that machine has to adapt. And more and more often, it will be a digital machine. Because it's not the machine that matters, but what is going on inside it—it is the possibility within. It is the responsibility of museum leaders, working with architects and artists, to make this happen.

As we speak, museums are confronting the fact that racism and deep-seated cultural divisions are embedded and reflected in many institutions. Now that we see the problem, how should institutions respond?

Rhana Devenport

Artists are change agents. Museums have a responsibility to collect, commission, research, and share works of art that are sustaining and generative. Listening establishes trust for new art and thinking to flourish. A constant recalibration of collections, exhibitions, and programs is required. Employing people thoughtfully is a great starting point—nuanced, diverse curatorial vision is the way forward. Sourcing great advisors, internally and externally, is another key tool. Governance matters, and ensuring diversity at the board level can make unimaginable shifts possible.

Racism, exclusion, and cultural divisiveness are ever-present in museum collections—but so, too, are radicality, criticality, and provocation. Simply opening the museum's doors or online portals is not enough. What's important is being alert, listening, learning, and ensuring artists are truly part of the conversation. Then there is hope.

Let's assume museums absorb these lessons about listening and sensitivity. What will it feel like to walk into that future museum? I remain wholeheartedly optimistic about the future of art museums, perhaps because I possess a deep faith in artists and their ability to catapult our intellect, emotions, and senses into unexpected places. Artists expand our experience of the world. The museum you speak of is a safe communal space for unbridled possibilities, where looking, making, experimentation, discourse, and conviviality occur simultaneously. Artists will always surprise us.

THOMAS P. CAMPBELL
Director & CEO, Fine Arts Museums of San Francisco
San Francisco, United States

WE HAVE TO GET OFF OF OUR OWN PEDESTALS

In 2011, Tom Campbell, who had by then served two years as director and CEO of the Metropolitan Museum of Art, invited me to undertake a fascinating consulting assignment: to assess how the largest museum in the United States engaged with the world. After a year of talking with curators and executives throughout the museum and surveying the Met's far-flung international programs and relationships, we launched a leadership institute for international museum directors. The Global Museum Leaders Colloquium was one of the transformative projects that Campbell, an Oxford-educated tapestry expert who had spent fourteen years in the Met's Department of European Sculpture and Decorative Arts, initiated at the museum during his eight-year tenure as director. Now director at the Fine Arts Museums of San Francisco, where since 2018 he has overseen the de Young and Legion of Honor museums, Campbell continues to think broadly about the field's systemic challenges. Few of these are as profound as the reckoning with colonial legacies and racial injustice, which was roiling the museum sector as we spoke in June 2020.

ANDRÁS SZÁNTÓ *Politics are intersecting with museums with an intensity we have not seen in our lifetimes. How are you responding?*

THOMAS P. CAMPBELL Against the background of the pandemic health crisis, the murder of George Floyd created a lightning rod for an explosion of pent-up emotion and discussion around the question of systemic racism in our society. This brings to a head a long-running discussion that has been going on in museums with greater and less intensity over the past decade. There are several overlapping issues, but the fundamental one is public trust. Surveys indicate that museums are respected and trusted. But the challenge for museums is that the audiences we are addressing have been changing over the past twenty years, and a significant part of our visitation has begun to question the values that we represent.

The background is that during the second half of the twentieth century, Western art museums and art history became increasingly professionalized and specialized in certain overarching disciplines. The people in positions of power in museums—predominantly white—became ever-greater experts in their fields of chosen studies: classical art, American art, European art, Asian art, and so on. And they essentially trained their audiences to enjoy exhibitions and programs that went in depth into these areas. Of course, these fields were built on foundations that go back to European colonial, and then American settler and colonial origins. So they represented a very partial story.

Those are the museums you and I grew up with. In the late 1990s and early 2000s, European and American museums began to rethink the nature of their audiences and how to engage with them most effectively. Collectively, we have been quite successful in reaching out to wider audiences and making our museums more accessible. But as we have opened our doors to larger and more diverse audiences, those audiences are rightly bringing different expectations. They don't want to just see the same cycle of exhibitions about, you know, European Old Masters, American colonial painters, and American modern masters. In the past ten years, we have seen an increasingly strong debate—in some cases, a renewal of historic debates—about whom museums are for and what their programming should be.

This is not happening in a vacuum. Across the society, there is a crisis of legitimacy for institutions—museums among them. Going forward, how can museums earn and rebuild the public's trust?
We have got to become more aware of the habits and bad practices that we inherited, often without even realizing it. We have to step back and look with fresh eyes at what we are doing and the narratives we are telling. We have done that in the museum industry on a number of occasions. Most recently, the field did it with the question of antiquities.

European museums are only just beginning to reckon with the legacy of objects that were taken during a colonial era and what should happen to those. There has been a faster response to the more recent expropriation of antiquities, especially by American museums after World War II, when a huge volume of antiquities was illegally excavated and exported to American collections. During the 1960s and 1970s, there was a "don't ask, don't tell" mentality among many collectors and museums. But as a result of increasing outrage and agitation by the archaeological field and the media, in the early 2000s, finally and belatedly, the American museum industry took dramatic steps to begin to repair the damage that had been done and to rebuild public confidence. The AAMD (Association of Art Museum Directors) introduced strict new guidelines, which then went through further refinements. Essentially, collecting practices changed. It is difficult now for an American museum to buy a looted antiquity without drawing criticism from its peer industry and from the press. That is one example of museums coming together to rebuild the public trust.

Do you see a chance of a similar process unfolding in regard to colonialist legacies and the practice of a more racially equitable and inclusive museology?
That is what we all hope for. Two categories of discussion come to mind. The first is the legacy of colonial appropriation and looting, and what European museums are going to do with the artifacts that were taken during colonial times—and which, in many cases, are the cornerstones of the business models of these institutions.

The second issue is the narrative that museums across Europe and America tell, triumphalist narratives—because history is

written by the victors—about the powers that be: the people who commissioned art and music and literature in Europe, and the white settlers in America.

All too often, museums tell *their* stories, uncritically. They don't tell the stories of the Indigenous peoples that the colonial empires were looting, raping, and pillaging. In America, they don't tell the stories of African Americans, slaves, and the holocaust of Native Americans. We are clearly at a moment of reckoning with that. And the museum industry, which intentionally or otherwise has been complicit in this societal narrative, is experiencing an awakening to these multiple blind spots. We have got to figure out how to be part of this correction.

You could argue that with antiquities the job was easier. It was about objects, the status of which could be corrected. Here we're talking about stories that were never told, histories never recognized. It is a harder reset. Would you agree?
Absolutely, not least because it means unpicking the very structure and architecture of some of our greatest museums. Museums built in the late nineteenth and through the twentieth century put their classical Mediterranean antiquities and their European collections and their colonial American collections on a pedestal in their most prestigious galleries. Other arts—from Africa, Oceania, Asia, etc.—were relegated to outer galleries. African and Oceanic art was presented as "primitive" art. Those distinctions were physically built into buildings in those ways. To unpick that narrative will involve huge cost, and it will be a long process. But cost and complexity mustn't be an excuse. We have an urgent responsibility to engage in this rethinking of the presentation of collections. This is a process that we initiated with the African, Oceanic, and Mesoamerican galleries at the Met, back around 2015, work that will come to fruition more than a decade later.

The project of the museum is a Western one. The model has been exported worldwide, but it has not yet really begun to absorb the mentalities of other countries and cultures. How much of this might come about through collaboration between institutions?
Collaboration and dialogue are key to moving forward. Museums in Europe and in America have been somewhat hesitant about

Thomas P. Campbell

generating that dialogue, for fear of setting off a trip wire about repatriation claims. The French president Emmanuel Macron pulled the lid off this issue with the report he commissioned in 2018, I think bravely and rightly forcing that discussion.[*] The more dialogue there is, the more we will begin to understand the origin of objects, their meaning, and what they represent.

European institutions have to move toward a position where they do begin to give back a sizable number of objects, including some of their great treasures. Many of these institutions were set up with the best intentions, as centers of enlightenment and learning. But as we have acquired a fuller understanding of the exploitative and colonialist actions they were founded through, that legacy has become an obstacle to their role as educational centers and places of objectivity. It casts a shadow that will only be removed when Western institutions reach generous, equitable solutions with the countries from which their collections originated. Part of that reconciliation will inevitably involve repatriation of objects.

Closer to home, you witnessed the toppling of statues near your museum in San Francisco. And one of the reckonings is that the museum itself is an emblem of the status quo, for better or for worse. The public reaction to civic statuary across America in the past two to three years is a fraught and important development for US society. Many of these works are civic statues; they don't belong to museums. They highlight the complacent white-supremacist ideas that people in positions of power have taken for granted. Many statues of Confederate leaders were put up during the Jim Crow era by people seeking to continue the subjugation of African Americans. The decades passed, and these sculptures became invisible to many—but not, of course, to those for whom they were an ongoing reminder of white indifference. The new activism, with these sculptures being pulled down, is symptomatic of the frustration of Black and Native American communities. While I do not condone the destruction of sculptures, I fully support what this movement represents.

* Three weeks after our conversation, the French government presented a draft law to enable France to return African artifacts taken during the colonial period. The 2018 report counted some ninety thousand African works in French museums.

So, what to do with these sculptures? Do you leave them in their damaged state, as lessons about an unjust power structure? Do you take them off their pedestals—literally and metaphorically—and put them in a park as teaching objects, to draw attention to the hate and propaganda they embodied? As an historian, that would be my inclination. One way or another, it has to be clearly understood that these are not figures we are putting on a pedestal anymore.

You arrived in San Francisco after twenty years at the Met, including eight years as its director. You came up through a classic curatorial track: degrees from Oxford and the Courtauld, years of working on exhibitions and studying textiles, until you became the head of an institution. How does this trajectory shape your outlook?

I got into the museum world, in the mid-1990s, because I was a scholar in my field, European tapestries and textiles, and at the time, I saw the museum, the Met, as a place that would allow me to pursue my research. I was an evangelist for my subject. I hadn't really thought deeply about the larger educational mission of a museum. But once there, now part of one of the greatest faculties of art historians in the world, I quickly became more interested in that broader educational mission.

During my time as a curator (1995–2008), I was strongly influenced by the movement in Britain, where the Labour government was pushing institutions to rethink their audiences. By the time I was being interviewed for the directorship, the perception was that the Met was a highly elitist place. As director, I had one overarching priority—to continue and sustain scholarship—but the other was to make the museum more accessible. Between 2009 and 2017, we increased attendance from 4.5 million to close to 7 million. Online, we were reaching tens of millions of people around the world. It was a thrilling sense of progress. In the year and a half that I have been director in San Francisco, I have also been taking steps to support and expand initiatives to reach wider audiences and to break down overly narrow narratives.

Is it working?

Very much so. Prior to the pandemic, we introduced a free

Thomas P. Campbell

Saturday program for residents of the Bay Area that resulted in a doubling of our attendance on Saturdays, with much greater diversity. And we are attracting a much larger percentage of low-income households.

What are you learning from them?
That there is unquestionably a wider, larger audience that we have only just begun to connect with. Much work needs to be done. For example, we need the Legion of Honor—which presents antiquities and European art with a strong emphasis on connoisseurship—to foreground socioeconomic narratives about the underlying power structures. At the de Young—which has an important collection of American art, from Native and Mesoamerican, through colonial and westward expansion, to modern and contemporary art—the narrative also needs to be rethought. We need less hagiography and more critical analysis of what these objects tell us—or fail to tell us—about what was going on.

It's hard to bring new voices into the museum.
The museum industry is full of smart, well-intentioned people who tend to skew liberal. We have made certain inroads. Museums are taking the diversity of their boards more seriously. They have advanced in collecting, exhibition programming, and educational outreach. The biggest obstacle I see is bringing more diversity into the professional ranks. There are disproportionately few BIPOC—Black, Indigenous, and people of color—members of the curatorial and conservation fields, especially in the more historic disciplines.

This is not an easy problem to fix. It begins with the educational system; there are not enough students of color graduating into these fields and choosing museums as a career. Until we have more people of diverse social and cultural backgrounds in our curatorial ranks, challenging our received narratives, we stand in danger of propagating only a slightly more politically correct version of the misleading histories we have been telling all along.

So what specific reflexes, structures, policies, and attitudes do museums need to leave behind to retain the public trust?

We have to get off of our own pedestals. We are experts in our fields, but we need to engage wider audiences and listen. I will give you an example.

Three weeks ago—it's so fresh, still—we were all shocked by the video of the murder of George Floyd under that policeman's knee. Anyone who saw that was revolted, nauseated. A few days afterward we had a staff meeting, where colleagues expressed their frustrations. A small number of people of color spoke then, of the need for change. My initial instinct was to say, "But look at what we have been doing. We have been buying works by Black artists. We just had the *Soul of a Nation* exhibition. We are doing free Saturdays. Look at the diversity we are bringing in." All of which is true. But the subsequent weeks have been a period of profound discovery, of the blind spots that so many of us have carried with us for too long. We are in a moment where we must deliver seismic change. This is a moment when we have to step back and say, "Please, what do you think we should be doing?" and then engage in genuine dialogue.

There are those who remind: the museum is also a place of refuge, a safe place where you can get away from the stresses and conflicts of the moment. How do you balance these different mandates?
I recognize that for many people museums are places of refuge and respite, of recharging. But we are not entertainment. Our fundamental premise is that we are places of education. We don't have to beat people over the head with a political agenda, but we shouldn't be afraid of telling it as it is. As historians, our job is to be objective and analytical.

In a properly functioning liberal democracy, where we have got effective political structures and an effective press and judiciary, museums perhaps could afford to be more middle-of-the-road. But the challenge we face now is that we have a totally dysfunctional political system and a president who has polarized the country, and who is ripping apart many of the democratic institutions that we all took for granted, and for which he seems to have no respect. So, in a way, now it is much more apparent that museums are political, whether we like it or not. We have our heads in the sand if we don't recognize that. There

Thomas P. Campbell

are all those posters out there, "Silence Equals Racism"; "Silence Equals Complicity." That is true.

I am not going to stop visitors who want to see our Impressionist paintings and Hudson River paintings and admire the beauty in the landscapes. But our signage and our labeling have got to be more objective in explaining that, for example, a beautiful landscape of Yosemite was actually made at a time when that land was being appropriated from the tribes who had lived there for generations. I think we should say that. And we should be programming exhibitions by contemporary artists who engage with these struggles and issues.

So, keeping all this in mind, how would you define the term "museum"?
For me, it is pretty simple. It is a place where people are presented with objects from the past and the present that allow them to understand their own heritage and that of other people, to better understand the issues of the day, and to empower their creative engagement in their own futures.

The topic that brought us together, a decade ago, was a part of this larger story: international engagement. We certainly do have a global museum system now. How should this system be managed?
After the Berlin Wall came down, it seemed that a new international dialogue was opening up. Now that has been set back by various factors: right-wing politics in America and in a number of European countries; the retrograde policies of Putin in Russia; China's isolationist direction. Cultural exchange continues to be a critical part of breaking down those barriers, those misunderstandings. We must push on with that work and find international bodies through which we can work effectively. The Bizot Group, a relatively small group of about sixty-five international museum directors, is a somewhat toothless organization—self-elected and self-interested. I think ICOM (the International Council of Museums) could play a more muscular role, although it is currently confounded by infighting and a bit of an identity crisis. Hopefully, it will emerge from that quickly. One of the challenges for art museums is that ICOM does not engage many of the European and US interna-

tional art-museum directors. I hope that may change in the future.

Fundamentally, art museums will be stronger if they can engage honestly as part of a global network. The old hierarchies in which museums in London, Berlin, Paris, New York, held all the greatest treasures have to be surpassed if we truly want to fulfill our mission. Give the Parthenon Marbles back to Athens. Return a significant body of Benin Bronzes. If we are to be respected as enlightened and forward-thinking educational institutions, then we have to shed the mindset of colonialism and exploitation.

What advice would you give to the next generation of aspiring museum directors, should they seek to create real change through leadership of art museums?
I guess it's two things. First, you have to care about objects, truly have an interest in them. It is quite extraordinary that the entire knowledge of the world within the next ten years will be available at the flick of a button. But to have a meaningful career in the art world, you still have to fundamentally enjoy objects. You have to get past the digital data overload and build relationships with the objects themselves. You have got to embrace the romance of the physicality of the objects, as well as the ideas they embody. That is where your roots, your foundations, have got to be.

Then, in your head, you have to be ready to think critically and embrace change. We have inherited a lot of historical narratives, and the biggest responsibility of our generation is to confront those narratives and see them with fresh eyes. We have to recognize the degree to which we have inherited colonialism, white supremacy, the victor's narratives. We have to see beyond those in order to learn from the past and become better people in the future.

Thomas P. Campbell

MERIEM BERRADA
Artistic Director, Museum of
Contemporary African Art Al Maaden (MACAAL)
Marrakesh, Morocco

A PLACE FOR FEELING, FOR UNDERSTANDING, AND SHARING

Adventurous museum innovations are happening today in private institutions, particularly in the world's developing regions. In recent years, the North African kingdom of Morocco has experienced something of a museum boom. Founded in 2016, the Museum of Contemporary African Art Al Maaden draws on the philanthropic support of two Moroccan collectors, Alami Lazraq and his son Othman Lazraq. MACAAL is an outgrowth of their Casablanca-based not-for-profit association, the Fondation Alliances, which is working to advance cultural development in the country. The Moroccan-born Meriem Berrada, who trained in arts management and worked in cultural communications in Paris, has steered the foundation to opening a museum, one of a handful of institutions on the continent specializing in contemporary African art. Creating a new museum has involved adopting international standards, while also working to develop professional networks and novel ways of engaging a local audience.

ANDRÁS SZÁNTÓ *Your museum is just four years old. How did it come about?*

MERIEM BERRADA The determination of two passionate collectors, Alami and Othman Lazraq, led to the creation of this museum. They own a real estate company in Morocco, and they decided, on the advice of Albert Mallet, an expert in international relations, to establish a foundation. Fondation Alliances first supported the company's sponsorship activities, and later its involvement in sustainable development. I joined in 2012, at a moment of strategic repositioning. The patrons wanted to focus on both social and cultural development. They decided to share with a wider audience the collection of Moroccan and African art they had assembled over thirty years. The idea of the museum was to give a home to this collection. It is now one of the four pro-grammatic initiatives of the foundation.

You studied arts management and worked in arts communica-tions in France. How can the museum be a vehicle to advocate for the arts in your country?

I joined the foundation as a cultural project manager. I had spent a short period previously working in the art market, but I found I had no interest in selling art. I was more concerned with sharing the works' history and exchanging ideas with potential clients. When I joined the foundation, in 2012, I found myself managing the collection and coordinating the installation of a monumental sculpture park in a golf course. The project was stimulating, but it wasn't consistently geared to improving the arts ecosystem.

The museum had been on the minds of the collectors for some time. As an initial step, I suggested a project called La Chambre Claire, which we launched in 2013 to give impetus to the young photography scene. It helps emerging photographers produce their first solo exhibitions: editing, printing, framing, staging, publishing their first catalogue, and meeting an audi-ence. Another early program was Passerelles ("Bridges"), which combined social and cultural approaches. We organized work-shops in social-housing districts in peripheral areas of cities like Casablanca, Marrakesh, and Rabat. Over two to four days, artists, in consultation with the foundation team and facilitators, would

engage with residents to explore a specific medium, starting with sculpture, then on to photography, and so on. It was a good starting point for MACAAL, a foundation stone for reflecting on its future audiences.

Where do you see MACAAL fitting in with the evolving visual-art ecology in Africa?
Developing a museum in Africa is challenging, obviously, but it offers a unique degree of latitude. The ecosystem has dramatically changed in recent years. African contemporary art has gained ground, with art fairs like 1:54 in London, New York, and now Marrakesh; the Also Known as Africa (AKAA) art fair in Paris; and big recent exhibitions at Fondation Louis Vuitton and Fondation Cartier, and in various biennials. In Marrakesh, several museums and residencies have opened since 2015—Maison de la Photographie; Musée d'Art et de Culture de Marrakech (MACMA); Musée Yves Saint Laurent; Comptoir des Mines; Montresso Art Foundation; 18, Derb el Ferrane; etc.—allowing the city to shift from a traditional folkloric orientation to being a contemporary art hub.

When we were developing MACAAL, back in 2012, the only comparative example I had was Fondation Zinsou, in Benin. I was also inspired by Bisi Silva and her path in artistic education, and Koyo Kouoh's work in disseminating art creation and empowering art practitioners. We have to keep in mind that the concept of the museum is not coming from our African countries; it comes from the West. To get a broader picture about the arts ecology in Africa, one has to look beyond museums, to the residency-foundation model, to organizations like 32º East | Ugandan Arts Trust, in Kampala, or Nubuke Foundation in Accra, Ghana. Navigating this landscape can be tricky, particularly if you see it with Western eyes. Overall, most of the relevant initiatives are private—that tells you something. Maybe it is time for the states to benefit from the expertise of the independent professionals who concretized these brilliant projects.

French and Spanish influences have left an imprint on public administration and schools in Morocco. What mark have they left on the cultural sector?

Meriem Berrada

As you know, Morocco was under a French protectorate in the middle part of the country, while the north and south were Spanish. I wrote my master's thesis, in 2008, on the impact of the French protectorate on Morocco's cultural landscape. The impact was huge, even though the period didn't last long. Much has changed since then, but the legacy of laws, regulations, buildings, and administrative processes is still felt. Meanwhile, the cultural scene is enriched by diverse secular craft traditions (ceramics, basketry, carved wood and plaster, *zellige* tilework, etc.); as well as music and dance, whether Arabic, Berber, or Hassani (*aïta, melhoun, ala, chaâbi, reggada, ahwach,* etc.); and the performing arts (*halka*).

Culture is very important in Morocco, but the state does not properly fund culture. What funding exists is subjected to a complex bureaucracy. The National Foundation for Museums of Morocco, a nonprofit institution that oversees museums on behalf of the government, has managed to reopen several museums formerly owned by the Ministry of Culture. They could do more to engage audiences and to support local artists and professionals, and not always look to Occidental canons by importing blockbuster Picasso or Giacometti exhibitions.

As for contemporary art, in the 1980s and '90s big banks and insurance groups were buying work directly from artists, mainly to invest and not really to engage in sustainable initiatives. From 2000, His Majesty Mohammed VI, the king of Morocco, who has a long history of nurturing the modern and contemporary Moroccan art scene, began to support more initiatives and art events across the country. His engagement as a collector and patron has led the Moroccan bourgeoisie to follow suit. One question, however, is to what extent did the market clients benefit from the content of this creation?

In this shifting context, what exactly is a "museum," in your view?
Besides being a space for learning, I believe a museum is a place for feeling, for understanding, and for sharing. It has to be inclusive and empathetic, to allow the largest possible audience to benefit. Unfortunately, art is widely considered elitist. It suffers from a reputation that you need an art-history degree to understand it or have an opinion about it. The main barrier is psycho-

logical, not physical. As soon as you dismantle this bias, you get many rich and spontaneous reactions.

But how to change perceptions and break away from the dusty, elitist museum, especially among the younger generations? To deconstruct the stereotype of a sterile, academic institution that is often associated with museums, it is important to undertake the exhibition mission with a convivial approach, conferring pride of place. Museums have to be living and experimental places. They should bring together culture, aesthetics, leisure, and also relaxation.

In this sort of situation, what is the museum's most important contribution to society?
Above all, making people aware of their own artistic heritage—their artists and what their country has done in creation. Last year, for example, we exhibited Mohamed Melehi, a Moroccan painter, designer, photographer, and educator whose work has been shown at MoMA and Centre Pompidou. Most people in Morocco don't know about him and the brilliant work he did in the sixties. There is an established and varied African contemporary art scene. We shouldn't have to go abroad to see our own art creators.

Many people consider Africa to be the next major region that will see a rapid ascent in the twenty-first century. Where might museums fit into that narrative?
What brought the museum to Asia was at first the local market, where emerging local collectors massively supported their artists. The African art market operates, for now, largely outside the continent. This has to change. But I do think Africa is a perfect place for museums—maybe not specifically the Western type of museum, but institutions conceived as spaces for sharing "the tangible and intangible heritage of humanity and its environment" (to use ICOM's words). The culture here is so rich. And there is much to be done on challenging the narrative.

Here in Africa, we don't need to go to a museum to feel creation. In some African ethnicities, people used to live with art objects, passing them from generation to generation. We lived with them, at home. They are not "sacralized" and trapped in a

Meriem Berrada

specific place. That is why the debate about restitution of cultural property is necessary. In the future, I think more initiatives will pop up all over Africa. The spotlights will be on Africa. But it could be a mess if we don't do it properly, with a clear vision.

What do the terms "colonialism" and "post-colonialism" mean for you, and what does "globalization" mean in this context?
Colonialism and post-colonialism are the data I work with every day. Not that I am not willing to focus on this, but it is part of our history—a canvas. It's just part of the fabric. I understand that people have strong political ideas about colonization and post-colonialism, and it is primordial to research and to understanding what came as a "cultural earthquake." Globalization is a fact as well. As with all facts, we have to understand it, to deconstruct it, to apply different gazes to it, and research and question it constantly—and then challenge the narrative that has been dominant for years.

You have developed innovative units for your museum, which may be references for a more pluralistic future for museums. Tell me about the Lab and the Bootcamp.
I built these programs on the ground, organically. There was no road map. The idea behind the Bootcamp was to address the needs and aspirations of cultural operators in the contemporary art sector in Africa—managers, communications specialists, and so on. I wanted to create a task force of work-ready professionals who are connected to a network of leaders. Nurturing local talent is essential. So I invited mentors with a well-established reputation in the sector, such as Marie-Cécile Zinsou and Koyo Kouoh. I wanted this to be our project, with a common voice to transmit the best practices to the next generation.

The MACAAL Bootcamp was inspired by the training I had in cultural management in Paris, but it was mainly based on my everyday practice. We did master classes, conversations, and workshops. We had thirteen mentors from Africa. I invited a top trainer consultant from McKinsey & Company, who used to coach public figures, to facilitate a workshop on leadership. The idea was to mix all of these experiences in an immersive four-day workshop in Marrakesh. It was a huge success. We have built a

"promotion spirit," keeping contact with the mentees, and sharing open calls, job applications, and exchanging ideas. So here, the museum is functioning as a place of training and education.

The MACAAL Lab is an experimental space to raise awareness about contemporary artistic practices: video, installation, sound. We dedicated a room of the museum to investing in the work of contemporary African artists. We work with the artists and local schools and universities, and we design workshops that last two to four days. The Lab is a space to experiment with different new practices of contemporary art, to raise awareness, and to have a more direct contact with artists.

You already alluded to ICOM's attempted new definition of the museum, which emphasizes the museum's social role. What programs are you doing to engage the community?
About the ICOM definition—I think this addition was very important. In our case, we cannot replace the school or other learning spaces. The museum can be a real alternative—of course, only if it is accessible, inclusive, and secular. I am totally in agreement with this new definition of ICOM. I believe the communities involved with a museum should definitely participate in its narrative.

At MACAAL, we see ourselves as a home, a living place. One example, and our flagship action in this regard, is our Friday couscous series. Couscous is shared every Friday in every Moroccan family. So once a month we host a Couscous and Art program, where we invite about forty people, mixing together different communities—artists, curators, construction workers—to share a couscous at the museum. Before doing so, we present the current exhibitions in the Moroccan dialect, and encourage our guests to react to the artworks. We end the visit in the garden, where we serve lunch. We believe art is meant to be shared with everyone, just like Moroccan couscous.

When we were planning our conversation, you suggested "lowering barriers" as a subject to explore in detail. What does "lowering barriers" mean to you?
It is a permanent concern. It echoes through my whole practice. It is about the choice of artworks. It is about deconstructing

Meriem Berrada

complex artistic concepts for the audience and the team. And lowering barriers is first and foremost about supporting artists and their production, allowing emerging artists to find and meet their audience, and putting them in contact with experts. For collectors, you have to lower barriers and share knowledge about a medium such as photography. *Why this medium? Why is there value, even if it is sold in multiple editions?* And of course, the Bootcamp is about lowering barriers to the profession, by inviting mentors and role models who can give this new generation access to networks and expertise.

What other policies have you put in place that successfully lowered barriers to entry?
We have to instill the habit of museum-going among our visitors. We have taken the gamble that the so-called remote public, even people with little interest in contemporary art, will discover this habit through free and festive occasions—a tea break, a yoga session, etc. We have been working to create a perception of the museum as a space of gathering for the community. Once people see the museum as that kind of place, they are more likely to come. I want this to be a place of social mixology. This is not easy, because in this country we cohabit, we coexist, but we don't mix properly. The museum is one of the few places where we can achieve this social mixing.

For your generation, technology is a fact of life. Is there a particular way that technology is helping you in this effort?
Not really. Technology is not our main focus. For the first years of the museum, I deliberately chose to focus on human connections, to install the museum in the local context. Our main target groups are those people who don't have the required equipment or the technological consumption pattern. The technology will come later on.

I know you must have been thinking a lot about architecture. But sometimes imposing architecture can also raise barriers.
Definitely. Our museum is faithful to Moroccan architecture, especially the architecture of Marrakesh. It can be intimidating in terms of its dimension, however. The main issue we have

at MACAAL is not the building itself. We are situated in a golf resort, so there is a strong physical barrier to visitation. Yet if we didn't have this place, we would not exist at all.

The first version of the museum was very big and expensive, so we had to downscale. In the end, I was happy with this shift, because while a huge building with a famous architect is helpful for international communication, when you work locally and want to get people to come to the museum, it can be a nightmare. Yes, architecture can be symbolically intimidating. For the kind of museum I want, the architecture has to be more organic.

Lowering barriers, from everything you have said, is about changing the relationship of the institution and its audience to something more coequal. What do museums need to unlearn to achieve that?
All the protocols. The whole model. We need more flexibility in our daily practice. Museums need to be more aware of what is going in their environment. They have to work with different disciplines, not only art experts. Other professionals can bring different points of view. Overall, I think the museum has to be more open—open to the public, open to the diversity of the visitors, and of course, more open in its management approach.

You have had the rare opportunity to develop a new institution— and you are not done yet. Even so, is there a dream project you would like to do?
I would further develop the MACAAL Bootcamp project. I am pretty sure it is necessary for the whole continent. I would love to engage more in education and art management. To raise awareness, you need to have leaders in front of you. You need to exchange ideas and learn from one another.

Finally, let's assume everything works out and your generation does its job, and museums proliferate across Africa. How could you tell you have succeeded?
We will have succeeded if we can measure the impact on the audience. If we can just go randomly on the street and ask people if they know our artists and discover that they do. The other sign would be publications. We have to research and compile what

Meriem Berrada

constitutes our art history. It didn't start with colonization; it started much earlier. We have to write this history. Because in Morocco, we do not have a book about our own art history. And Africa is not a country, it is not homogenous; West Africa is not the same as South Africa and North Africa. We come from different realities. It is very important that we know where we are coming from, because we have a rich culture. It is our duty to archive, to write and rewrite this history. We can do this all together, if we work together.

ANTON BELOV
Director, Garage Museum of Contemporary Art
Moscow, Russia

THIS IS A PLACE FOR YOU AND YOUR FRIENDS

My favorite memory of Anton Belov involves a long and elaborate dinner at a Russian restaurant in New York, where he regaled me with his life story. It did not at first suggest that he would end up running the leading contemporary art institution in Russia. A graduate of the Moscow Institute of Steel and Alloys, with a degree in the physics and chemistry of processes and materials, Belov, who was born in 1983, ran a small nonprofit gallery and launched a bilingual magazine before finding his way to the Garage Museum of Contemporary Art, a private institution founded by Dasha Zhukova and Roman Abramovich where he has been director since 2010. An avid beekeeper who loves to travel around Japan, Belov brings a scientist's penchant for experimentation and distrust of established paradigms to the Garage. He has spearheaded the institution's growth into a sprawling multi-building campus set around a public park, where the conventions of museum life are daily put to a test.

ANDRÁS SZÁNTÓ *We are talking on Blackout Tuesday (June 2, 2020). The art world has gone dark in solidarity with Black Lives Matter. How are you experiencing this moment from your closed museum in Moscow?*

ANTON BELOV We are supportive in many ways, because here in Russia we still have this legacy of feeling a brotherhood with people. And I think such discussions should be sustained. They should be part of the program, not only today but over a longer period of time. At Garage, we usually take up one big issue each year. Last year, it was migrants. We ran a huge program inside and outside the museum exploring how we feel about them, why they are stigmatized. This year, we are working on HIV, with lectures and group sessions involving different teams and the Garage staff.

Your journey into museums has not been typical. What was the path that led you here?

I started out studying science. I tried to do a PhD in high-temperature materials. It was about nanotechnology. At the same time, I was really interested in art and young artists. I was the editor of a student newspaper and I organized competitions for young photographers. When I realized that nobody was interested in my PhD in Russia, I started doing more in the art field. At that moment there were a lot of projects in Moscow that didn't pay any money, but they might give you two thousand square meters and make you the manager. I figured out how to do lighting, how to work with architects, how to organize exhibitions. I became friends with a lot of artists and gallerists. We started doing crazy projects. A friend invited me to talk to the founders of Garage. They felt my vision matched their ideas for creating something new. For many people, I was too young at the time—in 2010 I was just twenty-seven years old. But Dasha Zhukova was young, too. It was more about the vision of the institution and how we needed to develop it for the future.

You have had the rare thrill of inventing a museum from scratch. What were your models and inspirations? How did you go about conceiving something future-facing?

I started with research about existing institutions. The problem was that most of them were not very good models. American-type

institutions were working really hard to get money. European institutions were working hard to attract tourists. Asian ones were younger, self-absorbed, run by private individuals. I was interested in unusual hybrid models. I liked the New Museum, in New York, because it is not really based on the collection; I find them energetic. I liked Fondation Beyeler, in Basel, and how it is located in a park, how they communicate, and how they do shows. I liked the Schaulager, also in Basel, with its unorthodox collection. I looked at projects such as Naoshima Island in Japan and Inhotim Museum in Brazil.

Garage was always meant to be a center for contemporary culture. I was thinking about how to create this kind of multidisciplinary, educational, research-based, visionary institution. We started with a small team of fifteen people. Now we have four hundred and fifty. It became like a huge 3-D model as we kept adding more pieces. You can never stop. You constantly need to update and grow.

You were inventing the museum. But what is a "museum" for you?
That was always the question for me. What is a museum? The classical idea is about collecting, preserving, and exhibiting. But who decides what to collect, what to preserve, what to show, and how? I was always fighting the idea of the museum as a kind of pyramid, with the director and curators at the top and then going down to the ground, where the visitors receive what all these expert people have decided to show. I didn't agree with this idea. Why are they deciding for me?

I was dreaming of a child who could come into the museum, choose some objects, and come back in a few weeks to find a special room with his things. And he could show them to his mom and dad, his friends, girlfriend or boyfriend, and say, "I am the curator of this, and I want you to learn more about it." Maybe the museum could become a counterpart, an expert with a huge database. It would not be talking down to you, pedagogically, in this paternal style, but be more like a close friend with good experience and knowledge. Like, "Hi, brother, or sister, let us show you something, and if you need help, we'll help you. This is a place for you and your friends."

From the beginning, Garage had a broad social agenda. Its lack of
a collection freed it up to be many things to many people. What is
a museum's most important contribution to society?
The museum can help psychologically in this time of self-
isolation. This is something a museum should be prepared to do.
In Russia, we were the first museum that closed. I said, okay, the
guys in the Web department—the youngest in the museum—are
now the kings; they will make decisions about what and how
to communicate with the audience. All museums went online:
Zoom, livestreams, Instagram. It became a nightmare. You can't
have ten Zoom meetings a day. You can't eat that many cakes,
even if you love sweets.

So the question arose: *How can we provide real physical*
support? We talked to artists, locals, and hospitals. We under-
stood that a lot of people didn't have access to food. Old people
couldn't go out to get food. At hospitals, doctors who worked
for more than twelve hours didn't have time for a hot lunch. So
we decided that it could be our role to reorganize our kitchen
and café to prepare boxed food and hot lunches and deliver it to
them. That became our job. Now we were supporting artists who
didn't have food and locals who lived near the museum.

Another pandemic project was called Reflections. Philos-
ophers, artists, and writers didn't have money because their
projects had been postponed or cancelled. So we decided to offer
a fee for their writing, and then we invited artists to respond with
videos, sketches, and performances—all of them receiving a fee,
too. This was another case of how an institution can work to sup-
port society. We need to be there for artists, writers, doctors across
the street, families with children, unemployed or older people.

This social orientation is still new for a museum. It was percolat-
ing in the field before Covid. To function this way, you have to let
go of some old habits. Which reflexes need to be switched off?
Museums need to stop being so high-minded. A lot of people still
believe a museum is a temple, even when they advocate for muse-
ums being democratic, accessible, and inclusive. In the end, they
still behave like a temple.

Instead of a temple, a museum should be more like a mo-
nastery, if we were to continue the religious metaphor. Part of

Anton Belov

the point of a monastery is to work on science, research, the archive, exploring deep questions. But many monasteries also became hospitals and schools during past wars and pandemics. They protect people. Museums, too, should think of themselves as monasteries, devoted to this strange thing called art that is so hard for many people to understand, yet also being something horizontal, brotherly, always looking to support the society.

Apart from monasteries, what other types of businesses or institutions do you look at to formulate a vision for your institution?
The problem is that museums are always looking at other museums. When we built our office, I looked at Pixar. They installed a big café in the middle of their office, so on their way to lunch employees would meet people from at least three other departments and start thinking about projects. I also looked at how German car companies organized their work process.

I always try to learn how things work outside the museum field. When it comes to marketing, I looked at Red Bull and saw how they built their brand. I learned a lot from the start-up economy. When approaching the issue of inclusion, we established a structure similar to that used by cities, which work with experts on different inclusion topics. This helped us understand the ideal approach and apply that to the museum.

So if museums succeed in innovating the model, how will tomorrow's institutions be different?
Before the pandemic, many countries wanted to build museums that could amaze you. Starchitects, borrowed collections from the Louvre—major tourist attractions. However, when we think about the museums we actually love, they are usually not the ones that amaze us. Most of them are human-size. They talk to you. They have a story. They are strange. They open into new fields. Usually, they are connected to local themes, but they still speak a global language.

The future of museums will not be about crazy expectations of something amazing. The most interesting museums will be local institutions with a sense of genuine identity, connected to society, providing an experience of how a society lives, how it

connects to nature and the stories of individual people. These are the experiences you really want to have.

In Russia, as in the rest of Europe, it was popular in the nineteenth century to send young people on a grand tour. This is what museums should still be about—having an experience of life as it is lived in various cultural contexts.

Let's talk about some things we didn't really see coming. What are your concerns about politics and new threats, such as climate change and pandemics?

When it comes to museums, we should always think long-range—then the conversation becomes more interesting. A short-term future is not for a museum. We should think about eternity.

People forget pandemics quickly. Nationalism? Well, much of history is about big leaders who brought their societies war and ruin. There is no ideal system. You will never see a perfect political or economic situation. No matter what is going on in a country or a city, a museum can give you some shelter in the storm. Museums shouldn't try to react and adapt quickly to the politics of the moment.

We first met in New York during the Global Museum Leaders Colloquium at the Metropolitan Museum of Art. Every director made a presentation about their museum. You chose to speak about the museum as a campus. Why?

Because I was at the Met. And the Met looks like a giant castle. I was thinking about what the future of the museum should be. Many directors and trustees believe that the museum is like a shopping mall, always growing. The more space, the more shops, the more people, the more you can do. More exhibition halls mean more shows, and that means you can hire more people, make separate departments, and so on. However, I was always worrying about sustainability. Not just ecological or financial viability, but institutional sustainability. And about maintaining a human scale.

I remember my first visit to Fondation Beyeler, sitting on a sofa, seeing someone on a tractor working the fields behind the museum. And there was a mountain, and the sun was setting. And I remember thinking, *This is a small, human-size institution, where I can spend an hour looking at art and then go have lunch*

under an umbrella in the garden, and then maybe buy something at the shop. For me, it was much more satisfying than a huge institution.

At Garage, we don't want one building that is always growing. We want all of our buildings to be human-scaled. And the spaces between the buildings are as important as what is inside. Many of our programs are connected to the park around us: sculpture, summer cinema, space to sit outside. During our meeting at the Met, I decided that the most interesting thing to talk about would be the differences between Garage and the Met and our approach to space.

Behind all this is a certain idea of the museum as a place, as something more than a building. There are certain values embedded in the museum as campus. What exactly are you aiming for?
That is a difficult question. What should be at the center of the museum is always the person. It is not about the building. At Garage, the museum starts with you. It is really about the person and the experience of connecting to contemporary culture— whether it is the architecture, the playground, cinema, programs, communication style, or interactions with the staff. These small things help you to feel that you are in a friendly organization. I really believe that size matters. When you feel lost in a building, then you feel the institution is bigger than you.

What in the end is the value added in the campus concept? How does the whole add up to more than its parts?
People feel part of a campus. It feels like a community. The city becomes the campus for the museum, and the museum becomes a campus for the city. In a campus, people can feel part of a society. Corporations have tried to build campuses, but what they often end up with is a fake campus. They tend to make the same mistakes. Each element of the campus should have its own unique aspect. Different people should be responsible for different parts. You should have many different experiences in different areas. It should be the same overall idea, but always realized in a different form.

A person inside a big building never feels this intimate sense of connection. In the human-scaled campus and museum,

visitors become part of the experience. This is ultimately what's at stake. People will associate themselves with the model if they feel that they are a part of it. I really believe that in such a human-scaled campus, it is easier to feel yourself as part of a family, and as part of society, than in a monolithic building.

It is about agency. You define this experience. It's not just happening to you. You're writing your own story.
It's not happening without you. Without you, this doesn't work. And for many people, this is something special.

It reminds me of Marshall McLuhan's theory about hot media and cool media. Cool media demand greater participation because they have less information. You have to complete the experience in your mind, with your own imagination.
I like it. And I agree with it. I use Marshall McLuhan's statements a lot. You know, we built a huge playground between our buildings. It is beautiful. But it is always so dead when there are no children, at night. When it is full of people, it's alive. This is true for the whole campus. It only really has meaning when people are there, filling it with life.

So with all that in mind, what will surprise us the most about the museum of the future?
That it will look like a Soviet-type science institute. It will be open to everybody who wants to do research. The Soviet science institute was a crazy model. Thousands of people would work there on strange and unbelievable ideas, and the government covered everything. This is what we need for our museums. It's not about quick results and beautiful exhibitions. It is more about research on how to unpack things. About deep thinking and things that can help us in our understanding.

For example, it was always a dream for the Soviets that in the future everybody should be healthy. You would never die from an illness. You could do research about subjects like that in those institutes, or about other galaxies, all your life. And you would enjoy this, because you did not need to fight for money or have to deal with social problems. The idea was that you

Anton Belov

could just enjoy the experience of pure research. And I think this should be the case for the museum of the future.

Do you have any unrealized dreams that embody these hopes and aspirations?
I am always dreaming that museums could become much more open. I am always thinking about how to make this model more accessible. I see people inside museums who aspire to give you information, who connect with you, and who dream with you. I am always thinking about how to make all of the museum like this.

You have grown an organization from fifteen people to four hundred and fifty. You still have a long time ahead in this field. What will keep you interested in museums? What will fuel your appetite?
That is always the big question—for any person. For me, the answer is this: if I can continue to have new ideas and projects, and I still see ways to upgrade the institution or change it for the better, then I will still be here. However, as soon as I realize that I cannot bring anything new to the table anymore, then I definitely need to change and go into some other industry, like biotechnology or rocket science, where I can be interested and energized again. As soon as I feel I'm done with the Garage, I will hand over the job to somebody else and move forward to another field, where I can be young, unknown, and inspired once again to do crazy things.

Back to the future.
Of course.

MARION ACKERMANN
Director General, Staatliche Kunstsammlungen
Dresden (SKD)
Dresden, Germany

YOU HAVE TO INVENT
NEW FORMS OF LANGUAGE

For Marion Ackermann and the Staatliche Kunstsammlungen Dresden, 2020 started in crisis mode, shortly after the brazen heist of royal jewels from the iconic Green Vault, Europe's largest treasure collection, founded in 1560. It was one chapter in a long history that has seen its share of splendor and tragedy. The fifteen SKD institutions are housed in a complex of palaces that together contain millions of objects and include museums devoted to history, ethnography, folk art, scientific instruments, Old Master paintings, sculptures, numismatics, porcelain, applied arts, and contemporary art, along with an armory and several notable archives and libraries. Marion Ackermann has brought a contemporary art specialist's present-facing perspective to the institutions under her care. She came to Dresden having curated dozens of exhibitions by renowned living artists and having directed two German museums. I have always been struck by her forthrightness in acknowledging the social and political tensions surrounding art institutions today, and insisting on the museum's obligation to respond.

ANDRÁS SZÁNTÓ *For most museums, 2020 has been a time of crisis. For you, 2019 may have been worse.*

MARION ACKERMANN Our first big crisis was the theft in the Green Vault. It was done by professionals. They seem to have prepared for a long time, and perhaps they had inside knowledge, which is traumatizing. The second crisis was Covid-19, which is also, of course, an economic crisis.

And now we have to contend with another crisis: the loss of trust in public institutions. We have to prove our relevance again and again. That is our next crisis.

You were born into a family of academics. How did you end up in a life of art?

When I was two, both my mother and my father applied for the German Academic Exchange Service (DAAD). They were offered Ankara. It was 1967. My parents wanted to break out of a narrow system in the Western male-dominated society. It was a liberal time in Turkey. It was totally normal that my mother brought us children along into the university when she gave lectures. During holidays we went around the country looking for archaeological sites. This was the first source of my passion for art, archaeology, and culture.

I began my studies at the art academy, which was an advantage, as I learned graphics and painting techniques. But I had doubts about becoming an artist and switched to literature. In 1986, I went to Vienna, and that was the most important year for me. Every night for a year, I went to the Burgtheater, where Claus Peymann had opened up the theater to young people. It was a politically intense time. Kurt Waldheim had just become president, and questions arose about his complicity in war crimes. Peymann was an activist. After each performance he put bottles of wine on the floor, and we would sit there and drink and talk with the actors.

Meanwhile, I had my first museum job, working as a guide and developing programs for migrant children. Those kids came from countries all over the world and were not fluent in German. Drawings helped me to communicate with them. Transforming art into different layers and shades of language and bringing it to people was fascinating. To this day, my main tool as a museum director is language.

Marion Ackermann

You began as a curator at the Lehnbachhaus, in Munich. By age thirty-eight, you were the youngest director of a major German museum, the Kunstmuseum Stuttgart. Then, after running the Kunstsammlung Nordrhein-Westfalen, in Düsseldorf, you took over one of Germany's largest museum complexes. In Dresden, you oversee a diverse group of institutions. Can you bring one philosophy to bear on them?

Most of the Dresden collections come out of one region, Saxony, originating from the sixteenth-century *Kunstkammer*. It was not only about collecting art or objects from other continents, and this was revolutionary at the time. The collections also included scientific instruments. Objects were produced at court. The prince had a studio where he worked on ivory and other materials. He produced scientific instruments with artisans, while conducting research.

This combination of the production of knowledge and objects along with artworks was special. It guides us today. It means museums can offer a complex perspective on our world. Each year, we develop a major theme out of our collections. The lead question this year, which we proposed before the coronavirus, has been: *what is human?* And for next year this will be: *loneliness and empathy.*

What are your models for bringing the most out of these eclectic collections?

I have different models that have been important since the beginning of my career. The Centre Pompidou is a model for the museum as a machine, with the library at the heart of the building, open twenty-four hours a day; an institution hosting many sub-institutions, with public space outside. Another reference is the Reina Sofía, in Madrid, which combines iconic artworks and archives so big, you cannot come to their end—so many possibilities.

Interesting you should mention the Centre Pompidou. For this generation, it really defined the possibilities of the museum.

I would totally agree. I remember seeing it for the first time. It was overwhelming as a concept. In later years, as I traveled around the world, I saw other models, like Lina Bo Bardi's glass-easel gallery

at MASP, in São Paulo, and museums engaged with the community. At the Museum of Modern Art of Bahia, in Salvador de Bahia, when they had a financial crisis and had no money to pay guards, the curator and director sat inside the exhibition spaces, so they could talk to the visitors—which is a wonderful idea.

The Apartheid Museum in Johannesburg, South Africa, is another fascinating model for how to sensitize people through different models of curation. Your ticket tells you if you are "White" or "Black." Then you enter through different entrances while getting a completely different experience. This had a huge impact on me. I also like the Louisiana Museum of Modern Art, near Copenhagen, in Denmark, with its own TV station. The smaller the institution, the more radical it can be.

How would you define a "museum," if you had to sum it up briefly?
We speak metaphorically a lot about a "museum without walls," but I always imagine buildings and a space when thinking about museums. That feeling of entering a building is important. The atmosphere changes. You get involved in something different, comparable and at the same time also not comparable to a church. Museums are social spaces and public places of communication. And once you are inside, there is a certain freedom. Museums are politically neutral, open platforms, but once you enter you are in a space charged with its own history—which makes it, of course, not neutral at all. You meet people. You can activate your thinking. And when you leave, in a way you have changed. *Something happened to you.* This is a must for a museum.

I understand that sense of personal transformation. What about the museum's larger contribution to society?
First, it's about cultural heritage. You have to secure it. And second, you are obliged to make it accessible. This is fundamental. Our colleague and friend from the Hermitage Museum, Mikhail Piotrovsky, spoke about the "double guarantee"—the state has to guarantee that the museum is able to fulfill its mission and preserve the heritage, and the museum has to guarantee that the works remain accessible to everybody. And of course, we can help people define their "identities." For me personally, it is also important that museums inspire artistic production—not just by

Marion Ackermann

collecting, but by giving artists inspiration and budget to create new work.

In Germany, massive government support has been directed to the cultural sector in the wake of Covid-19. Nonetheless, as you mentioned, you still have to prove your relevance. How do you make the case?

That is a fundamental challenge. In former times, people had a deep understanding of museums. Now this is changing. Many people don't read newspapers anymore. We have to use tools like Twitter, Instagram, and Facebook. It seems impossible to me, though, to combine social media with poetic language and nuanced speech. We are, in a way, losing our language as our main tool. Proving relevance means engaging with complex issues.

Part of the challenge is bringing generations together. Also, for many people, modern and contemporary art can seem unapproachable, incomprehensible, and elitist. We successfully resolved both aspects during our Children's Biennale, in cooperation with Eugene Tan of the National Gallery Singapore. Of the one hundred thousand children who visited their Children's Biennale, 15 percent came with their parents and grandparents to look at international Conceptual Art, performance, and video. They loved it. Through the eyes of children, it was possible to reach many people. It was emotional. Perhaps we can use such experimental forms to demonstrate our relevance.

We both graduated from college as the Cold War ended. Our generation built a new world, for better or worse. Dresden is in the eastern part of Germany. In this context, what has been your main challenge?

Thirty years after reunification, you can still feel the differences, even in the youngest generations. We are separated by our experiences. Many colleagues who grew up in the eastern part of Germany still earn less. It is harder to get jobs. There is much injustice.

The injustice extends to the canon. Artists from the East remain largely unknown to the western-dominated art history. We just did an exhibition of Christa Petroff-Bohne, a great designer of the 1950s and 1960s. We are collecting works by Else Gabriel, the

performance artist, and Ruth Wolf-Rehfeldt, who did visual poetry and mail art in the GDR times. She stopped working as an artist in November 1989 because it wasn't necessary anymore. She is still living and she has a beautiful archive. But these artists are still not part of the official canon.

This brings us to our topic of museums and political power, which has two dimensions: how museums relate to political power, and the political power of museums themselves. What is your perspective?

The pandemic gave institutions a new experience of dealing with public authorities. It was unusual for us to be told to close down from one day to the next. In some parts of the world already-existing surveillance systems were made even more efficient. Normally, we are proud of our autonomy. We will have to redefine our civic role under these circumstances.

On the other hand, we have significant political power of our own. We have influence in the international community. With the rise of right-wing populism around the world, museums have to stop just thinking about the next blockbuster exhibition. Since Covid, this international cohesion has become more intense. I have Zoom conferences with colleagues now in Abu Dhabi, Iran, Georgia. They are so easygoing—no protocol, no hierarchies. There is a feeling of solidarity. Together, we have great power. And because we are still quite autonomous, we can do exhibitions with critical content. We can start and stop ethical debates. We can sensitize people and engage in activism. For example, when there are right-wing attacks on people in other countries, we can react and generate a strong public response. That is a form of political power that many politicians and extremists fear. And we won't let restrictive politics stop us from carrying out our joint projects under the radar of official politics.

Some people believe museums must take a stand. Others believe museums should be a refuge, a shelter from the storm. How do you balance these impulses?

It was my impression that in the 1960s and '70s museum directors and artists were often active party members. Joseph Beuys, for example, was involved in starting the Green Party in Germany. It

went out of fashion for artists and museum professionals to take a public role in the political-party system. But if there are anti-democratic tendencies in your country, racist attacks against your employees or ostracized artists, you have to react immediately. You must take a strong stand in an important moment, even if it means taking personal risks.

On the other hand, I do like the idea that a museum could be a place where you can hide, in a way, and be protected and relaxed, opening your mind and meeting other people, but at the same time also being confronted with clear positions—and I believe that those positions can be transmitted through art in ways that are elegant, subtle, and effective.

In the US, some institutions are coming under attack for not taking on positions that are strong enough. This is new, because museums used to worry mainly about criticism from the right.
Museums are being attacked from the left and from the right. They have to prove their relevance and find answers to criticism from both sides. It is very complicated. The only solution is what Beuys said—to be in a state of "permanent conference," constantly evaluating and discussing what you are doing in an ongoing form of self-reflection, and in connection with all parts of society.

These recent attacks on the museum are part of an aggression against something that you in Eastern Europe used to call the *intelligentsia*. In the Czech Republic, former communists and right-wing movements converge on this point: they denounce what they describe as "elite" institutions. What does that mean for us? We can have a big research agenda, we can offer knowledge and wisdom, we can have intellectual debates and stimulate new thinking. But when we are being described as elite, it is difficult to defend ourselves.

This is part of a larger story—the legitimacy crisis that afflicts many institutions today.
It's interesting to compare us to libraries. Libraries are not attacked this way. In Germany, libraries are the place where the diversity of society, including migrants, is visible. They are vibrant and open social places. By contrast, many museums have this heavy burden of being national institutions. They have this archi-

tecture full of symbolic representations of power. They don't have the same openness and transparency. We have to carry this weight with us. It makes the job difficult.

Germany has had its share of political extremism recently. What are you doing in Dresden to address it?
Public discussions work very well. Especially in the younger generations, we see rising xenophobia, particularly against Islam. As museums, we can react in different ways. One is a form of provocation. The installation of contemporary artist Manaf Halbouni, with three buses in front of the Frauenkirche, in the heart of Dresden, was a hint that it was not only Dresden that has been bombed and destroyed; so has Syria, in the past decade. This led to an explosion of discussion in the city.

The other response is more subtle. It consists of programs about transcultural processes. For example, our Turkish galleries feature weapons from the Ottoman period acquired by Augustus III of Poland—not stolen but collected, paid for, because he was obsessed with their beauty. And these objects are presented in the context of Saxon handicraft. You can also discover the Ottoman influence, for example, in porcelain. When people understand this process of cultural exchange, it opens their minds.

As we speak, museums are being criticized as symbols of a society that tolerates inequity, and as institutions that have benefited, directly or indirectly, from colonialism. What to do?
We have a deep obligation, first, to tell the stories. Until now there existed too many "untold stories"—for example, about human remains. People were killed in Australia, New Zealand, and Hawaii, and the bodies were sold in London and then purchased by collectors. This story is mostly unknown. I would like to do a project about it, telling the story without objects, of course, because you cannot exhibit human remains.

Then, we have to finalize many restitutions. We have started to restitute many works each year. The third step is to make people more aware of our collections—we are often attacked for not being transparent enough. But we have, for example, in our ethnographic collections many pictures and nude portraits of people who were photographed without consent, so we have decided not

Marion Ackermann

to publish these on the Internet. Next, we have to explain to a broader audience the complex history behind contested objects. Take Benin. It takes months to understand the complexity of this history.

The largest question of all is: *How do you overcome Eurocentrism?* A nice answer came from my friend Nana Oforiatta Ayim, a writer and art historian in Ghana, who told me, "Learn our languages; then you can overcome Eurocentrism."

Can a state-run institution separate itself from politics?
Yes, especially in Germany. We have a long tradition in which the state has an obligation to support cultural institutions and guarantee the freedom of culture. That is in our constitution. We have now had seventy years of this balance of state funding and autonomy. But it is a daily struggle, a daily balancing act, to explain to new generations of politicians what this means. In dictatorships, art is instrumentalized—that's why the guarantee of freedom for art is so important.

However, it is also good to have some financial independence and not be exclusively funded by the state. Max Hollein, when he was still at the Städel in Frankfurt, told me we're like lion tamers: we balance our multiple sources of support, and in the middle we find a small space of freedom. This is, by the way, why I am against fully free admission—at least for the entire museum. We need some earned income to help maintain our independence from the state and private sponsors.

So what do you imagine museums might look like by the end of this century?
As our mutual friend in Moscow Anton Belov anticipated with the Garage concept, gardens and nature around the museum will be much more important. Museums will not just be buildings isolated from other buildings. They will be parts of large open spaces, fully integrated into nature. Museums can also be cities inside cities, as Rem Koolhaas suggested years ago, looking at Asian and Middle Eastern countries. The museum becomes a safe place and a haven for people to do things that are different from their experiences in daily life. We could go further down that road.

Do you have any dream projects, if money were no object?
I am dreaming of intense solidarity with our international colleagues. We tried to install a co-directorship with an institution in Ghana, to share and give away power and to deeply question the concept of our ethnographical collections. I did this with Eugene Tan in Singapore, co-curating and changing our institutions through learning from each other. But we can go further: we can be inventive and creative together.

I wrote my PhD thesis on Wassily Kandinsky, who said he wanted to communicate through his art in a universal language that is more effective than Esperanto. I dream of finding ways to go beyond physical conflicts, to create an international community of humans, so we can be open and curious about one another, creating something together that has impact—to make the world a little better.

You really are a dreamer. This future presupposes a more horizontal, collaborative, humble museum. What qualities are needed from museum directors to deliver this future?
You need courage to take a stand. You need empathy. You have to be aware of all forms of injustice and find ways to react. Even small gestures matter. During the pandemic, when old people couldn't leave their homes, four hundred of our employees wrote postcards with art from our collections and personal wishes. We sent out ten thousand postcards.

You need to be flexible. You need to manage change at high speed, which is incredibly hard. You need to accept that plans will be confronted by volatility, and use this volatility as a creative tool. For example, I fear that many newspapers and magazines will not survive. So perhaps we have to do what the Louisiana Museum did and build our own TV or radio station, to disseminate our own content in a poetic form. You have to invent new forms of language.

For all this, you need creativity. So many things don't exist yet. You have to anticipate them and be highly creative in imagining how they can happen. And then take decisions, even if you are not sure.

Marion Ackermann

HANS ULRICH OBRIST
Artistic Director, Serpentine Galleries
London, United Kingdom

GENEROSITY IS THE MEDIUM EVERY MUSEUM SHOULD HAVE AT ITS CORE

A ubiquitous presence in the art world, Hans Ulrich Obrist is renowned for instigating projects and forging links. He likes to start his day by making at least one "urgent connection" via email—ideally between people from different disciplines. Another morning ritual involves reading the French-Caribbean theorist Édouard Glissant, who embodies the prolific Swiss curator's belief that immersion in diverse imaginations can shape new realities and change the world. Obrist, who was born in 1968 and now serves as artistic director of the Serpentine, in London, relishes delving into seldom-explored scenes. One of our collaborations involved icons of the Hungarian neo-avant-garde. Another was a series of joint interviews with the philosopher and critic Arthur C. Danto. Over the years we have connected around eclectic interests, from moving-image art to scientific networks to László Moholy-Nagy. Ever-hungry for new information and encounters, Obrist has shaped a generation's perceptions of curating and museums in a globally expanded artistic field.

ANDRÁS SZÁNTÓ *Everybody knows you as a curator, writer, project launcher, yet you are a museum person. You made an imaginary postcard museum when you were twelve. You were the "migratory curator" of the Musée d'Art Moderne de la Ville de Paris. You have been with the Serpentine since 2006. You are, famously, an inveterate interviewer. I may use your questions. Let's start with: Who were your influences when it comes to museums?*

HANS ULRICH OBRIST I had two mentors from the museum field: Kasper König, at the Städelschule in Frankfurt, and Suzanne Pagé, at the Musée d'Art Moderne de la Ville de Paris. I formally started to work with institutions at the beginning of the 1990s, when Kasper asked me to edit a book on public arts, *The Public View*. That's how I learned to do a catalogue. He was asked by the Vienna Festival to do a painting survey exhibition, *The Broken Mirror*, and I became his co-curator. At the time, people talked about exhibition makers—*Ausstellungsmacher*. I became one by working with him.

At more or less the same time, Suzanne Pagé heard rumors about this young kid from Switzerland who made a lot of studio visits. She was working on a Giacometti show. I explained to her that I became obsessed with art because of Giacometti. I was eleven when we went with my parents to the Kunsthaus Zürich and I saw those long, thin figures. Every Wednesday after school, I would take a train to Zürich and spend time with these sculptures. That prompted the imaginary museum with postcards. Suzanne had the idea, in 1991, that I could still interview people who had met Giacometti: Roberto Matta, Henri Cartier-Bresson, Balthus, Ernest Mancoba, etc. I entered the museum through that bridge between history and the contemporary. Two years later, she hired me as the migratory curator, who migrates between worlds—an unusual job title.

In my trajectory as a museum person, I never had a role that had existed before. In Paris, I started a very-young-emerging-artist program, and we decided it could migrate—the art could appear anywhere. I was captivated by Robert Musil's idea that art can appear where we least expect it. Rirkrit Tiravanija invited visitors to make tea and coffee. Barthélémy Toguo issued passports. Koo Jeong A put stamps all over the museum. With Félix

González-Torres, we became florists for a day. He said that if every office has flowers, the museum will become a happier space.

All this contrasted with the then-existing idea of museums being devoted to high-minded pursuits. Were you consciously working against existing models?

I always wanted to come up with new models of museums as batteries of imagination, to understand how one can effect change and introduce new ideas. In St. Gallen, I found a book in a thrift store by the German art historian Alexander Dorner, *The Way Beyond "Art,"* with a preface by John Dewey. Dorner had run the Landesmuseum Hannover and emigrated to the US to flee the Nazis. I probably read this book fifty times. He was inspired by El Lissitzky and László Moholy-Nagy. He believed the museum was for experimentation, a laboratory for interdisciplinary shows, for displaying futures. I tried to implement Dorner's ideas. The early 1990s was a time when museums started to have larger audiences and blockbusters. Suzanne Pagé made me realize we can have it both ways—we can be experimental and get a lot of visitors.

The Dutch curator Willem Sandberg was another influence. Following Dorner, he made the Stedelijk Museum in Amsterdam a laboratory for experiments and a place for artists. He was part of the Dutch resistance, and he used the Stedelijk to save people during the Nazi occupation. He made me think about how museums can produce reality and share resources, which is so relevant in the current moment.

Another key influence, I know, was the French-Caribbean thinker Édouard Glissant, who shaped your thinking profoundly about a more polyphonic museum.

I am glad you bring that up. There is a direct connection from Sandberg to Glissant. Glissant believed in a museum that would not only point at urgencies but also find agency to respond to these urgencies. He imagined an institution that would not commodify archives, as museums often do, but would gather and nurture and support archives of the present. He imagined the museum as a quivering place that transcends established systems of thought and looks to the utopian point where all

the world's cultures and imaginations can meet and hear one another. This idea directly influenced the *Utopia Station* project, which Rirkrit and I curated with Molly Nesbit at the Venice Biennale in 2003.

Glissant has been certainly the most important influence in my life. He completely changed the way I think about exhibitions. I first read him in the early nineties. We were introduced by Agnès B., and he became a mentor. The 1990s was when extreme globalization was kicking in. That is why Glissant is so important. He realized early on that we have to resist the homogenizing forces of globalization. He foresaw the rise of forms of nationalism and localism that lack tolerance—which we need to resist as well. It's why he said we need *mondialité*, which fosters global dialogue and understanding, while being able to listen to the local. Glissant is also known for his notion of *Creolization*—the blend of languages and cultures. It created something totally new, which led to these cultural fusions. Shows like *Cities on the Move*, which we did with Hou Hanru in 1996, '97, '98, were based on Glissant's ideas.

Another of Glissant's concepts that became important to me was the *archipelago*. Big museums are like continents, in a way. The archipelago of his Antillean geography is, by contrast, an island group with no center—a string of islands and cultures. That notion can be directly applied to the museum. Shows can be conceived as archipelagos, self-organized, with exchanges between them. And this exchange doesn't dilute identity—it enriches identity. Archipelagos make it possible to say that no person's identity, and no collective identity, is fixed, once and for all. It changes through exchanges, but without being diluted. Today, in my conversation with you, I am changing, because I change and you change. But I'm not losing my identity. To the contrary, my identity is becoming richer through this exchange.

Glissant is my toolbox. I read him every morning for fifteen minutes. It is a systematic ritual I maintain. With his friend Frantz Fanon, he was convinced that we need to produce reality and change the world. And now comes the most important point. Big museums have, as Glissant told me, always tried to fashion a synthesis. But he said we don't need that. What we need is a network of interrelationships between traditions and perspec-

tives. That is an important lesson. A museum shouldn't be about the recapitulation of something that exists in an obvious way. It should be about the quest for something we don't know yet. Glissant wanted to bring some of the world's places into contact with other places. Or as he put it, his museum ideas were about "multiply[ing] the number of worlds inside museums." That is what the twenty-first-century museum should be about: *multiplying the number of worlds*.

And last but not least, in observing that the places in which exhibitions are traditionally presented are invisible to large sections of society, Glissant encouraged me to think about other forms of engagement and new models of exhibitions that are more mobile and can go to where the people are.

These concepts open up new possibilities for museums. What other principles define your view of museums?
Richard Hamilton once said that memorable exhibitions are always the ones that invent a new display feature or a new rule of the game. In 1995, I was invited by Julia Peyton-Jones to guest-curate an exhibition at the Serpentine. We came up with *Take Me (I'm Yours)*, which invented a new rule of the game: you could do everything you're usually not allowed to do in a museum. For example, every item could be touched or taken home. This idea has evolved since then and found a new life. The idea that exhibitions can evolve over time is interesting.

I have also always believed that we should be thinking about generosity when it comes to museums. Free admission is a form of generosity. Generosity can be about making an experience available to everyone. Generosity is the medium every museum should have at its core.

This allows us to pivot now to ecology. You have refocused the Serpentine around ecological awareness. Before Covid, you announced that you would reduce your travel. Where does ecology fit into the museum's agenda?
Several dimensions drive our work at the Serpentine. One is *dynamic memory*—we live in an age of more and more information, but that can also mean more amnesia. Rosemarie Trockel taught me all about a transgenerational dialogue. The museum

Hans Ulrich Olbrist

of the twenty-first century needs a more just, diverse, inclusive, polyphonic art history. This means major solo shows of artists who have been working for decades but have not always had the exhibitions they deserve. For example, last summer we did the first European museum shows of Luchita Hurtado and Faith Ringgold at the Serpentine.

Another dimension, at the opposite end of the range, is to *support emerging artists*—to enable their first bigger solo shows. I began this in Paris and it is a really important aspect of the Serpentine. We do artists' first museum shows in Europe. Take Sondra Perry. We worked with Sondra on a Park Night, our experimental program with young emerging artists, which happens every summer in the Serpentine Pavilion and often leads to a solo exhibition. Perry's show *Typhoon coming on* was committed to net neutrality and ideas about collective production and action. She said she was "interested in thinking about how Blackness shifts, morphs, and embodies technology to combat oppression and surveillance throughout the diaspora."

This leads to the dimension of *new experiments in art and technology*—a shared interest of yours and mine. We commission works with AR and VR and look with artists like Ian Cheng at the impact of artificial intelligence on society, asking questions such as: *What are the emerging relationships between humans and machines? Is the existential threat of AI real?*

The fourth dimension is *civic engagement*. We have a department for civic art, and we have opened a Serpentine office in the London borough of Barking and Dagenham, which has a very high unemployment rate and where many people have never visited a museum. We commission artists to work in the community. Our public art and pavilions literally take the doors of the museum away, so people can encounter art unexpectedly in the park and around the city, where we expect it the least.

So we come to the dimension of *ecology*. A few years ago, preparing for the Serpentine's fiftieth anniversary, we commissioned fifty artists to do *Back to Earth* campaigns in response to the climate emergency, in collaboration with partner organizations. These campaigns manifest themselves in the gallery's program on-site, off-site, and online.

Our concerns about ecology have only been amplified in the current crisis. One question Covid raises is what new resources, research, and collaborative practices are necessary to respond to our most urgent problems? A related question for museums is: *how can we slow down our programming?* It's important to go beyond exhibitions and events that simply switch ideas on and off—the show, and then the next show. This race, this pace, always on to the next show. We need to question that.

My obsession, going back to the 1990s, was always on slow programming. How can we rethink the impact of what we do? How can we reduce the ecological impact of our work? *Do it* has been going on for twenty-seven years. Maybe exhibitions can last longer and expand beyond the conventional limits of the museum show.

Ecology is a massive, systemic, worldwide problem. Can museums meaningfully impact these macro phenomena?
That is a great question, and exactly why we decided to do not only an exhibition but a campaign. One campaign we launched during the lockdown is a collaboration with Judy Chicago and Jane Fonda, *Artists for Earth*. Seven thousand artists created artworks to respond to the environmental crisis. As we go back to normal, we must realize that "normal" was the problem to begin with. As Fonda and Chicago reminded: "normal" is ice melting, extinct species, millions of climate refugees.

We have to be humble. It would be megalomaniacal to say that museums can solve the climate crisis. But we can hopefully make a contribution. And that has to do with alliances—not just with other museums, but with other organizations, ecological institutions, companies, and brands. Borders are the main obstacle to such alliances. Artists have always taught us to cross these borders. We have to go beyond the fear of pooling knowledge.

Which brings us to the last dimension I wanted to mention, which is *convening*. The art institution as a convener can foster new alliances, as we do with the marathons, our knowledge festivals where we address a different theme each year from various angles. The most recent marathon, co-curated with the late French philosopher Bernard Stiegler, led to an open letter we wrote to United Nations Secretary General António Guterres.

Hans Ulrich Olbrist

Which brings us right back to the beginning of our conversation and the attempt to produce reality.

What else must museums unlearn to achieve these goals and to evolve?
The question of unlearning is key. The director and curator of the Logan Center for the Arts Exhibitions at the University of Chicago, Yesomi Umolu, recently outlined in a brilliant text the steps museums should take to dismantle structural injustice. Given the "genealogy of violence and injustice" that is now widely acknowledged, she wrote, museums have to "unlearn the practices and behaviors that emerged from this condition and seek to build anew along antiracist and decolonized lines."[*] The American poet Alexis Pauline Gumbs recently stated, "We have the opportunity now, as a species fully in touch with each other (think social media), to unlearn and relearn our own patterns of thinking and storytelling in a way that allows us to be actually in communion with our environment as opposed to a dominating, colonialist separation from the environment."[**]

This leads us back to Édouard Glissant—the need to surrender to the idea of being related to one another and to the environment. This means having to take down walls. To be more equitable, museums have to unmake the walls and separations of the current world and its rigid and specialized silos of knowledge. This also means breaking down the walls between museum departments, and between the museum and the outside world.

Given all this, how would you define the term "museum" in a few brief phrases?
I love the definition that the architect and urbanist Cedric Price (1934–2003) gave me. I found the note that he gave me for a lecture, which was inspired by *The Fun Palace*, the unrealized project he developed in the early 1960s with theater pioneer Joan Littlewood, for London's East End. The note said, "The twenty-first-century art institution will utilize calculated uncertainty and

* Yesomi Umolu, "On the Limits of Care and Knowledge: 15 Points Museums Must Understand to Dismantle Structural Injustice," *Artnet* (June 25, 2020).
** Ashia Ajani, "The Making of a Love Letter: Poet Alexis Pauline Gumbs Talks Resilience During the Climate Crisis," *Sierra* (Feb. 13, 2020).

conscious incompleteness to produce a catalyst for invigorating change whilst always producing the harvest of the quiet eye."

There is one more definition. At the end of the day, for me it all begins with artists. My entire life and work are about supporting artists. We live in a moment of great precarity. Museums should be support structures for artists. They should not just exhibit them and make them visible, but actively support artists.

I can't help but turn one of your frequent questions back at you. What unrealized projects have you always wanted to do that offer glimpses of the future?
I have an archive of thousands of unrealized artists' projects. One of my dreams is to make a home for it: an institution to house all these unrealized projects, and that can help artists to realize them.

I once had the idea of doing an exhibition in an empty house, which would grow in layers—a bit like a 3-D version of the surrealist game of exquisite corpse.

Another dream is to start a movement of night trains, to reintroduce night trains all over Europe and the world. That's how I started my research in the 1980s and '90s, and sadly many of these night trains disappeared. We have to bring them back.

I always thought to one day start a Black Mountain College for our time. Another unrealized project is to do an exhibition at the Serpentine with David Hammons. And finally, to have time to write my novel!

And I have long dreamed of curating a city. Particularly now, with so many crises roiling in the world, it would be interesting to invite artists to build a place where one could think about the twenty-first century. I don't know if it would be a city, but certainly a kind of community. This is the most undefined and unrealized project. I am talking with Olafur Eliasson about it.

That would be the ultimate example of the museum's walls melting away. Here comes my last question: What advice would you give to an aspiring museum director who wants to leave a mark on the museum of the future?
I would rather listen and learn from that young museum director. To listen is very important. As the poet and artist Etel Adnan

taught me, "the world needs togetherness, not separation. Love, not suspicion. A common future, not isolation." So a first piece of advice could be to make love, a common future, and togetherness central to the museum of the twenty-first century.

Another could be to listen to artists, to be close to artists, to make sure that they are involved in all aspects of the institution. Another is to focus on generosity. That is the core of everything.

Another could be to read Édouard Glissant every day. I would advise an interdisciplinary approach. We can only understand the visual arts if we look at all other fields of knowledge and know what is happening in music, literature, architecture.

Another is that what is happening outside the museum is just as important as what's happening inside. Make the walls porous. Think beyond exhibitions. Foster alliances. Every morning, I make an email introduction between two people who haven't met before.

Another point is to always be curious. The root of the word *curare* in Latin is not just "taking care" but also "being curious." A museum director without curiosity is lost.

Finally, but not least, go outside your zone and geography. We both come from small countries. When you come from a small country, you are more open to actually leaving. I think it is really important to go outside the comfort zone of one's own language.

This list goes on. It is an infinite conversation. Don't stop.

SONIA LAWSON
Founding Director, Palais de Lomé
Lomé, Togo

WE CAN CREATE OUR OWN MODEL OF THE MUSEUM

The West African coastal nation of Togo, lodged between Ghana and Benin, endured a colonial period lasting less than a century (1884 to 1960), divided into two distinct phases of German and then French rule. Foreign dominance was exercised in both periods from a grand governor's mansion overlooking the ocean and surrounded by a park. Recently, the Togolese state determined to transform the symbolically charged structure, the Palais de Lomé, into an ambitious arts center, with a wide-ranging remit to promote culture and creativity of all kinds—from the artistic to the scientific to the culinary. As founding director, Sonia Lawson, a former luxury-goods executive and a graduate of Sciences Po and HEC in Paris, oversaw the conception, management, and reconstruction of the long-abandoned palace and its sprawling grounds. For Lawson, it was an opportunity to contribute to the cultural and economic development of her country of birth. The complex opened in November 2019 as more than a museum. Under Lawson's supervision, the park was turned into a showcase for the region's exceptional biodiversity, where environmental and cultural education for future generations are fused into one.

ANDRÁS SZÁNTÓ *Your title is "founding director," which is a rare opportunity. Most directors take over existing institutions. What circumstances led to the founding of the Palais de Lomé in the former headquarters of the Togolese government?*

SONIA LAWSON It's a great honor to be the founding director of such a venue. This place was part of the colonial history of Togo. It was the former colonial governor's palace—first the Germans, then the French. Then it lay abandoned for more than twenty-two years. When I began the project, everything was in ruins. I proposed to turn it into an art-and-cultural center—not exactly a museum—with temporary exhibitions and the park. The challenge we had to figure out was how to overcome the past and transform a symbol of oppression into a place dedicated to creativity, and for the public.

You've had an unusual path. You were an executive for LVMH and L'Oréal in Paris before immersing yourself in the art world. How did you find your way to this project?

It's the path of life. I was raised in Paris. I always went to museums and exhibitions with my friends. I couldn't imagine I would transform this pastime into a job. I was an executive for luxury-goods firms. I think the Togolese government selected my project because it had a corporate approach. It proposed that the transformation of this place should be connected into making it financially sustainable. That is why I proposed to have restaurants and boutiques with real branding. My experience with international luxury brands and my knowledge of management were seen as a plus. That is how I began the journey. So I moved back to Togo. When you are from the African diaspora, you have a role to play for the future of Africa—at least that is what I think and hope.

This was not just any place. It was a symbol of German and French colonialism. What does it mean for a museum to be installed in a space so full of historic associations?

People have forgotten about German colonialism, but it left a mark in Togo. It was the first colonialization Togo encountered. In the nineteenth century, Europeans divided Africa like a cake. One slice was taken by the Germans. After the First World War, Germany was defeated and Togo lost one-third of its territory to

Sonia Lawson

what is currently Ghana, and for a while was divided between France and the United Kingdom. After 1920, we were a French colony. Therefore, we have been influenced culturally by the Germans, the French, and a little by the UK.

When the Germans left, their symbols in the building were replaced with French ones. The German eagle was replaced by the French flag. Later, after independence, the French flag and shield were, of course, displaced by the Togolese. Each period has its own cultural layer. At the same time, the longer history of Togo is of a country that was a safe harbor, where other people from West Africa gathered in times of war. Togo is a cultural hub whose history positions it at the confluence of many of West Africa's great kingdoms and peoples. For instance, the Yoruba people of current-day Nigeria founded the kingdom of Tado in Togo—the birthplace of the Aja, Ewe, Xwla, and Fon people, who now live in Ghana and Benin.

I was born in Hungary, which was occupied at various times by different powers, which came through and left an imprint. It is a difficult legacy, but an interesting one.
It is important to understand that this palace was previously a forbidden place for the Togolese. When I began the restoration, some Togolese told me: "Do we need to restore this colonial building?" I said, "You are right, it is about colonization. But don't forget, it was built by our ancestors. So it is part of our heritage and patrimony." We can build the Africa of tomorrow out of the past. For me, it is a huge irony that we now use the colonial building and symbol to showcase the creative talents of Africa of today and tomorrow. We transform the symbols of the past into something else.

The Palais de Lomé is more than a museum. It is set out in a twenty-six-acre botanical park with sculptures. Technology, ecology, design, and science are part of the mix. You have performances, and two restaurants, a bookstore, and a soon-to-open boutique. How did this broad agenda come about?
We have rich know-how in many fields in Togo. Togolese food, for instance, is considered among the best of West Africa, so having a restaurant is relevant. Also, having a place where you

can showcase local products was important. We put them in a boutique that includes items by local people with know-how in weaving, ironwork, pottery, ceramics. We want to reach different audiences. There are people who are interested in cultural heritage. There are those who like architecture and history. You have art lovers, you have food lovers. Then there are people who are just interested in strolling around the park, because we are the only park in the city. We need to be relevant to each group.

What were the biggest challenges in establishing a museum in a country that previously lacked one?
Several challenges. First, to have the proper teams was a challenge. We worked with three architects and with ten construction firms selected from a tender. None of them had an extensive experience with heritage buildings. One challenge was to work based on archival information, to be faithful to the building historically. Our builders needed to understand the importance of this. The second challenge was to make people understand what we are doing. At the beginning, some people said: "What is the point of this park? I am not interested in trees. Why do we need such a big space?" Explaining that such a park is not a waste of space was a challenge.

Another challenge is making clear why culture is useful in a country that faces economic problems. We had to address how culture is relevant, and not just something nice. To convince people that culture and sustainability contribute to the economic development of the country.

The last challenge was the venue. How to make people feel welcome? Because it was the forbidden place, the place of power. We had to convince our visitors that now the power is in the people's hands—that this is their place.

All institutions, even those that are a century old, are grappling with such questions. How to be useful? How to welcome everybody? In Africa, we are seeing the emergence of new institutions, which can provide new answers.
Africa has always been bubbling with creativity, but there are not many venues to show it and experience it. There is a solidarity and partnership between institutions in various African coun-

Sonia Lawson

tries, and that is something that I consider positive. Artists are very important in this conversation. They feel the energy, they want to speak to their public. They are excited about what is happening on the continent.

Developing the audience is a challenge. There are several ways to address it. For example, we worked with more than 350 people during construction. After the work was completed, I invited them to come with their families. Many of them were really surprised and even shocked. They said, "No, it's not for us." But I said, "You know this place by heart. It is your place. You are part of it." And when they came—not all of them came—they were really proud to show what they had done. Our exhibitions guides explained everything in the local languages, not just French and English. This changed everything. The workers appreciated the narratives, and they were happy to show their work to their families. Some of them did not have a typical aesthetic reaction. They said, "Oh, this is an object I see in my everyday life, and you did something out of it very different from what I would have thought."

How then would you define a "museum"? And what sort of impact can it have?

We have defined ourselves as an art-and-cultural center with temporary exhibitions, in contrast to museums that have collections. But increasingly, we have things that we collect, so that definition has begun to shift. In our context, a museum is, of course, about objects and artifacts, but it is also a means of gathering people—of expressing something about ourselves to the rest of the world. I use "express" on purpose. What we try to do is bring something to the global conversation about museums, adding our own way of doing things, to express where we come from and who we are.

As an example, during the construction period we traveled throughout the country with the architects. We went to places that are not touristic, to forests and villages, and we came back with ideas that were really useful. For example, in some areas of the park we decided not to have fences. In the villages, we saw they planted trees instead of fences. Ideas like that were incorporated into our plans.

In West Africa, there is a strong tradition of storytelling. In Senegal, Guinea, and Mali, they call them *griots*: traditional sto-

rytellers who tell stories, and they sing as well—they are actors. Some of our exhibitions were presented by them. They use ancient methods to speak about topics of today. You play, you sing, you dance, you speak. It is another way of engaging with the public and presenting the exhibitions.

An emphasis on biodiversity is one of the unique aspects of your institution. That is not something you see often in cultural institutions. Your mission states, "The Palais de Lomé and its park will contribute to the cultural awakening and the introduction of young audiences to biodiversity." Tell me more.

Lomé is the only capital in coastal West Africa to have such a park in its city center. I am proud of this, and I hope it will inspire other African capitals. Our role is to preserve and share the richness of an exceptional environmental space in the heart of the capital.

At the beginning, the park was just supposed to be a nice setting, like a nice nest or jewel box. I was lucky to work with one of the chief masons, who is also a traditional healer. Before construction, the park was like a bush or jungle. As we went through, I would say, "Oh, this is a bad weed, we need to cut it." And he said, "No, this one heals a disease." A mundane plant was able to cure disease. It was special. He made me taste herbs and plants. He showed me a species of wild iroko tree, which only grows if the seed is dropped by a bird or the wind. It is difficult to cultivate, and it is used in traditional voodoo ceremonies. It is symbolic. He told me we are lucky to have it here. I realized we had a treasure trove with all these plants of the park.

That is how it all began. We asked a team from the University of Lomé to do an inventory of all the plant species. I discussed all this with artists, and some of them were very excited. The park gave them ideas; some had crazy and fresh ideas. It became obvious that the park, the traditions, the know-how around herbs and plants, should be embedded as part of the project.

Your palais lists "the use of plants," "the beehive," and "bird watching" on its website as key features. The gardens have sections for forests, savannah, an orchard, medicinal and educational gardens, and so on. How do these figure into the whole?

The idea was to showcase Togo and its various landscapes to

Sonia Lawson

our audience. This biodiversity is also a way to make people feel connected to other parts of the country. There are well-known gardens in the French style and the British style. I said, "Let's have a Togolese garden." So while parts of the garden are manicured, other parts are really wild; we wanted to let it grow, to see what it can be. Scientists were interested in what can grow in an urban zone. At first, some visitors were surprised that parts of the garden are not so orderly. We explained that we did it on purpose. In the end, they understood.

One day, an artist brought us the seeds of a beautiful tree to plant. When its flowers fall to the ground, it is like a white carpet. He told me it grows near the village he comes from. This gave us the idea to go out to the villages, where you have wild fruits that are less known to the average inhabitant of the capital. They are really tasty, and they grow in the forest. I would like to bring them to the park. There are also wildflowers that you cannot see anywhere else in the capital city. They are also going to be planted in the park. It's all another way of experimenting with nature.

There has been much talk recently about the expanded role of the museum. ICOM's proposed museum definition included an aspiration to promote "planetary well-being." How can an institution like yours add to this conversation?
Younger audiences in the city don't know much about nature. When they are exposed to nature, it is something new and different for them. Given all that the world has undergone in the past few months, the importance of what you eat, how to train the immune system, and reflection about the surroundings and the environment are even more important. It is about psychological well-being. Because when you go inside a museum, it changes how you feel from your everyday life.

In our medicinal gardens there are herbs and plants people can use in their everyday life. It is a way to engage reflection about what we eat, the notion of soil, and what it gives us. I think we have an important role to play in the well-being that you experience. When you go to a place you like, when you hear the birdsong, when you see the colors of the trees—you feel better. You feel it, you like it.

In our programs for children, they can discover plants and species. To give you an example, the younger generations of West Africa love Coca-Cola. However, they do not necessarily know that the cola in Coca-Cola comes from Africa. The cola nut has caffeine. The root of the cola plant was traditionally used for dyeing textiles. People don't know this anymore because we no longer use these traditional methods. The younger generations like Coca-Cola because they think it's cool and modern. But they don't realize where it comes from. This is just one simple way we can be relevant to the younger generation.

What about the bees?
We were contacted by a scientist who is passionate about bees, who asked if we could incorporate them somehow in the park. The disappearance of the bees hasn't been a problem in western Africa, but this is changing. We have several bee species at the palais. One of them, *Melipona* bees, only lives in tropical climates. They have no stinger and produce high-quality honey. I am afraid one day they might disappear. We are working with Fab Lab, a digital fabrication laboratory, to create an app to help people discover the bees.

Biodiversity leads to many fields—to science, to industry, to commerce. How do you connect the palais to other discourses and different areas of practice?
One of our focus themes is about urban planning and architecture. For an upcoming exhibition, the guest curator will be an artist-thinker-researcher who is reflecting on the world of tomorrow. How can we create an African smart city? Will it be like Silicon Valley—a Silicon Africa? He wants to do something different: a smart city, with all that technology can offer, but with small gardens where you can collaborate with people of different backgrounds. One of the collaborators is a political-activist rapper who has done a video of people who sell things on the street. They know the city by heart. You see them in the video talking about their lives, their hopes, their dreams. They have beautiful stories. They have overcome difficulties. The video will be exhibited in a market outside the palais. People who work in the market, the street hawkers, who don't usually dare to come

Sonia Lawson

in to visit us, will see themselves in these works and in the film projections in their area.

How can institutions like yours stay viable—culturally and economically—in the future?

That is the real question, and one of my main concerns. The palais was mainly funded by the state for its launch, the renovation, and some of the exhibitions. This will be complemented with our own resources and by the private sector, as well as international funding. Our eventual target is 20 percent state and 80 percent private funding. Our business model is unique in the West African context. Significant resources will derive from activities and services (such as ticketing, boutique, restaurants, space rental), as well as sponsorship and philanthropy. The Friends' Circle of the palais will play a role, gathering members from various countries and backgrounds. Obviously, our venue is unique, so we can rent spaces in the park or inside the palais.

What other kinds of new art institutions do you foresee emerging in the future, particularly in Africa? What's in your crystal ball?

In my crystal ball I see a growing number of museums in Africa, various types of museums—not just in the capitals, but out in the regions. I hope they will not only preserve the past, but also showcase what we have today and help think about tomorrow. I imagine them as a lab to think about the future, without forgetting our roots and our nature. A lab where we can have a local and a pan-African vision at the same time. I hope we can create our own model of the museum, which can be a source of inspiration around the world.

When the Palais de Lomé has fully established itself and all its programs are operating, how will you know the project has succeeded?

We will have succeeded when we see the next generation inspired by this place. If someone says after visiting this place that they have decided to become a gardener, or a beekeeper, or a collector, or an artist—because they were inspired by the trees, or the bees, or the works of the artists. I will also see success when it is common to talk about art and biodiversity in Togo. When this

is a typical conversation, everywhere. Success is when all kinds of people feel comfortable to come to see our exhibitions and discuss them and how they relate to their lives. Success, finally, will be when an African is able to mention, as you mention the *Mona Lisa*, contemporary African artists' names and their works, totally naturally, and not only in the circles of art lovers.

I hope we can expand that circle.

Sonia Lawson

Contemporaneity

MAX HOLLEIN
Director, the Metropolitan Museum of Art
New York City, United States

WE HAVE TO COMPLEXIFY
THE PRESENTATION

In the 1990s, Max Hollein and I, both in our twenties, found ourselves in New York City, having moved there from sister cities—he from Vienna, I from Budapest. He was the implausibly young chief of staff to Thomas Krens, the Guggenheim Museum's hard-driving director. I was at a think tank at Columbia University. To honor our roots, we indulged in Austro-Hungarian pancakes at a now-defunct café in SoHo. Hollein would move back to Europe for his first directorship, at age thirty-one, at the Schirn Kunsthalle, in Frankfurt. His remit soon expanded to the venerable Städel Museum, with a collection spanning seven centuries, and the adjacent Liebieghaus sculpture collection. The son of an architect, Hollein led a total rejuvenation of the Städel during his ten-year tenure. All three museums he led logged record attendance. When life became too predictable, Hollein moved back with his family to the United States to run the Fine Arts Museums of San Francisco. Since 2018, as the director of the Metropolitan Museum of Art, he has been setting the artistic vision and direction of one of the world's most influential institutions at a time of transformative change in the field.

ANDRÁS SZÁNTÓ *This is your second New York phase. When did you know museums would be your journey?*

MAX HOLLEIN Fairly soon. When I was a teenager, it was clear I would be involved in something creative. I did different internships during college—newspapers, an ad agency, and I won an internship at the Gemäldegalerie in Berlin. I stopped after three weeks because I felt it was not for me. It was really the internship at the Guggenheim, in 1992, that convinced me I should be in museums. It opened my eyes to how a museum could operate, compared to museums in Austria—way more confident, more involved in the social fabric, more internationally oriented, pushing the envelope. All of that attracted me.

At the end of the internship Tom Krens said, "If you ever finish your studies, you have a job." I don't know if this happens to you, but when Americans say something out of politeness, we take it for real. I remember when Leo Castelli once said to me, "We should have lunch"; I didn't understand what he meant was "This conversation is over." I thought he really wanted to have lunch, so I called him up the next day and said, "Let's have lunch." Well, and then I did have lunch with Leo Castelli. Tom offered me this job in the elevator. I called back two and a half years later and I said, "Okay, I'm finished with my studies now, and I would love to work with you." I was straight out of college. We lived in a studio in Hell's Kitchen.

That was the era of the Bilbao effect and the museum as a global brand. How did the apprenticeship with Tom Krens shape your outlook? And who else influenced your view of museums?

For me the biggest influence, as for a lot of people, was my parents, especially my father, Hans Hollein, but also my mother, Helene, who was equally connected in the Viennese art world. Through them I got introduced early on to the artistic scene. My father was involved in museums as an architect and was very encouraging in connecting me to things. On the other hand, the reason I wanted to leave Austria was because my father was a fairly towering figure in the Vienna scene, and I knew I had to go somewhere else.

Tom was certainly influential. I was very young—probably the youngest and most inexperienced chief of staff in museum

history. He saw someone who was smart and engaged, high-energy. He got 24-7 support and full loyalty. I got the most intense experience and professional relationship you could hope for. After five and a half years, it was clear I had to leave. I said to Tom, "I need to leave because I risk becoming a copy, probably a mediocre copy of you." He didn't understand it at first. But I needed to strike out on my own, just as I had to force myself out of Vienna to kind of get out of the shadow of my father.

Running from two father figures ...
Exactly. Of course, there were other people, but these two were the most formative. You can't really call your father a mentor, but Tom really mentored me.

The institutions where you have worked are extraordinarily varied. What was the common thread?
I was interested in institutions where I could really make a difference. Not so much in the most prominent jobs. I was interested in a museum that had significant potential for change and where good and inventive leadership could significantly transform and elevate the institution. At the Schirn there were so few visitors, and the program was so all over the place, the city of Frankfurt was thinking of closing it. The potential future of the Städel was complicated. The Fine Arts Museums of San Francisco were certainly at a challenging moment. In a way, the Met is an odd choice—but when you are asked, you go. My trajectory was not so much geared to becoming the head of the biggest, most prestigious institution. I was looking to make an impact. I certainly think there is an opportunity for that at the Metropolitan.

I remember vividly when, after fifteen years in Frankfurt, Nina and I had to force ourselves to leave. Everything was perfect. One day I went to the baker to buy some rolls. When I wanted to pay, the baker said, "No, no, we don't want money from you, Mr. Hollein, you have done so much for the city." I went home and said to Nina, "Listen, we have to leave here; it will only go downhill from here." San Francisco felt like an adventure, and again with significant potential. A lot of my friends—whom you know as well—were flabbergasted. They thought I would go to

Berlin or London and run one of the major institutions there. I had a different criterion.

Let's talk about museums today. Having worked in several of them, how would you define a "museum"?
That is almost as difficult as defining art. For me, a museum is not just a place, but a task and an offering—an entity that, of course, collects, preserves, and presents art, but which, even more important, is a platform for engagement with art. On the one hand, curated, but on the other hand, as open as possible. The museum, both physically and also through its research and knowledge creation, creates ever-broader and more varied contexts for you to engage with art and connect with different social and cultural developments. All of that also involves a certain kind of communal experience.

Museums have changed in our lifetimes. What are their most impressive achievements and big pivots?
The biggest driver of change is the audience. It started out being highly exclusive and elitist. This audience has diversified and expanded at an unprecedented scale, and it is taking ownership of the institution. This shift to having a broad and diverse audience, and the audience not feeling like a guest in a museum, but feeling that this is *our* institution, which therefore should represent *our* values—this is a big transformation.

The other major transformation, which started in the 1960s, is that more and more we understand the museum to be not only a place you visit, but an engaging educator and performer outside its physical parameters—a provider of narratives, contexts, and experiences. At the center is the museum and the gallery visit, but the impact radiates beyond our physical confines.

We are speaking in mid-August, two weeks before the Met is supposed to reopen after the Covid lockdown. Uncertainty surrounds museums. Some have talked about positive changes emerging from this time. How do you see it?
This is a health crisis, an economic crisis, and a social crisis—and I don't look at it as a positive thing, that's for sure. I think it's a struggle. But there may be three elements that we can perhaps

build on when the health crisis is over. One is the obvious: we have learned, more than ever, how to use digital tools and share information in a more professional and engaging way. Our digital offerings are expanded and transformed. Our ability to stay connected with our audience has significantly improved—and that will be a major development. This runs the gamut from kids' classes to online symposia. I said to my team, "Whatever we do digitally now, let's make sure it stays with us." I want them to be sustainable and scalable—because this will continue.

The other, even more crucial development is a moment of reckoning with history and social justice and racism and discrimination. If there is one good outcome of this crisis, it is that it has made us aware of our failures and the necessity to do better and more. It has made us realize that we haven't listened enough, learned enough, and that we must be not only mindful, but truly focused on how we become an antiracist institution. That will stay with us as a priority moving forward.

Finally, an interesting development in relation to our staff is that when everyone was sheltering at home, the institution became even more collaborative. The situation created an experimental spirit, an element of introspection, and a feeling that we need to support each other. This was quite powerful, and I hope it stays with us.

We were all ready to get off the merry-go-round, I think. But let's talk about contemporaneity and how a museum can address its moment. Can a museum that encompasses five thousand years engage meaningfully with the present?

Contemporaneity has two parts. One is about contemporary art in the museum, specifically in an encyclopedic museum, and the Met in particular. One reason the Met stands out among its peers worldwide is that it covers more or less all of art, from the beginning to now. We have no cutoff. It's one flow. Contemporary art has always been part of our institution, and that is important.

However, this is not just about contemporary art. The Met has to be a *contemporary institution*. What I mean is that in all different areas of the museum, we need to find ways to speak to the current moment. That doesn't have to mean putting contemporary art in every gallery. It means connecting to the present.

Max Hollein

For example, we can look at an exhibition like *The Last Knight*, which was about Emperor Maximilian, at the end of the Middle Ages, through a contemporary lens. This is propaganda in the fifteenth century. This is about how an ambitious leader cements his power. By using these lenses, you open it up for interpretation that resonates today. I want to make sure this is a museum that does not only relive previous times, but more important, in how it does so, it lives in the current time.

Some of that requires changing approaches to curation and presentation, and a kind of updated institutional style. What changes will this require?
You have to clearly allow dissent. The idea that the institution can only speak with one voice is obsolete. There are different ways to look at something, different ways to translate culture. I encourage our curators to allow that. And there can be many different institutional voices. External voices should also participate, and we have to surface them. One needs to abandon the idea that there is only one narrative about the development of culture in the world, and that this narrative is somewhat linear. There are multiple intersecting narratives. There is no single story of culture, but various, sometimes conflicting stories, depending on the vantage point of the observer. Being more transparent about this and owning it more—that is what's important.

Maybe technology can help facilitate these multiple interpretations.
I agree. You have to apply a certain matrix thinking, a three-dimensionality of the organization of information that can be put into context. All of that can and should be supported by technology.

The Met is full of objects that didn't start out as art. They have been put on pedestals, behind glass—aestheticized. How can a museum bring out context and meaning in such objects?
There are multiple ways. The newly reopened British Galleries at the Met show one way it can be done. It's not just about juxtaposing objects and providing information, but about creating an intellectually charged environment.

I would suggest that it's less interesting for a visitor if a painting by Lucas Cranach was made in 1531 or 1533, and more interesting that it was done to support Luther and the Reformation. There is a famous Cranach the Younger portrait of Luther on his deathbed. Luther is smiling. Copies of this painting exist in many collections, and you wonder why. And why is he smiling? Well, Cranach was summoned to Luther's deathbed because Luther married Katharina von Bora, a nun, and the Catholic Church predicted Luther would be captured by the devil at the moment of his death. So as Luther lay dying, Cranach was summoned to depict the smile on his face—he was *not* captured by the devil after all. This image then needed to be reproduced quickly and sent to all parts of the country. Artists are sometimes like ministers of propaganda. This is one example of going beyond the technical or aesthetic aspects of a painting. And such stories speak to us today.

There is another aspect, and you alluded to it with the British Galleries. It is a more immersive and multisensory museography. We grew up with the white-cube gallery. Long before, there was the period room and the Wunderkammer—*these exquisite juxtapositions and moods. Is it time to use this arsenal more?*
Absolutely. One of the things I immediately became interested in when I got to the Met was our period rooms. Of course, period rooms are interesting, but also deeply flawed. They are time capsules that pretend to show reality, but are actually a construct. Nonetheless, the period room is a powerful and engaging environment in which to tell complex stories. Our most recent period room is the Frank Lloyd Wright room. One step we are taking now is to ask: *What would be the period room of today? How would we represent our moment?* So we are working on a period room for now. We will hopefully inaugurate it next year.

Going beyond the white box is one thing, but museums in general can provide a more changed environment. I am more interested in creating that environment, not just with design but with presentations and dialogues that embrace tension and misunderstanding and complexity. Our tendency to simplify is misguided. We need to complexify the presentation, not only to

Max Hollein

make it more engaging, but to make it more truthful. The white cube is about simplifying.

The white cube is a period room.
Exactly. That is true.

I would be happy to nominate objects from my boys' room for this new period room. You are the son of an architect who cut his teeth at the Guggenheim, a museum deeply attached to architecture; I am interested in your view of museum design.
I hold architects in the highest esteem—not just because I'm the son of one. Museum directors, curators, theoreticians, have been instrumental to shaping the discourse about what a museum should be, but architects also played a major role. We would not be here today if architects were not part of that discussion. Mies van der Rohe's Nationalgalerie, in Berlin, is an architectural statement that expanded our idea of how art can be presented. Same is true for Renzo Piano and Richard Rogers's Centre Pompidou, and many other examples. Architects don't just provide shells waiting to be filled, so to speak. I see them as proponents of a larger discourse to develop new prototypes of what a museum is and can be. I experienced this in my own family. My father built the Abteiberg Museum in Mönchengladbach, the outcome of a close dialogue with the artist Joseph Beuys and the museum's director, Johannes Cladders. Architects are deeply analytical people and intellectual thinkers. They are absolutely crucial to where museums are today and where they are going.

What is the role of the big museum in contemporary art? There is a strain of thinking that big museums shouldn't be in the business of sorting out what new art is important—there are smaller organizations for that, not to mention the gallery world.
You want the institution to be in dialogue with where the world is going and which artistic languages and topics are relevant, and have an opinion about it—an opinion articulated in what we collect and how we show it. I would hate for the Met to only present or collect artworks that are fifty years old or more. A clear manifestation of the Met's voice with regard to contemporary art necessitates us collecting and presenting in that field. As an

encyclopedic institution, we can even be bolder and more playful than a classical contemporary museum. Some of our choices might turn out to be flawed or misguided thirty years from now. I don't think that is such a problem. There is room for mistakes—but there is so much more room for opportunities. I would not miss out on having Wangechi Mutu's sculptures on the façade of the Met, or having Kent Monkman propose a different idea of history painting inside this very institution. It's so meaningful to have it at the Met.

Recent months have reminded us that contemporaneity is a tense and contested terrain. Whose voice do institutions represent? What does it mean to be inclusive? Museums are having a hard time with these questions.
If, as I believe, the museum should be a mindful and engaged participant in our current cultural discourse, then you will invite a level of debate and become a platform for discussion. That can be challenging, but also extremely fruitful. It demonstrates the institution's role for society, within a community, within a social context. Museums are where communities should convene for engaged dialogue. They should not stand on the periphery. However, this role challenges the institution: what we should be focused on, where the research is going, what we need to surface more.

Let's hop in our time machine. How do you imagine tomorrow's museums to be different?
Bringing more and more objects to one place will become less relevant, versus how you translate the knowledge, understanding, and complexities of these objects to a wider audience. I do think the physical experience of the museum will continue to be powerful and strong. But museums will expand significantly in ways that are not just physical, but also digital and intellectual in regard to their engagement in various areas of the world.

A question I have enjoyed asking in these conversations is which habits do museums need to unlearn to stay relevant?
One tendency—we share this with academia—is that we always first want to know everything before we put something forward.

Sometimes, it is more interesting for the public to know what we don't know, rather than to know what we know.

You said you are hard-pressed to find silver linings in this moment. Your compatriot Robert Musil wrote, in The Man Without Qualities, *required reading where we come from, "If there is a sense of reality, there must also be a sense of possibility." I want to close by asking you: What gives you hope about the future of the museum?*

My personal feeling, and the feeling of so many, at this time of closure is how much we miss the museum—the interaction with art, the community, the togetherness in an institution. Once you cannot have something, you realize how much it's part of your life and how important it is for your life. This year has made people aware, more than before, how important museums are for them. If ever there was a time when we could see what museums really mean for people, I think it is now.

CECILIA ALEMANI
Director & Chief Curator, the High Line
New York City, United States

A MUSEUM WITHOUT A CEILING

One of the memorable experiences of my lifetime was collaborating with the Italian-born curator Cecilia Alemani on a project initiated by Art Basel that turned the Argentine capital of Buenos Aires into a citywide outdoor museum. As the head of the art program of the High Line, New York's immensely popular elevated park, Alemani, who was born in 1977 in Milan, is a leading proponent of inserting contemporary artworks in the public realm. We spoke when the High Line was still closed during the coronavirus epidemic, and while Alemani was busy preparing for her next major curatorial undertaking, as the first Italian woman invited to lead the Venice Biennale.

ANDRÁS SZÁNTÓ *It is a beautiful summer day in June, yet the High Line is closed. Even an outdoor venue has hurdles to clear before opening. How has this time played out for you?*
CECILIA ALEMANI As for everybody, it has been a surreal time. The full uncertainty of this period has been intense. The High Line is the only park in New York that has been closed, because officially it is coded as a "building," not a park. It is very hard to respect distancing rules, because the path is just eight feet wide. Which is sad, because people want to find peace and relaxation. They wish we were open.

You are from Milan, Italy, a great place to grow up around art and museums. Did you have one of those "aha" moments, when you fell in love with art?
The first one was in school. I was studying French Surrealism, in French class. When I was growing up in northern Italy, it was common to study French, not English. Reading and learning about André Breton and Paris in the twenties opened up a new horizon for me, where I could see an intersection between disciplines like art, literature, poetry, and cinema. That was the first "aha" moment. Another was going to see modern and contemporary art exhibitions. I remember a Boccioni exhibition in Milan; a painting called *Materia* was an eye-opener. On both occasions, I came to art through the lens of philosophy and literature, which is what I was studying at the time.

Most of your career has been devoted to curatorial projects, with Frieze, with Art Basel, with the X Initiative in New York. You did a number of collaborations with private galleries and public museums. How have these experiences shaped your expectations of museums and the presentation of art?
I have never worked officially in a museum—maybe because I didn't want to. I wanted to take the path of independent or freelance curator. I worked for many years as the assistant of the curator Francesco Bonami. At the same time, I was curating my own smaller projects, at Artists Space and Art in General, for instance. I would also write those little reviews in *Artforum.com* called Critics' Picks. Not that they brought me a lot of money, but it was a way of registering what was going on in the art world. I wanted

Cecilia Alemani

to be out in the streets and galleries, looking at as much art as I could.

I never said no to anything. The only thing I didn't want to do was work for an auction house—maybe that's where I drew the line. I wanted to see the different sides of the profession. Then I did the X Initiative project, in 2009–10. It was spearheaded by Elizabeth Dee, who managed to get her hands on the former Dia building on 22nd Street. In three to four months, we put together a temporary organization and created a series of exhibitions. That project became a hub for an art world that was suffering in the pain of the recession. And right after that, I started working for the High Line.

You do not run a museum in a conventional building. But the High Line is, in fact, a kind of museum, with revolving exhibitions, often following a theme. What exactly are you trying to accomplish?
I like to think of the High Line as a museum without walls or, more accurately, a museum without a ceiling. The High Line is one of the few institutions that offer the public an array of experiences without being prescriptive. We are not a botanic garden, but you can admire our gorgeous horticulture. You are surrounded by a breathtaking cityscape while attending public programs. And if you are interested in art, you can experience it in a very special setting. The strength is the dialogue and interconnection between these different elements.

When I started that job, I was concerned about how to be popular without being populistic, and soon I realized the concept of a targeted audience wasn't applicable to the High Line, with more than eight million visitors a year. Instead, I tried to focus on the idea of bringing amazing, museum-quality art to the city and to our visitors, regardless of whether they have a specific interest in art.

But you do approach the programming as a museum might. You have a calendar of exhibitions.
Most of the artworks we present are newly commissioned, which makes us unique. We want to support artists to make their first public artworks. Often we invite artists who have never done public art before. We offer our expertise and a production team to work with the artists to realize their works. Artists really appreciate it, because working with us is a learning process. There are a lot of

restrictions here, but the same challenges become stimuli that push the artists to think outside of the box.

We should acknowledge that you were recently appointed as the next curator of the Venice Biennale. This means you will have to, in one way or another, respond to this moment—which is a tall order. You have to summarize it. Is that even possible?

I got appointed in January and started thinking of what kind of exhibition I wanted to curate. In early March, as the Covid pandemic exploded, I had to shift my thinking. Then the biennale was postponed to 2022. So in five months, I have envisioned three different shows! Now I am taking a deep breath and just spending time talking to artists. That is the best tool to approach these times.

Meanwhile, because the Architecture Biennale has been delayed, this summer we are organizing a show about the history of the Venice Biennale, curated by the directors of the six sectors: music, theater, visual arts, dance, cinema, architecture. We are looking back at those moments in the history of the biennale when the exhibition intertwined with *History*—big moments of crisis, revolutions, moments that introduced new artistic languages. And what you come to understand is that it is hard to make judgments in the middle of a crisis. It is okay to be confused.

So let's talk about the museum of the future. The museum of the future builds on the museum of the present. How would you define that institution as it exists today? What is a museum's most important contribution to society?

A place of culture and education. A space of learning. A space of exchange. I would be more skeptical of defining it as a social space in the most contemporary way.

How will tomorrow's museums be different, thirty or fifty years from now?

There will be, for sure, added layers of digitalization. We are now living through an extreme test version of that. One good thing coming from this current situation is the understanding that virtual reality can be an additional layer—but not a full replacement—of the museum experience.

Cecilia Alemani

Some people say museums will be hyperlocal or hyperglobal. I don't think so. I imagine this as a short-term crisis. The format of the museum has been around for so long; it will adapt to new circumstances. There is going to be a phase in which museums have to recalibrate collections in terms of restitution, inclusion, and representation. I hope that happens in the next ten to fifteen years.

I hope museums will define their own identity in a clear way, so they don't become copycats of the same collections around the world, with the usual blue-chip names. They should focus on their own DNA: What makes them unique? What's their specificity? I don't want to go to Helsinki to see the same collection that MoMA has. To me, it is less about locality than about specificity.

Right now, there is a fairly standard curatorial tool kit being applied around the art world, which reflects this moment in time. However, museums didn't always tell their stories in white-cube galleries with a limited number of objects.

What we did together for Art Basel Cities in Buenos Aires, where the city becomes a museum, and where you occupy spaces that are not necessarily conceived to be a museum—I think that sort of project could help to bridge the museum as an inaccessible place to its surroundings. It is not a substitute. But it would help museums beat their isolation and remove the label of being elitist.

In the 1970s, many events and exhibitions of the Venice Biennale happened around the city of Venice, not just in the pavilions—in the streets, in the squares. It's amazing to see the pictures. It felt so authentic. It was less of a festival organized to please the few. It was coming from within. I am usually skeptical of talk about "community"—or "territory," as we say in Italian—but this is a way of bridging the distance between the museum and its surroundings, and creating an experience that is not only happening inside the four walls of the museum.

One of my favorite moments ever was standing with you in Buenos Aires, looking over a bridge at the giant grain silo that had been transformed by Barbara Kruger for your exhibition, Hopscotch. It transformed the city and broadcast important ideas into the public realm. I want to explore those possibilities of activating the public realm. Who is doing this the right way?

It's hard, because in most cities, like Paris or London or New York, everything is so institutionalized. You do need a little spontaneity. The same thing we did in Buenos Aires would be hard to imagine happening in New York. Maybe it could have happened in the 1970s. Now it is hard, because of the real estate.

Biennials in general are more flexible structures than museums, and can adapt to different circumstances. Then there are some, like Manifesta, that move to a new city every two years and engage with all different sets of parameters and conditions. I always love visiting them, because you get to know new cities through the lens of art.

Public space has greater importance now. As a practical matter, post-Covid, we are more likely to go outside than inside to spend time together. Is this just a passing phase?
It is definitely an opportunity, although it is nothing new. One great example is the Whitney moving to its new location next to the High Line, and realizing that the history of the piers on the West Side is relevant to their story, too. The project of David Hammons came out of that history, which has largely disappeared.

Younger generations seem to care less about history. Museums have to preserve that connection. One of the most fascinating things about the High Line is being part of Manhattan's West Side—from Westbeth and all the artists who lived there in the sixties and seventies, to the Meatpacking District and the queer-liberation movements. These histories shape your identity in different ways. You can use the public spaces around institutions to engage with that context.

One of the director-curators in this book likes to say to artists, "If it looks like art, it's not good enough." But so much public art looks like art with a capital A. How do you push artists to engage public space in more original ways?
I don't work with big names whose works are everywhere in the art plazas. My job as a public-art curator is to push artists to try out the public space, to experience it coming from a field that is *not* public art. That's what makes it refreshing and different. The High Line is not a sculpture garden or a traditional park. I think of it as an outdoor gallery where instead of walls, we have trees,

Cecilia Alemani

and instead of a wood floor, we have soil. I don't want to think of it as a corporate plaza. One can see an artwork from Josh Kline at the Whitney and then come to the High Line and see a completely different work by the same artist.

For art organizations, this is a challenging time—from both ends of the political spectrum. Public tolerance for utterances in the public realm is thin. How do you navigate this treacherous terrain?
These are indeed complicated times. People get upset about everything, and social media amplifies a very intolerant climate. I think we live in a deeply contradictory moment, in which we strive for change but at the same time we don't make space for nuance, and we therefore run the risk of becoming very conformist. Art is a place for experimentation, for pushing boundaries, not for pleasing taste or for obeying an idealized moral standard. So I try to listen and to understand the concerns, especially of the younger generations. At the same time, I also try to stay focused on what artists want to say with their artworks, and on what is urgent and relevant for them. Looking back on the history of art and great exhibitions, the ones I remember the most are not the ones that respected the status quo. They are the ones that pushed boundaries, the ones that dared to say something different, that stood out, that provoked, that broke the conventions.

Between political attacks and anxiety about funding sources, it is hard to create that space of freedom.
Very true. In America, I am not so sure it's possible. It is going to be really hard. In Europe, it is a bit different because of the financial situation of institutions, which allows them more freedom; however, there you have much less money overall.

I am worried that everybody is going to become the same. If we have to obey these heavy ethical and societal rules, then we are all going to do the same programs. And that is not interesting. If there is a different voice, I don't understand why we have to punish that voice. Isn't that enriching the dialogue and the conversation? If we all say the same things, how boring will that be?

I hope there will be spaces for new institutions. I have a hard time understanding why, instead of wanting to change old institutions, we don't put that energy instead into creating new institutions.

I think of Marcia Tucker, who in 1977, after being censored by the Whitney, opened her own institution. Nowadays, nobody does that.

Do you have a little notebook of projects that you dream about realizing one day?
Buenos Aires was a way of doing something completely different that I had never done before. I would love to do that in Milan, or wherever. However, if I could make a wish for an institution that is missing in New York, I would definitely say that we need an institution like the Institute of Contemporary Arts in London—one that is more agile and dynamic because it doesn't have a collection. The gap between the big museums and the nonprofits is too dramatic in New York. There is nothing like a European-style *Kunsthalle*, which could help give midcareer and emerging artists exposure outside of the smallest nonprofits.

From what other fields do you think museums can or should borrow as they evolve? Do you see points of energy in other areas of society that we should be looking at?
That is a very good question. I guess I would go to another passion of mine, food. I'd look at the slow-food movement, and how it is a global movement while preserving local individualities and traditions. Museums should deepen their roots in their local contexts and use that to create a global network of knowledge-sharing.

If you ever had a chance to build a new kind of museum, from the ground up, and incorporate your best hopes for presenting art, what would it look like? And what would it feel like?
I want a museum that is a great storyteller, regardless of what the story is. And one that could tell opposite and oppositional stories. And one that could challenge your brain to make you understand that a museum doesn't tell one story in one narrative, because it represents humankind—and humanity is complicated.

I don't want museums to fall into a unique point of view. I think it is about giving voices to different ideas and thoughts, articulating them visually, and then telling another story right after. I don't know if that is still a museum. But it is an approach I would like to see more of in museums.

Cecilia Alemani

BRIAN KENNEDY
Director & CEO, Peabody Essex Museum (PEM)
Salem, Massachusetts, United States

MOMENTS OF WONDER AND AWE, SURPRISE AND DELIGHT

In 2014, I spent a few days in Warsaw with Brian Kennedy, who was then the director of the Toledo Museum of Art. A few months prior, we had conducted a strategy seminar with his team in Ohio. The ostensible reason for our trip was a symposium on museum architecture, but it was really a chance to see museums. His enthusiasm was contagious. Years later, we would work together on strategic planning for the Peabody Essex Museum, in Salem, Massachusetts— the oldest continuously operating museum in the United States, with its first precursor established in 1799—which he has led since 2019. The Irish-born art historian's biography is unusually peripatetic even by the standards of today's globalized world: arts-policy roles in Dublin and Brussels; assistant director of the National Gallery of Ireland; director of the National Gallery of Australia, in Canberra; and his first US directorship at the Hood Museum of Art at Dartmouth College. He brings his library of twenty thousand books and his large collection of art postcards with him wherever he moves. Equally at home with the museum's curatorial and business functions, Kennedy is an avid proponent of visual literacy and of making the art museum available to everyone.

ANDRÁS SZÁNTÓ *So how does an Irishman who lived a lot in Australia get to run the oldest continually operating museum in the United States?*

BRIAN KENNEDY Through a series of fortunate accidents. I have always adopted the motto, "If you see a door open, walk on through." That happened first in Dublin in 1989, when I was working in the Department of Finance and writing about Irish art. I was approached in the street by the personnel officer of the National Gallery of Ireland, who asked me if I would be interested in applying for the assistant-director job. I remember asking, "Do you think I could do that?" I became assistant director at the age of twenty-seven. It led to an incredible adventure.

Fast-forward eight years, and I got a call out of the blue from the then-retiring director of the National Gallery of Australia, asking if I would be interested in being a candidate for her job. So off I went with my wife and two young children, and had an amazing eight years. But I had always wanted to come to America. Of the US institutions that approached me, I was intrigued most by one that was completely different from the two previous national institutions. I ended up spending five years as director of the Hood Museum, at Dartmouth. I became an adjunct professor in the art-history department, ran the museum and developed momentum for its expansion, engaged in contemporary art, and could also curate and write. I had an amazing time, my eyes opened by enthusiastic students coming to the museum each year—the first digital natives.

Then came the call from Toledo, where I spent a truly memorable nine years. After two national institutions and a college institution, I was moving to a civic institution with one of the finest collections in America. And when I felt my time was done there, I responded to an approach from the Peabody Essex Museum. I was drawn by the remarkable transformation that PEM has achieved in the past twenty-five years, growing into a major international institution, in a picturesque New England city by the ocean. And here I am.

Very different institutions. How have they shaped your ideas about museums?

In Ireland, I became interested in the multisensory nature of

the arts, how time and space can interact with and engage the public. I was involved in a government report called *Poverty and Participation in the Arts*, and that radicalized me somewhat. I realized that if you wanted to be a national institution, you had to be more open. Importantly, the National Gallery had free admission. When I went to Australia, I asked if I could make admission free, and we achieved that in just over a year. I started to focus on how a national institution would seek to represent all Australians. I began to appreciate that programming is key to attracting inclusive audiences. You have to program to the interests of other people, rather than just projecting your own interests and hoping they will come.

I was in my forties by the time I got to Dartmouth, and was engaging with eighteen-to-twenty-two-year-olds who I felt were members of a conservative generation. But these young people are now the ones out protesting. They had in fact been radicalized, in new ways, about bigger issues—the environment, equity, and climate change. We did many exhibitions around such topics. In Toledo, we went about engaging a diverse community in a city with a significant African-American population. We made a huge effort, and the racial and economic diversity of our visitors improved tremendously. Our annual neighborhood block party drew ten thousand people. We also had free admission. Issues of repatriation and provenance were then coming to the fore. Until my time there, the museum had never returned objects to origin countries.

Throughout this journey, were there any "aha" moments that made you look at the museum differently?
At Dartmouth we had the good fortune to work with the artist Fred Wilson, who was invited to mine the collection. His exhibition was titled *So Much Trouble in the World—Believe It or Not*. The first part of the title came from a Bob Marley song, and "believe it or not" came from Mr. Robert Ripley, who had received an honorary degree from Dartmouth. Fred's exhibition brilliantly exposed the hypocrisies and contradictions in the institution and in its museum.

First, he showed that the collection had more than two hundred portraits of Daniel Webster, an alumnus, and just a

half-dozen portraits of Native Americans, even though Dartmouth had been founded for Native Americans. It was only two hundred years later, in 1970, that Dartmouth would again actively engage Native American students. This was shocking to me. And then at the end of the exhibition, Fred included objects revealing that Dartmouth, back around 1900, had been a center for the pseudoscience of phrenology, which linked behaviors and mental abilities to skull shapes. One of the collections was a series of plaster-cast heads of people who had been placed in a forty-seven-acre human zoo in St. Louis during the Great Exposition of 1904. Among them was a man called Ota Benga, who was kidnapped from Africa and put on exhibit. He was later exhibited for three weeks at the Bronx Zoo in a monkey cage, before his release following protests by Christian ministers. The idea that that could happen utterly appalled me.

What Fred did was extraordinary. And here's the kicker— he punched the solar plexus of Dartmouth and its museum, and what happened? Nothing much. He was way ahead of his time.

We are talking at a time of extraordinary moments of change for museums. First came the pandemic. Then the economic fallout. Then the national reckoning around race. How do you see this moment for museums?
As museum directors, we live in a bubble, though we tell people we do not. We believe we do good work and there is a worthiness to our institutions. In my own case—and I have heard others say this—this is the first time I really had to face the reality of my "white privilege." Terms like this were not part of our conversations a year ago. Here we are in this time of extraordinary emotion and enragement about the killing of George Floyd by a police officer, recorded in nearly nine minutes of excruciating video. For institutions, this changes the conversation.

Only a few years ago we were talking about provenance and repatriation. In the past decade, we have been drawing up diversity and inclusion plans. These seemed to be matters we could cope with, because they did not affect institutions at their core. But when museums that strive to be paragons of public trust are critiqued at their core—for how they were formed, and the

systemic wrongs they have perpetuated—this forces a reckoning. It will require humility and openness.

You and I have spent a great deal of time recently thinking about the unique institutional DNA of the Peabody Essex. It is a story not many people fully know. What drew you to this place?
PEM has had a deep engagement with multisensory learning. It is situated "off-Broadway"—and that is interesting. It has a wonderful group of curators and a phenomenal trajectory since the merger of the Peabody Museum and the Essex Institute of Salem in 1992. This museum has vaulted into the top twenty in America in terms of budget, endowment, square footage under roof, and growth in staffing. And it is a lot of different museums in one. It is a museum of art, but it is also the first maritime museum in the US. It is a museum of history. It is a library and an archive. Its collection encompasses tens of thousands of objects gathered from around the world by mariners from one of America's richest cities of the nineteenth century. The museum has an entire Chinese house, moved brick-by-brick from China. And it is America's oldest continually operating museum, founded in 1799. So it offers up a whole sequence of opportunities.

How would you define the term "museum," thinking here mainly about art museums? What would be a short definition?
What makes a museum, first and foremost, is that it has a collection. These are records of human history, of culture, which I define as "what we do around here"—whatever those people and those places are. It is evidence of human creativity and imagination. It assists our awareness and understanding of where we live and how we are connected with the world.

What ultimately is a museum's most important contribution to society?
The pursuit of knowledge can only take place through curiosity and the appreciation of wonder, and a determination in whatever fashion to study and research. There are thousands of versions of what a museum can be, depending on its collection. But the overriding concern for me is what Leibniz called "the theater of knowledge"—the performative aspects of display, which

require a lot of thought, research, and scholarship. Museums can be appreciated by the amateur, the lifelong learner, the connoisseur, and the expert. One of the most amazing things museums do is make you go, *How/why did they do that?*

You have been watching this story unfold on three continents. At one point you were treasurer of the Association of Art Museum Directors. Museums certainly have changed a lot. What has been the most important pivot in your professional lifetime?
I think of Stephen Weil, who wrote in 1999 that museums would change from being *about* something to being *for* somebody. He was indicating a future that at that time we were still struggling to understand. As museums, we had lived a fairly self-satisfied existence for a long time, essentially serving ourselves. Over the course of my career, that has shifted.

Meanwhile, the competition for people's time has become much more intense since the onset of the digital world. Museums have privileged the actual experience of encountering objects for far too long. And now issues of racial equity, social justice, and human rights provide a whole new prism for self-examination by museums. As museum directors today, we are called upon to examine the function of the museum through a whole series of different perspectives on ourselves.

What do museums need to unlearn to stay relevant in this new moment of self-awareness?
We need to unlearn the orthodoxies of the Western intellectual tradition and the Greco-Roman construct of the museum as an academy. The function and practice of museums in other cultures are going to be very different. The relative rise of prosperity, of civil rights and human rights, the emergence of a majority-minority America—these societal shifts compel a new understanding of the need to engage wholly different perspectives on what a museum is and can be within a community. Museums can no longer seek to invoke a set of relatively homogenous belief systems.

So we arrive at a topic that is dear to you. Over the years you have elaborated a complex set of ideas around visual literacy. It started

*at Dartmouth and became the heart of your strategy in Toledo.
Can you summarize its key underpinnings?*

For me, visual literacy is the ability to read, understand, and write visual language. It is an ability that you can learn—a language. When learning a language, we first have to learn its vocabulary and grammar; then we become fluent and are able to read and understand it. In a world where we are moving from the information age to the relationship age—where information is ubiquitous—having these behavioral, communicational, and social skills is crucial. The more you understand what you see, the more you can do something about it.

How does this play out in the museum?

A museum, even in its physical construct, raises a host of questions that illustrate the importance of visual literacy: *What does it look like? Do you understand what happens in there? Does it reveal itself?* Uncomfortable questions are being asked of us right now regarding diversity, equity, and inclusion. As some have said, show me a photograph of your leadership team, and it will tell me about your approach to diversity. No doubt, people of different social backgrounds will literally see a different museum.

In order to have a different perspective, you need alternative points of view. Two of the most intriguing, provocative, and helpful people during my time in Toledo were people I invited onto the board. One was a successful auto dealer, who is also an art collector. The other was the head of the local baseball and hockey teams. Their perspectives were always different, so people-focused and so much better at marketing and understanding customers. The point is, there are multiple ways to understand what you see.

How can we maximize the potential of visual literacy and learning in a museum?

Museums help people to learn in a multisensory way, by moving through space and time. That learning is not just based on what is written on the label. It is what is experienced by different people, based on their own awareness. That is different from a theater or a symphonic hall. A museum allows you to move around, to spend as long as you want in a particular place, look

Brian Kennedy

at things up close, and stand back. There is tremendous freedom of engagement. The engendering of this diversity of experience, and the opportunity for healing and solace that comes from moments of wonder and awe, surprise and delight—all these are interesting to me.

All true, but what would be a specific visual-literacy-nurturing innovation that could express these ideas inside the museum?
The way I have always thought about it is that if you concentrate on basic visual elements and on the principles associated with them, that could tell you a huge amount about anything. Let's take it to the museum itself. Let's examine a museum by color, line, shape, space, and texture. (I would add sound as well— I think one of the most important things about a museum is its tone.) In terms of visual principles, when you think about balance and proportion, rhythm, movement, variety, unity, emphasis, and harmony—if you took each of these and examined the museum closely, and if you asked lots of people to bring their own perspectives to bear, there would be a huge amount you could learn about a museum.

In Toledo, we set up an organization inside the museum called COVE—the Center of Visual Expertise—to conduct these exercises, including on a consultancy basis. When we applied visual-literacy practices to safety training for hazard recognition, for example, we found that in safety training people see things differently. Send one person into a room to find hazards, and they come back with a list. Send in six people, and the perspectives will be multiplied. That is an example where the use of visual language literally can save lives. All over the country, some of the largest companies, from Walmart to Disney, are engaging these visual practices.

Our image of the future is tied to seeing. As you have pointed out, the terms "visionary" and "farsighted" suggest the centrality of vision to imagining the future. So how will tomorrow's museums be different?
Many will be distinguished by what they do outside their premises as much as what they do inside. Their contribution to knowledge will be hugely enhanced by a wholly different approach

to content. Salman Khan came to Toledo and talked about the Khan Academy. The idea that art history could be packaged into segments that people could easily absorb, yet that were full of complexity and layering, was revelatory to me.

I think museum activities will be much more community-based. We will see more humility in seeking out why people don't go to museums and asking them what they like to do there. Museums will have to learn from other sectors. Video-game culture, for example, is bigger than museum culture. Can we make gaming and creative play a core attribute of the museum experience? Questions like these are going to be ever more important in the future.

Given all this, what kind of new institutions do you see emerging in terms of function or physical appearance?
I see a greater urgency to create different kinds of museums out of the collections we have. This will involve difficult choices. To make room for other kinds of work from other parts of the world, it will be necessary to reduce the square footage available to what people are accustomed to looking at. Meanwhile, the flattening of ideas about what people consider to be art is also going to change the nature of what people are willing to pay money to see. This is generally good; however, some might find it horrifying. More people may be more interested in going to the Nike Museum than seeing Rembrandts.

One factor we have to incorporate into our thinking is that it took tens of thousands of years for the world to have a billion people, in 1804—but we got to four billion by 1975, and are just shy of eight billion now. Where are these additional four billion people? In countries like China, India, Indonesia, Pakistan, and Nigeria. Where will they travel? That is part of our future fact as well.

Back in Salem, I am curious what you see as the future. A decade or two from now, how would you know your efforts have been fruitful?
I envision Salem being one of the most remarkable small cities in America, telling the story of American architecture through multiple buildings, some owned and operated by PEM, others by

Brian Kennedy

local history societies and other organizations. This multiplicity will create a heritage town with a vibrant community activity, marked by festivals and parades that happen in sequence, culminating in Halloween. The museum will be the pulsing, vibrating heart of this activity, speaking through its collections, working with contemporary artists, celebrating new technologies, conducting research and scholarship. Salem would be a place where you feel more alive.

SANDRA JACKSON-DUMONT
Director & CEO, Lucas Museum of Narrative Art
Los Angeles, United States

I WANT THERE TO BE A MAGNETIC PULL

A few years back, I had the pleasure of co-teaching summer classes for UCLA sociology students with Sandra Jackson-Dumont, a trailblazer in the museum field who was then serving as the Metropolitan Museum's chairman of education. We would meet in a classroom in the Met's education wing. I remember how inspired the students were at seeing a Black woman occupying a leadership role in a large institution, who spoke openly and passionately about the promise and limitations of museums. Each time, a line of students would form after the class to share their thoughts and get a word of advice. Jackson-Dumont had arrived at the Met after a long career that took her from the Whitney Museum to the Studio Museum in Harlem to the Seattle Art Museum. A San Francisco native and a graduate of the Whitney Independent Study Program who loves to dance in her spare time, Jackson-Dumont frequently curated exhibitions alongside her roles in education and public engagement. We spoke as she was boxing up her New York apartment, days before relocating to Los Angeles, where she is overseeing preparations for the Lucas Museum of Narrative Art, a billion-dollar experiment in reinventing the art museum.

ANDRÁS SZÁNTÓ *You seem to have a special bond with young people. Much of your life has been devoted to museum education. What pulled you in this direction?*

SANDRA JACKSON-DUMONT I always found it interesting to be in a dialogue in real time with real people. I find that museum education and public programs allow for that—interactions with everyone from kids to academics to bankers and scholars and artists. It brings forth something really interesting, whether through the lens of an object or through the lens of an issue. I find acts of serendipitous thoughtfulness the most rewarding. At the center of education is the exciting prospect of people figuring out how they can be their own freedom-agents. What took me in the direction of education was the desire to be a participant in helping people see more deeply and think more critically.

Prior to the Met, you were at the Studio Museum, the Whitney, and the Seattle Art Museum. What did you learn from those roles?
I first heard about the Studio Museum on a public-television broadcast when I was an undergrad and still a biology major. When I came to New York on an exchange program—I hadn't gone abroad, ever; I didn't even own a passport—it was like being in another country. I landed an internship at the Studio Museum. The rest is history. What I learned there? I learned voice and per-spective. I saw many things modeled in successful ways, not the least of which was pride of self.

I received a fellowship to the Whitney's Independent Study Program just after graduate school. And there I learned how to speak the language of the art world. I ended up working there when the director was David Ross, surrounded by an amazing, eclectic group of people. Adam Weinberg was a curator at the time; I remember he had a bird in his office from a Joseph Cor-nell show, which he had saved. Thelma Golden was a young cura-tor. Barbara Haskell was there; so was Eugenie Tsai. Connie Wolf was head of education and became my boss. I remember David Ross saying we needed to figure out whether curators should sign the wall texts, and I thought, *Wow, authorship.*

In Seattle, I wanted to understand money, entrepreneurship, and stewardship. Who was investing? How were they investing?

Why were these collections being built? So I learned something different from each of these places. At the Studio, I learned how to think in community and to be an individual; at the Whitney, I learned how to implement things from scratch; in Seattle, I learned to shape relationships with funders and artists; and at the Met I was able to bring together all of my skills and competencies.

Who or what were your other inspirations?
My graduate-school thesis was on constricted images in Black photography. I knew Deborah Willis was an amazing scholar who was working at the Smithsonian on what was then the African American Museum project. She had the best files on artists. I made a bold cold call, requesting an appointment with her to see her files. She said yes. When I got back to campus, the head of the art-history department said, "Deborah Willis called and said she wants to be on your thesis committee." She has been in my life ever since.

And there were countless others. Lorna Simpson. Lowery Sims. Kimerly Rorschach. Vivian Phillips. I learned the significance of having personal and professional values.

And so after these experiences, and six years at the Met, you started at the Lucas Museum in January 2020, six months ago. How will this museum be different?
What is most exciting is not retrofitting something that already exists—and having resources to do it. Our museum will sit at the intersection of art, people, places, and ideas. Narrative art tells a story—and everyone has stories. We are a museum dedicated to visual storytelling, and it is a big and broad and robust field. And through visual storytelling, we will expand the role of art and of museums in society. We will not be talking about objects without talking about people and their intersections with them. My moon shot, ultimately, is that the art of storytelling connects us to shaping a more just society.

In June, you made news by announcing six appointments on the same day, all women and most of them women of color. It sent a signal.

When I was at the Met, I was once told that someone said, "Sandra has to be careful not to get stuck in that 'community' space." Now everyone wants to be in that space, without always understanding the values, dynamics, and the relational labor associated with the emotional work. After we made the announcement about the new hires, some people asked, "Where and how did you find all these amazing women?" My answer was, I knew them or knew about them. They were working in other institutions: the Art Institute of Chicago, MOCA, the Met. These people exist in the world. They are not unicorns. This can be done. Period.

You published a letter online that was originally intended for your team, which included this sentence: "While there have been advances in our nation's dealing with human rights, it is obvious that we are still a country fragmented and tormented by the diseases of inequity, inequality, and racial violence." What tools do museums have to address this situation?
Staff need to be well prepared, in an unscripted way, with the skills and competencies to tend to all kinds of discussions and practices. We do not exist in a bubble. We exist in the world. And the objects we present are made by people who inhabit places in the world. We need to allow works not only to exist in the moment they were created, but to instruct us about the present time—there's so much to learn from them.

When the Met installed an exhibition of medieval tapestries featuring beautifully and graphically rendered compositions of terror, pain, and violence from several hundred years ago, while in real time we were reading in the news that terrorists had beheaded someone, we could see that there really is nothing new under the sun. Museums need people to facilitate such sensitive spaces.

Before we go into more detail about education and inclusion, I am curious how you would define the term "museum," thinking primarily here about art museums?
I define the term "museum" as a physical and intellectual and imagined location that is fluid and has the possibility to bring people together. It is the custodian of critical conversations, objects, and people related to the past, present, and future.

Sandra Jackson-Dumont

The museum sits somewhere at the intersection of a communal conversation, the imagination, and history. Our most critical contributions happen where those meet—when the museum makes it possible for us to imagine a different future. Museums have the potential to be learning centers where people of any age can come to experience different ways of learning. I imagine people coming to learn about technology and getting certified, and folks saying, "Oh, you got a diploma at the Lucas Museum, that's amazing."

I see the museum as a super-special place, where people can feel fed. In a museum, I can simultaneously be sacred and secular. You can have spiritual reflection and/or sneak a sweet kiss in the corner of a gallery during date night. Museums are important to society because one can experience in them the mundane and the magnificent in close proximity. At the Lucas Museum, we will have eleven acres of green space in the center of Los Angeles. I imagine grandmas and aunties on their morning strolls. I imagine teens going up on the top of this building and having their first kiss.

In short, we should be at the center of people's existence— because people desire us to be, not just because we said so. I want there to be a magnetic pull. The irony is that this is not so different from what museums have been talking about doing for some time.

You and I have had many conversations over the years about what ails museums, and also about their opportunities. What needs to be fixed about museums?
Museums need to do more than just talk about progress—they need to be about it. To be honest, I think leadership is at the center of what needs to be fixed. We need critical, inclusive leaders and boards that expect their museums to be at the nexus of the experiential, the social, and the diverse. You can hire people who come to the museum with a specialization and practices that center on diversity, equity, inclusion, and accessibility. Institutions must do more than offer workshops about diversity. They must put the workshop learning into policy and practice. They must address a sense of belonging. Leaders have to define elevated expectations and behaviors, to clarify the thoughts and

practices that need to abound in an institution. At the Lucas Museum, strategy will be framed through the lenses of diversity, equity, inclusion, accessibility, and the sense of belonging.

Acquisitions is another area that needs scrutiny. The canonical presentation of art history has such a commitment to rigid boundaries. I have often suggested that encyclopedic institutions should close the whole thing down and hang it differently.

At one museum they did the math and found that if they collected only work by women, it would take almost eighty years to achieve gender parity. That's how deep the imbalances run.
It won't happen overnight. But it can't happen if we just talk about it. I have a quote on my wall by Okwui Enwezor: "To sojourn forth with the endeavor, the weight of the canonical art history must first be shrugged off, let it fall gracefully by the wayside." He says, "That does not necessarily mean casting it aside in toto, nor abandoning its important insights, but we must acknowledge and identify the persistent blind spots of that history…" Like Okwui, I'm not saying all of art history should go away. But we need to approach it through the lens of varied publics and with nuanced criticality.

Let's talk more about museum education and how it intersects with equity and inclusion. What are the most common misunderstandings about museum education?
The number-one misunderstanding is that museum education is just about K-12 school programs and tours, and that it is not critical or scholarly—that the rigorous intellectual work is happening somewhere else. Second, education is often assumed to be synonymous with community efforts, the place where people of color find their way into museums. That is an overly narrow perception. The truth of the matter is that education and public programs are extremely complex, particularly in museums, since this is explicitly where art, scholarship, and education intersect with people, equity, inclusion, and social issues.

In the 1970s, Lowery Stokes Sims and a guy named Irvine MacManus were hanging Impressionist paintings from the Met in Bronx Borough Hall. Nina Simone performed at the Met. Critical conversations about the state of affairs in the city happened in

education. Similar events have taken place at most museums. An education program brought iconic filmmaker Julie Dash to the Studio Museum. An education program placed Nan Goldin to talk at the Whitney, where LGBTQIA teenagers could be found in the audience. Education programs have been a catalytic force for dialogue about who we are, who we once were, and who we can be.

Education programs have a stealth approach to problem-solving, and as a result they often appropriately ruffle feathers. When done well, they are at once seductive and transformative. Education programs make the museum relevant to the everyday world—to municipalities, to government, to political figures, to "the people." Even so, they are marketed and resourced the least.

How will education be organized differently in the Lucas Museum? What will you call it?
The Lucas Museum will have a deputy director for "public pro-grams and social impact," or it might be called "public practice and social impact." Instead of "education" we are going to call it "learning and engagement," and under this department there will be an area specifically for K-12 teacher training and student development. Out-of-school activities are a different kind of teaching, with more emphasis on youth development. Those again require different skill sets, but they relate to the larger social-impact goals. There will also be a full range of academic and social learning opportunities for adults of varied back-grounds and interests.

Will your head of public practice and social impact be part of your core team?
Yes. What I'm calling the director's advisory right now will include the COO, the chief curator/deputy director for curatorial and collections, and the deputy director for public practice and social impact. We are still defining external affairs, which over-sees communications and PR, including the design studio. And this group will likely include the head of development, for which we will also explore experimental approaches. The final lead role will be the deputy director for strategy and administration.

Where else do you find models that may be helpful to rethink the museum?

If you go into a Nike store, you will see shoes on pedestals, under plexiglass; you will see a label explaining the shoe. This is the language developed by the museum field, which expresses a visual value that people understand. The sneaker industry took its cues from the art world. The limited-edition sneaker or clothing line is another example. And they have people lining up outside of stores to buy these brands. There are even auctions for sneakers. There's an entire industry that mirrors our industry.

Creativity and innovation used to be our thing. But it is the tech industry's thing now. I am interested in how we can learn from other industries. For example, I am a big fan of IDEO, the global design and innovation company, and their intersectional thinking and creative problem-solving. They think about the practice, not just the thing. Changing a behavior is the product of good practice. I also love how filmmakers are telling stories now. I am interested in how we can connect these worlds. I want to create a relational culture of learning and exploration that is reciprocal and interrogative, in a good way.

In the entertainment industry they pay attention to and learn about their constituency, because it is connected to their livelihood. They're not just making films for other filmmakers. The art world could take a page from them. We say, "Oh, people don't get it." I disagree. It never seems to occur to museums that people may simply find their ideas weak or not that interesting. On the other hand, people may not understand you because you didn't articulate your ideas in ways that are digestible, and compelling enough for someone outside your small group to understand. One should never assume relevance. You really have to know the audience.

When it comes to forging connections with a wider community, where do museums tend to fall short?

Where anyone falls short—not just museums—is that they don't understand people. It's that simple. You have to go where the people are, and be there without a microphone. You have to engage as an invested individual or institution and be willing to learn. Think about what you are trying to offer and how it inter-

Sandra Jackson-Dumont

sects with people's lives. It is important to have a people-first approach. In fact, I don't find community engagement to be elusive. People talk about wanting to commit to community, but they don't know where to begin. They haven't hired the right people who are trained for this kind of engagement. If you haven't invested in this area the same way you have in Flemish paintings, or the restaurant, or ticket sales, or marketing, then it will feel elusive.

The Lucas Museum by its nature will have a closer relationship to popular culture. Where are the opportunities?
There is nothing more seductive than great stories, because they connect us. That's the moon shot. Popular culture resides in our everyday psyche. Stories and popular culture make magic. What this institution will do is help people see themselves and their stories in great works of art across time and space.

And what are you learning from this process so far? This has been a deep dive into imagining a new kind of museum.
I have been here for six months, in a most unusual time. We are a start-up. It's messy and it has been fascinating. While I am a willing participant in a super-interesting experiment that is challenging the ways museums are used and function in society, I've had to keep reminding myself to unlearn some stuff. We are also in the midst of a pandemic—medical and racial. I think what I am learning about the most is leadership. I realize, now more than ever, that leaders have more power and influence than I have been led to believe. How you use that power and influence is a question of judgment and values.

Let's assume everything goes according to plan and the museum opens in 2022–23. What will success look like?
Success cannot be "a bunch of people came." That's only one lever. Another would be that people within a certain radius keep coming back. Examples might include teachers integrating the museum experience into their curriculum, artists using our spaces on a regular basis for inspiration and intellectual banter, people walking the park daily, kids begging their parents to take them to the Lucas Museum. We will have outcomes for what we

implement in order to avoid the trappings of attendance and exhibition reviews as the sole measure of success.

I want to end with those students we used to teach. Some, usually women, would stay behind to talk to you, clearly looking at you as a role model. What advice would you have for a young woman or man thinking about entering the museum field?

Think about who can mentor you. Find someone you are interested in learning from, and be where they are. I have found people to learn from everywhere I have been. My greatest models have been those who had a point of view and helped me build the muscles to develop my own.

Sandra Jackson-Dumont

DANIEL BIRNBAUM
Director & Curator, Acute Art
London, United Kingdom

THE MEDIUM THAT MIGHT KILL ALL OTHER MEDIA

I met Daniel Birnbaum in the early 1990s at one of the legendary parties hosted by the artist Ronald Jones, then chair of Columbia University's art department, who happened to be my upstairs neighbor. Birnbaum was studying philosophy at Columbia, and Arthur C. Danto, my thesis advisor, was a mutual mentor and friend. Birnbaum eventually moved from art writing to heading institutions: from Sweden's leading art residency program to Frankfurt's Städelschule to eight years as director of Stockholm's Moderna Museet. There, among his many accomplishments, he introduced the metaphysical painter Hilma af Klint to a global audience. In 2009, he oversaw the 53rd Venice Biennale. All the while, he continued to publish in *Artforum* and elsewhere. In 2018, he made the leap to become the director and curator of Acute Art, a London-based initiative that puts augmented- and virtual-reality tools in the hands of leading artists. Olafur Eliasson's AR work *Wunderkammer*, launched shortly before our conversation, has reached around 100 million viewers. This and other Acute Art experiments point to emerging practices that traditional institutions are just beginning to embrace.

ANDRÁS SZÁNTÓ *When we met at Columbia University, in the early 1990s, you were studying philosophy, and your main connection to art seemed to be through criticism and ideas.*

DANIEL BIRNBAUM My entry into the art world is 100 percent through writing. I was a student in comparative literature and art history. Philosophy is where I continued to study, first in Berlin, and then for three semesters at Columbia. I was always also a journalist and an art critic. It is how I made a living over many years. I worked for one of the biggest tabloids in Stockholm, *Expressen*. They had pretty serious cultural pages. I reviewed books and exhibitions, and a few art-related events.

So you were continuing in the tradition of Swedish art writers becoming museum directors, like Lars Nittve.

That is true. Before Lars there was Olle Granath, who was director of the Moderna Museet and the Nationalmuseum. He was even more extreme than us. We were at least close to some artists before joining the museum. I would write their texts and I would help them install. Olle became director coming straight from his newspaper.

You have continued to write and translate in an academic vein. Arthur Danto played a role in both our lives. How does being grounded in theory and criticism define your outlook?

I always understood myself primarily to be a writer, even when working for institutions. When I was dean of the art school in Frankfurt, my first big institution, I always said that if it takes so much time that I can no longer write, I will quit. Later, as director of Moderna Museet, there were periods when there was simply no time. But I did continue to write for *Artforum*.

I can say that Arthur was a friend of mine as well, but more like a teacher. He took me to an *Artforum* party, and there was editor-in-chief Jack Bankowsky, and Arthur walked up to him and said, "This is Daniel, one of my students—he's going to write for you from Europe." Of course, *Artforum* was a dream for me. Writing for *Artforum*, which remains a great publication and back then was the bible, is what made me an art-world person. I can thank Arthur for that. He kicked me into the professional art world.

Apart from being a writer, you've run a residency program, an art school with a gallery, a national museum, the Venice Biennale, and now Acute Art, which experiments with augmented- and virtual-reality art. You've covered the bases. How have these roles shaped your idea of what a museum can or should be?

Daniel Buren, the highly intellectual French artist, wrote several huge volumes of essays. He was one of the first people I got to know in Frankfurt. I read his essays on the different frames of the art world: the studio, the museum, the exhibition. And in a way, I passed through all those frames. The art school was the studio. The biennial was about exhibitions. And finally there is the museum. To say something highly pretentious, Hegel criticized Schelling for pursuing his education in public. Likewise, instead of learning in the proper way, I threw myself in the deep end. I didn't know what it was like to run an art school. I was also not so well prepared to run a national gallery. But it was interesting to explore different institutional frames.

So with these experiences in mind, what is a museum for you?

Perhaps the right question is, *What is an interesting art museum?* Moderna Museet was founded in the late 1950s, the same year as the Louisiana, in Denmark. Sweden wanted to be so modern that this would not just be a state museum of modern art—the museum itself would be modern: the "Moderna Museet." It had a few key strengths. One was Duchamp, who had a major impact on the program. Moderna Museet was also one of the first institutions in Europe to develop a close dialogue with a new generation of American artists. The logotype was done by Robert Rauschenberg. Andy Warhol's first solo museum show in Europe was staged there. Another strength was its radical interdisciplinarity. In the 1960s there was no film institute or dance theater in Stockholm. Everything happened in the Moderna Museet. Fifty years later, that is now no longer so unusual. But one can still take that as a starting point: that idea that the visual arts are more interesting when embedded into other art forms.

Was there an epiphany, an exhibition, a touchstone that defined your perception of museums and what they could be?

Daniel Birnbaum

I said earlier that I entered the art world entirely through writing. That is not entirely true. Actually, I entered the art world through my own mother. My mother was a curator who worked with medieval art. She and my father were part of a progressive group of people in the 1960s. My first experiences of an art museum and what it could be, even for children, was actually at the Moderna Museet. There was a show in 1968 called *The Model*. It was one of the most extreme forms of experimentalism that ever happened at our museum. Pontus Hultén, director from 1957 to 1973, invited the Danish artist Palle Nielsen to transform the museum into a playground. Fifty or sixty thousand kids came to the museum. There is even a picture of our eventual prime minister, Olof Palme, who was education minister at the time, playing around with his children. I was five years old, and that was a major encounter, without my knowing it, with the kind of experimental curatorial project that is possible in museums.

Pontus Hultén's name keeps coming up in these dialogues. He is sort of the secret hero of this book. Several directors mentioned the early days of the Centre Pompidou, when Hultén was in charge, which for our generation embodied the radical potential of the museum.

It was through the books of the Pompidou that I got to know him. To me, one of the most fantastic periods in museum history is those years when Pontus staged *Paris-New York, Paris-Berlin, Paris-Moscow, Paris-Paris*. And those books meant a lot to me; I collected them. I knew who Pontus Hultén was, of course, because he was from my own little town. I met him a few times later on. A lot of people were slightly intimidated by him. It's like being a filmmaker in Sweden, and then there is Ingmar Bergman. But curators are quickly forgotten, and I often remind people about the great Pontus Hultén. He was a visionary when it came to making the museum more productive, elastic, and relevant as a center of production, and not only of consumerist reception. I associate him with a truly adventurous interdisciplinary approach to culture. For me, he was a starting point.

*Over our lifetime, what have been the most impressive achieve-
ments of museums? What is the biggest shift you have seen
happening?*
We have two decades of incredible expansion and globalization
behind us. When I started to look at contemporary art in a more
professional sense, it was almost as if everything important was
happening in New York, or in Cologne. Of course, that was an
absurd misunderstanding, linked to the art market and so on.
But it was a quite influential misunderstanding that shaped how
most of us looked at art.

The great catalysts of change were the biennials. Through
them, artists from many places in the world were linked to the
Western art world, which expanded. What happened in the bien-
nials in the early-to-mid-1990s then started to migrate into the
museums. Now even MoMA, the ultimate, most paradigmatic
and influential museum of modern art, has gone global.

*These were signposts toward the future. From which other fields
can or should museums borrow as they evolve?*
We are approaching the strange world that I am working in now.
Running a museum is always an attempt to find new collabora-
tions, new ways of funding things. Stockholm is a more high-tech
city than people realize. Skype is a Stockholm company; so are
Spotify and Ericsson, which pioneered the telephone. There
is an interesting art-and-technology thread running through
Moderna Museet, from Picabia and Duchamp on to our moment.
The 1960s Experiments in Art and Technology (E.A.T.) involved
a Swedish engineer, Billy Klüver, and his American contacts,
notably Robert Rauschenberg and his friends, among them John
Cage and Merce Cunningham. In Stockholm, I was part of some
interesting conferences on art and technology. I tried to bring
people from that world into our museum. Maybe that became
the diving board through which I exited the museum.

*You pivoted into that space at the intersection of art and tech-
nology with Acute Art. Tell me about it, and where you see new
technology in the museum of tomorrow.*
I was lured into this. It wasn't my idea to explore augmented and
virtual reality. Acute Art is privately funded. It was established by

Daniel Birnbaum

a Swedish art collector who doesn't want to be too visible. He and a few friends thought that VR and AR will change everything—not just art, everything. They took me to Warner Brothers Studio in London. I looked at some Disney VR productions. I came out dizzy, almost wanting to throw up. I had never seen VR before. But I realized, *Okay, this is a strong new medium*—as disruptive as photography was in the nineteenth century or TV in the twentieth. I told them I could help to link these new tools to artists.

The E.A.T. project tried to do the same thing, giving important artists access to new technological tools. In retrospect you can say that with Cage, Warhol, and Rauschenberg they did exactly that, at least in a Western context. Acute Art wanted to engage artists who are not tech-y but who stand for something. A ballerina with Jeff Koons was an early project. His objects are so perfect, they can hardly exist in the world, so he could do a perfect shiny object in VR. Olafur Eliasson, a key artist when it comes to experimental atmospheric and immersive installations, did an early work. Marina Abramović did one. Of course, you can't just work with rock stars. But it was a strong start, and people have noticed. Since then, we have worked with many artists. I think of it as a kind of curatorial adventure.

But where would this kind of work sit in the museum? We did collaborations with the Serpentine, Frieze, the Ludwig Museum in Cologne, the Serralves Museum in Porto, and private institutions such the Julia Stoschek Collection in Berlin—all well-known art structures. I don't think anyone knows where this kind of art will sit in the future. What will be its place in the commercial art world? What will be its place in the institutional world? There are elements in these mediums that break up the structures of existing institutions.

The dream of a portable museum, a museum without walls, has been with us through the twentieth century, ever since Duchamp's Boîtes-en-valises—*and along with it, the dream of a museum with less grandiose ideologies: looser, less intimidating, more flexible. Can technology deliver that?*
Boîtes-en-valises is an answer to what Walter Benjamin wrote about art and mechanical reproduction. These boxes can be carried around and placed in anyone's home as a kind of

mini-museum. VR, AR, and mixed-reality projects are different from an artistic and curatorial point of view, but they offer similar distribution possibilities.

We launched Olafur Eliasson's *Wunderkammer* recently. You open the Acute Art app and download objects that are very Eliasson-like: a sun, clouds, a rainbow, rain—magical, extraordinary things in nature. One can place them in one's living room. Hundreds of thousands of people have experienced Olafur's work this way in their homes. The *Boîtes-en-valises* were produced in a series of ten and then twenty. Now this expansion beyond the walls of the museums has happened on a vastly larger scale. Of course, this technology is limited to what you can see through a phone. However, it is participatory. You can place the sun next to your dog, or your sofa. You can send it to your friends and post it on social media—it reaches an enormous number of people. It has incredible potential.

Virtual reality is, of course, the medium that might kill all other media, to use a slightly aggressive rhetoric. It is so overwhelming. Who needs opera, film, cinema, or video art when this becomes fully developed? However, VR is not easy to distribute. You still have to install headsets. And maybe it is not a utopian idea, but a dystopian idea—everyone sitting at home, watching their own thing. In the art world we like to share experiences. So the museum without walls that is emerging with new technology may be imperfect; but in principle, it is already here.

In this context of massive innovation, what do museums need to unlearn to stay relevant, to keep up with this rapid expansion?
We are talking in the middle of a major crisis that no one could have predicted a few months ago. Maybe what we need to unlearn is the expansive model of the museum. One always thought that one should build another wing, and every second show should break an attendance record. Maybe one has to go beyond the idea that everything happens in architectural structures and behind walls, in ever-growing buildings, with ever-bigger staff.

I don't want to sound like a sentimental idiot who thinks everything was better before. But the elephantiasis of institutions today is not normal. Twenty-five years ago, you could go to the Met or MoMA and be quite alone in them. The galleries

Daniel Birnbaum

hadn't yet grown into mega-galleries. The art fairs weren't everywhere. It was not routine for professionals to travel to another continent just for a few days.

With new technologies, one version of the future could be that you don't need such institutions anymore. You can have your own electronic *Boîtes-en-valises* at home. I am not actually a believer in that—I think we will always want museums. But institutions don't have to be enormous. They don't have to be totally global. Maybe technologies can keep the international conversation alive even when people stop traveling as much as they used to.

Can technology help crystallize new structural forms, new kinds of institutions?
With Hans Ulrich Obrist, I have been working on essays on new formations for at least a decade. One was published in *Artforum*: "Museums on the Move." We were thinking whether there should be some sort of network-like connections between institutions that make local nodes or productive centers, not only receiving centers. Could they be linked together into something? I said, "It should have many heads." And Hans Ulrich said, "An electronic hydra!" The hydra, of course, was a monster in Greek mythology with many heads. Maybe it is not the best metaphor, but a many-headed institutional structure, one that is not monolithic or centralized, and that has many places linked to one another electronically—through virtual- or augmented-reality connections—is actually what we need in the future. This is now pure metaphysics. But if one of the new limitations of our condition is that we cannot travel as much—and we shouldn't— then maybe the global exchange could be made possible through structures like that. Hans Ulrich got so excited about this idea, he started to make drawings of the Electronic Hydra. All night, I was getting new drawings via WhatsApp. That Electronic Hydra may be the answer to your question.

The pandemic is just the latest test for museums. Cratering finances; legitimacy crisis; calls for more just and inclusive institutions; climate change; authoritarian politics—can museums stay resilient in the face of this onslaught?

Museums are the memory banks of our civilization. As long as they are not just about entertainment or tourism or city branding, if they are actually centers for intellectual reflection, then they will remain relevant. Yes, they should be more inclusive—that is a major challenge. The climate emergency, which Tate declared, is something to take seriously. On the other hand—and I don't want to sound cynical—how is a major museum, built on mass audiences, in a tourism center, mounting exhibitions that require shipping art across continents, supposed to operate responsibly? Not unless you transform the model entirely. All this will have to change. Which is not to say that everything Internet-based is harmless from an ecological point of view. Those server farms suck a lot of energy. This is part of a much bigger challenge. And yet, new, immersive technologies do offer a glimpse of the future where many of these problems will be partly solved.

I remember a funny story from the Städelschule. There were two Austrian professors, Peter Weibel and Peter Kubelka. Weibel, who later became director of the ZKM in Karlsruhe, had founded a media institute in Frankfurt that was part of the Städelschule. Kubelka was a believer in more classical things, and especially cooking. He said it was more important for students to know how to bake bread than to develop electronic kitsch with the tools of the military-industrial complex.

I have to say, for most of our life I have been more on the bread-baking side of things. But with an iPhone on your breakfast table, this is no longer an either-or choice. You have a bite of your toast and you have your iPhone, this ultra-complex device woven into your daily practice. That is our new life world. It will create entirely new visual systems of exchange. And you may not need those big structures—those shiny new buildings and huge collections—because it's all there, in the palm of your hand.

Daniel Birnbaum

KATRINA SEDGWICK
CEO & Director, Australian Centre
for the Moving Image (ACMI)
Melbourne, Australia

YOU HAVE TO GET OUTSIDE THE BUBBLE

I first learned in depth about ACMI—the Australian Centre for the Moving Image—when conducting research about institutions that support moving-image practices for a new art commission. What struck me about ACMI was not just the range of activities it undertakes to explore the potential of new technologies and mediums, but also the audience-friendly way it approaches the endeavor. Being closely linked to film and entertainment has allowed ACMI to loosen up and experiment with the operational models of museums. I spoke with ACMI's director, Katrina Sedgwick—a former actor whose professional career has encompassed film, TV, and large-scale cultural festivals—weeks before the reopening of the institution after a multi-year comprehensive renovation.

ANDRÁS SZÁNTÓ *You were acting in films and television from a young age, and later joined a multidisciplinary theater company. What got you involved in museums?*

KATRINA SEDGWICK It was quite a circuitous journey. I realized in my mid-twenties that I was not going to be Cate Blanchett. It was time for a change. I grew up in South Australia, where we have wonderful arts festivals. I wrote to the general manager of the Adelaide Festival of Arts for a job. From that opportunity I spent the next fifteen years working in multidisciplinary arts festivals, mainly as director and CEO. That included establishing the biennial Adelaide Film Festival, in 2003. I structured the festival as a celebration of the moving image, including film, TV, and visual art. After the first year, an extraordinary thing happened. I received a phone call from the premier of the state, offering us one million Australian dollars for every festival to invest in Australian film. We had money to invest purely on the basis of creative merit.

From there, I went to the Australian Broadcasting Corporation, which is like the BBC. I was head of arts for television for three years. And then I got asked to be the director of ACMI. So it was a circuitous journey to museums, but a useful one. Through my festival experience, I am used to creating programs that have multiple points of entry, that encourage curiosity and discovery, and that engage with industry to support artists and practitioners to explore new ways of expressing their ideas and sharing them with the public.

Now here you are, in the world of art. What else do you bring with you from the worlds of film, TV, and entertainment?

I am interested in breaking down silos between forms. I worked in multidisciplinary theater for a decade. I am interested in how practitioners move between art forms, and how technological tools can be deployed creatively. I am seeking to bring together a broad audience to explore wonderful work and the process of creating that work in an inviting, welcoming social space. Theater has been one of the biggest influences on my professional life: the resourcefulness one has to bring to it, the collaborative, ensemble approach to making it, and the entrepreneurial and commercial approach to "distributing" it.

Tell me about the Australian Centre for the Moving Image.
ACMI is extremely popular in Melbourne, but not everyone
outside Australia knows about it. You are currently closed for
redevelopment—brilliant timing. What will emerge when ACMI
reopens?

We are the national museum of screen culture, established by
the Victoria State Government in 2002. We explore all things
moving-image: film, TV, video games, digital culture, and mov-
ing-image art. What makes us unusual is the collision among
work that embraces everything from the blockbuster and main-
stream to the experimental and niche. We have a collection that
includes the state film archive. It is modest: 250,000 objects,
the oldest one being 127 years old. We have a free permanent
exhibition, which explores the past, present, and near future of
the moving image, and really forms the spine of our institution.
We have temporary gallery spaces and a rich commissioning
program, and we make exhibitions that we then tour nationally
and internationally. The exhibition we made with DreamWorks
Animation studios in 2014 was, on its Brazil tour last year, the
most-visited exhibition in the world in 2019.

Again, great timing …

We have two cinemas that we program year-round. We host
twenty festivals and conferences. We have education spaces.
We had more than 1.5 million visitors in 2019. Another half-
million people saw our touring exhibitions. We are as interested
in illuminating the process of making as we are about the final
product. We connect audiences to the makers. Our new media-
preservation lab sits in our public foyer space. You will see the act
of preservation being done by our team on a daily basis. There
is an Audience Lab, where video-game makers or artists using
AR and VR can test out their work with our visitors. So we are a
working laboratory, and a connection point between the public
and the creator. Four years ago, we also established a co-working
space in our museum. We have sixty desks for practitioners, busi-
nesses, and researchers to base themselves in our institution.
That is yet another way of being part of the conversation.

Katrina Sedgwick

Let's talk about moving-image as an artistic medium. This is the forward edge of art innovation today. Can it find a proper home in the museum?

Visual artists have been experimenting with moving-image mediums since they began. Clearly, moving-image is becoming more and more visible globally, particularly as the technology becomes less expensive. We have done major exhibitions of artists such as Candice Breitz, Yang Fudong, William Kentridge, and Shaun Gladwell in our thousand-square-meter temporary gallery space, where we can show their works at scale. We were the founding commissioners of Julian Rosefeldt's thirteen-channel work, *Manifesto*. Our team is extremely skilled in working with artists to develop and stage these works. And increasingly, we have been moving into supporting artists as they explore new media, like virtual reality. The first three VR commissions we did with performing-arts practitioners, adapting work they had made to VR. We then set up a commission for visual artists who had an established gallery practice to do their first VR work. That has been really interesting.

So the museum created its own support mechanisms for this new field. What else do museums need to do differently? What habits do they need to unlearn to be platforms for new media and new creative experiences?

Our audience has three intersecting dimensions: the public, the education sector, and industry. Our sweet spot is when those three come together in conversation. We are interested in exploring the development of a work, not just its final incarnation—making sure that the public and the education sector are part of that journey. We see ourselves as a trusted space where people can come from different backgrounds and explore new ideas together. That is a shift in purpose that museums have been making for twenty to thirty years and is gaining in momentum, especially as Covid-19 is making deep social inequities widely visible. Post-Covid, it will be all the more important.

As a field, we need to break our own rules. In 2005, I learned that the BBC—talk about a traditional bureaucratic institution—was looking at how to use their incredible archives more effectively. They set up a Creative Archive, which operated for only

eighteen months, but I loved it. They digitized a hundred hours of audiovisual material that was not encumbered with complex copyright. And through the Creative Commons License, they created an interface that enabled the public to access that footage, to play with it and reuse it. People could make a mash-up, the way you might make a hip-hop track, out of the material in that archive. Likewise, a trainspotter could go in there and find train footage and share with their trainspotting friends. It was a way of mining this amazing resource. For me, this was a penny-drop moment. Digital technology was not just about social media, and it can be an extraordinary tool for all of us to work differently.

There is a massive shift all of us have to make, particularly with Covid. We are not always going to be able to physically visit the museum. I established our Experience and Engagement Department five years ago to creatively harness the digital tools available to us, to improve how we work together as an organization and expand how we engage with our audiences. We've been using the intervening years to experiment. With the forty-million-dollar renewal project we are currently delivering, we are investing in developing bespoke digital products, including our eXperience Operating System (XOS), which runs our back-end-connecting collection software to exhibition-delivery software, and into our website and what we call our post-visit experience. Our new permanent exhibition is designed to evolve—with XOS we will be able to deploy media at five minutes' notice to our institution, on any screen, as well as captions for accessibility—and this opens up a lot of new opportunities for the future. We are thinking deeply about how a visitor engages with us after they visit. In a digital world dominated by opaque algorithms, we want to influence what our audiences watch going forward, by providing human-curated recommendations, both at the time of the visit and afterward.

Immersive experience is nothing new, culturally speaking. We have long had cathedrals and palaces. Large-scale installations have long been made by artists. Yet in recent decades, art has been primarily exhibited in the so-called white cube, in an antiseptic, cerebral, anonymous setting. Lately, there is more public

Katrina Sedgwick

fascination with immersive experience. What is bringing forward this desire?

People are thrilled to be transported in that way. But immersion can also become relentless. We have spaces with extraordinary moving-image works, but next to them we will have a room full of costumes, for example. The cabinet of curiosities has been an inspiration for our permanent exhibition. We designed a twenty-meter-long cabinet, full of objects from across the various kinds of media that we explore.

I think what people love is the theatricality of immersion. We made a show, *Wonderland*, in 2018, based on the screen adaptations of *Alice in Wonderland*. Since 1903 there have been more than forty-five—film, TV, music videos, etc. We created a very theatrical, immersive exhibition that was the opposite of the white cube. You arrived in a hall of mirrors. You had to open different doors. There were things you had to climb over. A map with a little chip triggered magical animations. We were simultaneously telling a story about special effects in cinema. We had a white room that, with projection mapping, magically turned into a fully immersive Mad Hatter's tea party, bringing the process of CGI to life. The exhibition was designed by a theater designer, and our curators worked with an advisory group that comprised all sorts of different arts backgrounds, a multidisciplinary think tank. We were inspired by the Victoria & Albert Museum's *David Bowie Is* exhibition, which we presented in 2015, and by Teatro de los Sentidos (Theater of the Senses), an experimental theater company in Barcelona. We wanted to support the telling of the story with the tools of theatrical design and with digital technology.

You spend a lot of time with artists and content producers and technologists. Where do you see moving-image going?

It is important not to get hung up on the technology itself, but to focus on how you can support artists to experiment with the technology as a canvas for their ideas. The technology is going to constantly change. Depending on whom you ask, VR is over, and AR will be the dominant mixed-reality platform. I don't know. I do know that commissioning artists in both of those spaces will lead to exciting shifts in their practice, but also exciting shifts in how the platform can be deployed. The way artists use their

creativity in one particular medium doesn't lock them into that technology. As a museum, we can raise money to give artists proper funding to experiment. Nine times out of ten, they do something very interesting.

New technologies, timeless themes. What other mechanisms or approaches would you like to see in museums so that this wider sphere of creativity is recognized?
Artists and practitioners are experimenting with new tools. It is the museum's responsibility, given the pace of this evolution, to look outside the usual exhibiting forms and exhibition spaces and make sure that we are not just talking to ourselves. We need to get out into those nooks and crannies where practitioners are experimenting. It is hard to work out the logistics of presenting this kind of work, and it can be expensive. But it is really important for this work to be presented alongside more traditional art. You have to get outside the bubble.

You are in the midst of renovations, so you are thinking about a museum as a place, as an architectural proposition. Sometimes I feel hotels and malls are better at creating places where people actually want to spend time.
In 2015, a company called Meld Studios created a user-experience visitor journey map for us. It described our main foyer space as working more like a shopping mall, where people can sit down, take time, or check email using our Wi-Fi. And we loved that. We thought a lot about social spaces in the museum, and how we can make them more welcoming, to encourage people to dwell, to spend time, to share stories, to be social. Previously, we looked quite corporate. Our building was slick, but cold. So we tried to warm up the space.

The museum when it reopens will be fully licensed through all the foyer spaces. You can grab a drink and sit in a nook, do your email, whatever. We opened up the retail space, so you can pick up a book and browse and spend time. You do not have to engage in depth with the collections or the exhibitions, but the foyer spaces are full of clues about what is inside. Shopping malls are brilliant at this. We want people to come in, and we want them to spend money in our café, for example. We are bringing on a

Katrina Sedgwick

celebrity chef soon, so people will want to eat our food. Once they are in, hopefully then they will explore our ideas and stories, and become part of our community.

I don't think it is entirely a coincidence that your institution is in Australia. There are perhaps advantages to being slightly outside of the center, a kind of freedom. What is it about this context that lends itself to open-minded thinking?

That is true across the arts. Our dance community is doing incredible things. In theater, there is breathtaking work going on, and in music. In one sense, we are at the center: we have the world's oldest continuous living culture, through our First Peoples, who have lived here and shared their stories for more than fifty thousand years, and their contemporary practices across the arts are extraordinary. On the other hand, in terms of the Western world, as a colonized nation, we are on the edge. Equally we sit on the edge of Asia and the Pacific. We are a nation of contradictions.

We are an incredibly diverse and multicultural nation. We have a rapidly growing Asian population. We have had waves of migration from the Middle East, northern Africa, South America, and of course from Southeast Asia. The mix of cultures here is extraordinary. And we look outward. We are a nation of travelers. We see what's happening elsewhere in the world, and we want to be a part of it.

In a lot of ways, being on the edge has meant that we are hungry, we are out there looking and learning. And perhaps because of that, we are not as precious about the way things need to be done. It doesn't mean there isn't a very healthy old-fashioned establishment here that we have got to push up against. We remain a white-male-dominated nation in terms of the distribution of power and wealth. But there is an openness and a sense of experimentation with an anti-authoritarian energy, which is useful for poking and pointing and trying out something a bit different.

You spent much of your professional life in other creative fields, collaborating with practitioners outside the museum world. From which fields do you think museums as organizations could or should borrow to invigorate the museum field?

Embedding digital and visitor experience at the heart of the museum is critical. Most institutions work well with social media and web-based platforms as a marketing tool. But we have to think much more expansively about how digital can be used internally to engage with the audience, and to think really deeply about their experience.

For me, contemporary practice in the performing arts has been inspiring. These ensemble-based practices are flat in their structures, and they bring people from different fields together, at an early stage, to create and develop work. That is where you have clear evidence that a multidisciplinary approach to making a work or solving a problem can be incredibly fruitful. It can enable you to take a leap that you might not otherwise make creatively, programmatically, even operationally. It is a model I like.

What keeps you up at night? We're living in a world of reactionary politics, pandemics, climate change. Institutions in some places are running out of money. What's the biggest fear?
My fear is that culture, and in particular galleries, museums, libraries, will be seen as a luxury rather than for the crucial role they play. I am absolutely passionate—and I know you are, too—that these institutions need to be at the center of our recovery. Here in Australia, because of government investment, we are less at risk. I am looking with dismay at the vulnerability of so many wonderful museums in the United States.

It is more important than ever to have these safe democratic spaces to explore ideas together, to look at our past, and to get a glimpse of what the future may bring. We need spaces where humans can curate and select what those stories might be, rather than a machine doing it for us. As we move into an economic depression, I hope those things won't be sacrificed. It would be an incredibly destructive short-term move that would undermine the recovery of our communities.

Cirque de Soleil just filed for bankruptcy today ...
That is just crazy. The other fear is: What if there is no vaccine, and the entire model is broken? What does that mean? Cirque de Soleil is on the front line, because their sustainability is all

Katrina Sedgwick

about box-office revenue. For all of the performing arts, they are so reliant on that revenue—and for now, that is gone.

I don't want to end on a negative note, especially since you seem to be an incurable optimist. So tell me what gives you hope. You are months away from reopening. Hopefully a vaccine is found, and the world turns the right way up. What is your best hope for innovating the museum and enabling the best use of the new creative tools that we now have?

I am incredibly excited to open our doors. We have this amazing platform now that is designed to iterate. I am excited to see how the things that we are trying out will work, or not work—how they evolve, what impact they will have. I am excited about the role we are going to play in the recovery of Melbourne and our creative industries. And I am excited to see how artists are going to respond. What has happened to creative industries through this pandemic crisis is devastating. But I know that out of this, too, extraordinary work will appear, and I am excited to see what that will be.

AXEL RÜGER
Secretary & Chief Executive, Royal Academy of Arts
London, United Kingdom

THE BORDERS WILL LIKELY
BECOME MORE FLUID

I first met Axel Rüger a decade ago at a museum confer-
ence in Vienna. Then director of the Van Gogh Museum
in Amsterdam, one of Europe's most popular cultural
attractions, he spoke candidly about the art institution's
responsibility to maximize revenues and operate more
efficiently—not as an end in itself, but as a means of ensur-
ing the museum's autonomy, stability, and sustainability.
A keen command of the commercial aspect of the museum
is serving Rüger well at London's 250-year-old Royal
Academy of Arts, one of the few major privately financed
art institutions in England, where he arrived in May 2019.
This is the German-born Rüger's second posting in
London; he was previously curator of Dutch paintings at
the National Gallery. In a post-Covid world, institutions
relying on donors, government, or tourists will have to find
additional sources of income to keep the museum vibrant.
To do so, Rüger reminds, museums will need to profes-
sionalize and embrace new operating models.

ANDRÁS SZÁNTÓ *I will not soon forget your Instagram posts of walking around the empty streets of London from the worst days of the pandemic. A strange time.*

AXEL RÜGER It was surreal. I live in Covent Garden, the center of London. The streets were completely deserted. And this is one of the busiest global cities. It makes you reflect on what city life is really like, particularly after the recent explosive urbanization of the world. It was an interesting and emphatically lonely experience to be in a city that was so empty.

What originally got you interested in museums?
I did a gap year in America after high school. While there, I read the profile of a young museum director who had been appointed in Atlanta, where I was living. That put into my head the notion that I would be interested in working for museums. Much later, when I actually started working in museums, I was incredibly lucky that my jobs were in major museums with world-class collections and a large public, and with resources to do ambitious exhibitions and publications. That is not the norm for everyone. After being a curator for a while, I realized I would like to be part of the bigger conversation and be at the grown-up table—to not just have opinions about everything but also do something about it. That put me on a trajectory toward a leadership role. It happened faster than I expected. I was thirty-seven when I became director of the Van Gogh Museum.

And there you developed a reputation as an innovator. Were there role models for you?
I was fortunate to be hired by Neil MacGregor at the National Gallery, a consummate museum leader from whom I learned about the outward-looking functions of a director. Maxwell Anderson advised me to try and get as much work experience early on as possible to distinguish myself from other art-history students, and to always make time for students. I got a lot of advice from Glenn Lowry at MoMA, particularly early in my career as a director, and from people outside the museum in the Netherlands. Through these external influences, I developed a particular view on the need for professionalization in museums and the art sector.

At the Van Gogh Museum, I learned about the commercial dimension of museums, and to overcome the built-in hierarchical culture of museums, where it is assumed that people on the art side are a higher-order species than those on the commercial or administrative side. I believe the museum needs a vast variety of expertise to flourish.

The Royal Academy has recently gone through a period of intense transformation. It's an old institution with a contemporary mandate, and an unusual structure. You are "secretary"—and you have zero public subsidies.
It is completely different from the Van Gogh Museum. Mind you, the Van Gogh Museum only had 13 percent public subsidies—the rest was self-generated. Then again, Van Gogh is a global rock star. If you can't make money with Van Gogh, you should try a different business.

The Royal Academy is led by the Royal Academicians. The historic title of my role is secretary, in charge of daily operations. More recently they added CEO to the title, to clarify the role in our time. Since its inception, the Royal Academy has had an art school. As a museum, we are largely driven by an exhibition program, not the collection. This means we can give ourselves liberty to host exhibitions on a wide range of topics. There are so many aspects here—working with living artists, a body of elected academicians and a governance dominated by artists, a school, being exhibition-driven—that make this place different and exciting.

How would you define the term "museum"?
Typically, a museum is defined by a collection. If it doesn't have one, it would be a *Kunsthalle*. The Royal Academy narrowly escapes that latter definition. We do have a collection, albeit little-known (although we have a Michelangelo and work by many prominent Royal Academicians). Collection and collecting, and the mandate to preserve heritage and make art accessible to a broader public—these define a museum for me. But in my mind, a museum is also a cultural enterprise. Museums still have, unfortunately, a rather fusty, dusty image. In fact, they can be unbelievably dynamic and modern.

To make this happen, you need resources and to steward them. At the Van Gogh you tried out some interesting ideas. What does the idea of "museum as business" mean to you?

Museums are for the public good. But they still need to pay the bills, and they have to meet statutory requirements. Usually, you manage the collection on behalf of someone—the public, the state, a city, a community. You are entrusted with that precious thing. Your task is to steward the collection and the collective memory within it, to hand it over to the next generation unscathed and, ideally, in a better state than you found it in.

The business and financial side allow you to do these things. They are not ends in themselves—that would tip the scale in the wrong direction. Museums exist on the basis of a public consensus that the community wishes to support a museum. You need that foothold in a community. When a museum is a completely private endeavor, the accountability is somewhat different. But due to the charitable status of most private museums, they must also relate to their community and be held accountable publicly.

What I mean by the museum as a business is that museums are subject to economic realities that are not all that different from those of commercial businesses, and that there is an urgent need for many museums to become more professional. A distinct difference, however, is that museums usually cannot take on the entrepreneurial risks that businesses can take, because they lack the necessary risk capital.

There is considerable cultural anxiety about mixing art and commerce. These are often seen as opposites. How do you see it?

There is a German word, *Berührungsangst*—fear of contact. I have long ago lost that fear of contact. Art has always had a commercial dimension. I am grateful to have worked at an auction house for a while, where I saw how artists and art are dealt with in commercial settings. I don't have that fear. I don't see those barriers.

There ought to be a lot more permeability between the cultural sector and the commercial sector. The cultural sector still has an unfortunate reputation of being something like a hobby. Any CEO of a commercial company feels naturally qualified to serve on the board of an arts organization. But when I asked

one of my board members, "You are on my board; could I be on yours?" I got stunned silence. One of them said, "What would you bring to it?" And I said, "I don't know where to begin. I run an organization with a vast international profile. My financial targets are as tight as yours. We make a lot happen with a lot less money. I have a public responsibility. I have to manage creativity. I am in charge of a global brand. My stakeholders range from the royal family to every supplier. And when we sneeze, it's in the press the next day. So tell me what I am not doing?"

This is then met with, "I never thought of it that way." And yet the next step of being taken seriously as a candidate for a commercial non-executive board position never happens. You hit a stone wall. And until this wall becomes more permeable, in both directions, the cultural sector will remain stuck in this "hobby" corner.

So how do you see business models changing going forward?
There is a strange tension in our field. On the one hand, the museums everyone is talking about are, on the face of it, unbelievably successful. A museum with five million visitors per year—we have several in London, in normal times—is a global brand. And then you have many smaller, local museums that are struggling to find visitors. That gap is disconcerting.

Now, as a result of contracting resources and audiences due to the pandemic, there is a lot of talk about having fewer exhibitions and concentrating on permanent collections. But as a society, we are still event-driven and focused on experiencing something new. So I am not sure this virus period will fundamentally change everything. You get bored with Netflix as soon as they don't provide a new episode.

Speaking of Netflix, some have suggested museums could build excitement from exhibition to exhibition, in serialized sequence.
Some museums have tried that, but the arc of attention would have to be really long. It would be months if not years before a continuation—you'd lose the plot. But on a conceptual level it might be interesting. We certainly need to think about new models.

The real challenge is thinking about our audiences. Younger generations are interested in different experiences. That is why

at the Van Gogh Museum we launched a commercial venture, the *Meet Vincent van Gogh Experience*, to travel around the world. It did not have original art. It was inspired by participatory and immersive experiences, from *Van Gogh Alive* to L'Atelier des Lumières, in Paris, to TeamLab, which are very popular. Somewhere in there—I haven't discovered it yet—there will be a new nexus of experience and art that creates a new type of three-dimensional experience. The borders will likely become more fluid. Perhaps the current crisis will accelerate that.

Are there other revenue streams museums could unlock? Cafés and shops and rentals won't cover all the bills.
There will never be a one-size-fits-all solution. Each museum needs to take from the content it has. Of course, to score commercially with Vincent van Gogh is a lot easier. As soon as a museum has an icon, it will put it on absolutely everything. Otherwise, no one has found the holy grail of a really major source of income that is going to save the day for us.

In the pandemic, much programming shifted to digital and is being made available for free. The best you can say is that this may have expanded the audience. Whether it will translate into larger audiences when institutions reopen remains to be seen. We had to make this content available to keep people sane and inspired—and I subscribe to that. But it will be difficult to turn around and put this content behind a paywall.

It reminds me of the newspaper industry. It became difficult to convert to paid subscriptions.
Exactly. Whether eventually, in an evolving digital economy, there will be an opportunity to monetize the museum's content—without putting up barriers to attendance—is something we will need to see. Otherwise, there is the art trade. But to bring that together with the museum business is hard. The Royal Academy since its inception has been selling artworks through the Summer Exhibition to support artists and our schools. We display usually 1,200 works. The exhibition becomes one enormous art gallery, and it is a major source of income, about 5 percent of our budget.

Axel Rüger

How does that compare to the box office?
The box office is much higher for us. At the Van Gogh, it was almost 50 percent, which is unusual. Most museums get less than 10 percent of revenues from ticket sales, and they rely a lot more on philanthropic support.

But is there a reliable earned-income source? If you want to be entrepreneurial—which politicians in some European countries are encouraging us to be—you need risk capital. And that is something we usually don't have, and it's frowned upon. You certainly won't get money from the public purse for risky business endeavors. If an exhibition bombs or a performance fails, that is accepted. But if you invest in a commercial venture, that is looked at with suspicion. You have to have robust finances to do it, because if the venture fails you have to be ready to write it off without putting the entire organization at risk.

Speaking of capital and risk, art finance remains a fledgling field. Is there a larger role for financial instruments going forward?
There are of course museums that carry debts to finance capital projects. Some have issued bonds, more so in America. The question, always, is how much do you risk leveraging your organization? Borrowing against a collection is against the statutes of many museum associations. And you could only get substantial money if you used your major works as collateral. If the Van Gogh Museum mortgaged *Sunflowers* and defaulted, it would be in a pickle. The director's head would roll. The public's trust would be out the window, and you would probably not be able to rebuild it.

It's often noted that museums are cash-poor but sit on huge assets. During Covid, American museum associations loosened regulations on deaccessioning, allowing institutions to sell works to cover operations.
I do think that collections need to be protected from the vagaries of taste and the economy. The big example is Nazi Germany, where the state sold off Expressionist works because they were considered degenerate. These will never return. There needs to be a mechanism to protect collections from those influences.

Moreover, it is a fallacy to assume that funds generated by selling minor works from the collection would save museums.

The history of deaccessioning has yet to prove that a major sale has saved a museum. In the 1960s, the Royal Academy sold for commercial reasons the Leonardo Cartoon, which was bought by the National Gallery, where it is on prominent display—which is great. Did the Royal Academy get rid of its financial worry and sail flush and bright into the future? No. Financial problems returned shortly thereafter.

The fact is that deaccessioning is not ever going to be a major income boost unless you sell the triple-A works—but then you may as well close the institution. You will always only sell relatively minor works, and, aside from the fact that income from deaccessioning must benefit solely the collection, that would never have a long-term impact on sustainability. Deaccessioning should be driven by collection-management considerations. Collections maintenance and storage costs soak up a huge amount of money.

One gets the feeling there are not a lot of cupboard doors that haven't been opened in the search for money. What about expenditures? Do the words "efficiency" and "museum" belong in the same sentence?
Anything can be more efficient. This brings us back to professionalization. These words are often dismissed as corporate language. God forbid we become corporate! I do feel strongly that museums are, in the end, organizations. As such, they ought to be run in a professional and efficient way. That doesn't mean the staff are robots. But it behooves us to look carefully at processes, how things are managed, how money is used. Many cultural institutions have no real performance management. Why is that? Because we are creative?

William Baumol and William Bowen in 1968 wrote about the "cost disease." Their example was the string quartet: you can't perform a string quartet with three people. Do museums have a version of this?
It has to do with ambition. To continue the string-quartet analogy, you cannot do it with three people, but you don't need five. And if they wish to perform a symphony, they would have to grow. We constantly hear there are too few people to do everything we do. But hiring people is like building wider streets. They only

Axel Rüger

alleviate traffic jams for a while, because wider streets attract more traffic. More staff generates more work. It's a spiral.

Humans are programmed toward growth. You want to grow the collection. You want the next exhibition to be bigger, have more outreach. If we do one publication, why not two? Maybe we could get more money from the shop if we double it in size. Ultimately this leads to these building expansions. So in that sense there may be a cost disease for museums—a disease of spiraling ambition.

How should museums manage their relationships with commercial partners?
Museums are under heavy public scrutiny. That scrutiny has grown exponentially—and there is nothing wrong with that. But if it were only about corporate funding! In fact, museums can be extremely elitist and exclusionary. They do not reflect their societies, really. Museums have to ask serious questions in light of recent events. In this context, funding sources—both corporate and private—are coming under ever closer scrutiny.

And here we get to an interesting tension. Public trust creates an expectation that museums should be lily-white in their morals. It is increasingly becoming a problem to find partners that, in the public perception, are able to live up to those same standards and expectations. Meanwhile, there is an ever-shifting public consensus about what is acceptable and what is not. For example, accepting money from tobacco and fossil fuels has come under serious pressure. Yet nobody asks about accepting money from alcohol brands, even though you could argue that alcohol is no less problematic. We constantly have to maneuver this sliding scale of public sentiment.

So given all this—or despite all this—how do you imagine tomorrow's museums will be different?
While we love our grand and elegant buildings, the barriers they create are problematic. One does hope that future museums will feel more open, permeable, and democratic. If we don't pay attention, we may lose our connection to our societies at a time of rapid demographic change. Museums are too often seen as bastions of a certain world order.

Yet people do want ceremony. When the National Gallery built a fairly unassuming smaller entrance at street level, it was in the beginning rarely used. You found people lugging baby carriages up the stairs of the imposing upstairs portico. In their perception, the street entrance was for deliveries or the staff. So there is a ritualistic aspect that people appreciate when visiting a museum. However, ultimately, we create huge barriers that we cannot be proud of.

Imagine you return to the Royal Academy decades from now, get off your levitating taxi or whatever, and walk through that beautiful courtyard. What do you think will surprise you the most?
The biggest surprise will be that the audience is going to be a true reflection of London's diversity. That is one of the biggest ambitions of the Royal Academy today. The program and the staff of the Royal Academy will reflect the city.

Of course, there will be a greater connection with whatever digital media are around in fifty years' time. Even so, I want to hold on to the belief that the physical object will still matter. No matter how sophisticated we become in replicating things in new media, the materiality, the three-dimensionality, the Benjaminian aura of the original artwork, will never cease to fascinate us. That is what I want to believe.

ADAM LEVINE
President, Director & CEO
Toledo Museum of Art, Toledo, Ohio, United States

THE BEST OF EVERYTHING, FROM ANYWHERE

Adam Levine took up his post as director of the Toledo Museum of Art, an imposing institution in the midst of the Covid-19 lockdown. By his mid-thirties, Levine had already been a Rhodes Scholar, a Metropolitan Museum of Art curator, a museum director in Florida, and the founder of a quantitative art-research business. A former competitive boxer, Levine has been a frequent collaborator of mine on strategy and research projects. We spoke during his first month as director of the Toledo Museum, an imposing institution in what was once one of the most prosperous cities in the United States, and where he had previously served as deputy director.

ANDRÁS SZÁNTÓ *So, at thirty-three, how does it feel to be the youngest member of the Association of Art Museum Directors?*

ADAM LEVINE I have gone through a lot of my life with people commenting on my age. I recognized early on that wisdom is correlated with age, but it's not entirely dependent on it. I have been fortunate, or unfortunate, to experience a lot in my life so far, including failures. I carry those lessons with me.

What got you involved in museums?
I always knew I wanted to work in one. I grew up in New York, in Riverdale. I had parents who were engaged in the humanities. Museums were part of the routine. The Met was our staple, and our visits always included the galleries dedicated to ancient Egypt, Greece, and Rome. The Guggenheim was "the snail museum," and we would run up and down its curving ramp. I was afforded the opportunity to become comfortable in these spaces.

I showed up at Dartmouth College knowing that I wanted to study art history. I didn't stumble upon it. I applied for a position at the Hood Museum at the university. There began my long connection to Brian Kennedy, who was then about to become director. I would later work for him as his deputy at the Toledo. At the Hood, I got a job in the exhibition department. That formative experience made me decide to be a museum director.

Was there an experience that summed up for you what a museum can be?
Yes. I was in high school. The Met had an exhibition. It might have been *Crossing the Channel*. *The Raft of the Medusa* was in the first room. And in that same room was a picture by the artist Francis Danby, *Sunset at Sea After a Storm*. I grew up with a view of the Hudson River, with beautiful, vibrant colors every night. I had a visceral response to this deep red sunset in a quintessential Romantic painting. That was my first really aesthetic experience in front of a work of art. It caused me to wonder what made it beautiful. It changed my path.

My first encounter with you was in a rather different context, in a loft in SoHo, as I recall, where you were running a tech start-up.
I think the very first one may have been at Café Sabarsky, at the Neue Galerie, over an apple strudel. In college, in addition to art history I studied anthropology and applied math. I spent some time consulting at Sotheby's. It occurred to me in 2007 that figuring out the value of art was an automatable task. I developed an algorithm to price art. Eventually, I founded a company, Art Research Technologies, which had that office in SoHo. We were creating quantitative content for the art market. I built the company while still in graduate school, and we sold it a few years later to a London-based finance firm.

Not your typical museum-director story...
There was a moment when everyone was talking about the MBA director, that post–Thomas Krens moment of speaking about the need for business savvy. I also did a brief stint in investment banking, just enough to know that I didn't want to do it full-time. There are directors who have had business experience. I think there are opportunities in thinking through the skill sets that twenty-first-century directors will need. Beyond the requisite art-historical knowledge, some operational business experience, coupled with governance experience, isn't a bad basis to build on.

With all these lenses on, and having worked at the Metropolitan Museum, the Toledo Museum, and more recently in your first directorship at the Cummer Museum, in Jacksonville, Florida, how would you define the term "museum"?
I think a museum is meant to engage the arts in inquiry about the history of humanity. And we do so through the collection and display and conservation of artworks that we hold in the public trust. However, it remains unclear to me whether the twenty-first century needs a revised museum or a brand-new institution— something that isn't really a "museum" per se. I am not sure what we would call it. Whether a museum can do all the things we are now asking it to do, and still be a museum, is a legitimate categorical question.

Adam Levine

What is the essence of this enterprise?
It was the Italian thinker Benedetto Croce who said, "All history is contemporary history." The past is constantly reinterpreted through the present, and the present is reinterpreted through the past. This explains why museums are never neutral. We are situated in our moment, and we apply that ideological framework in the way we interpret works of art. So the essence of the museum, I guess, is that it's the interpretive intersection of past and present.

So how will tomorrow's museums be different from the ones we see today? Let's think ahead thirty or fifty years.
We are having this conversation against the backdrop of Covid-19. Humans are incredibly bad at extrapolating from their current moment. You see it time and time again, this overestimation of the present. At this moment, there is a lot of conversation about going digital. And certainly, in thirty years digital technology will be able to give you a reasonably similar experience to being in the presence of an artwork. But none of those technologies will replicate the scale of the experience. No matter how good, you are still not going to have that spatial experience of being in a museum.

The museum experience is not strictly about the art. It is about art in a particular space, in a particular moment in time. I do think scale matters. A physical work of art is about its aura. You would never dream of shrinking down a Bill Viola. What you sacrifice in removing a work of art from a museum and transporting it to another medium, for the sake of convenience, is the intentionality behind the work of art itself.

Museums do their best to facilitate that kind of physical experience. They are very intentional about how things are lit and how you flow through space. I am optimistic that the museum of the future will have lots of opportunities for people to take their visit home with them, and to learn about things without ever having visited the museum. But if we do our jobs well, we will have architected those experiences so they remain irresistible. We will leverage technology for interpretation, not to replace the visit.

*There is an analogy to the movie theater here. You can have
a huge screen in your house, but it's not the same as going to a
movie. Part of the proposition is having a cultural experience
in a public setting.*

What I like about this analogy is that there is a lot that museums
can learn about consumption patterns in the field of moving-
image. In Toledo, we are working on gaining insights from Netflix.
One lesson you learn is that people love serialized content. They
love to enter that universe. Imagine if museums found a way to
have each program build off the previous one, and if we figured
out a way to distribute that through digital media in a way that was
binge-worthy. That is a digital future I would like to imagine.

*You find yourself in a classic behemoth of a columned museum.
It has scale galore. It represents the assumptions and aspirations
of the past. How do you think museum architecture should evolve?*
The first phase of our building was completed in 1912. Ultimately
completed in 1933, it has 250,000 square feet of Beaux Arts archi-
tecture clad in Vermont marble. The architect, Edward Green,
also designed the Albright-Knox Art Gallery in Buffalo, New York.
While it is symmetrical from the outside, inside every gallery has
a different size. It never gets stale.

We are fortunate to have a Frank Gehry building, completed in
1992, and the Japanese architecture firm SANAA's first American
building, our glass pavilion, completed in 2006. These different
spaces somehow cohabitate on our campus. They are certainly
moving away from a classical form toward notions of a more
democratic museum, and on to total transparency. I think there
is an increasing understanding of the visitor at the core of the
architecture.

*Museum architecture has certainly adapted to engage the audi-
ence. What else do museums need to unlearn to stay relevant?*
We need to unlearn the way we do marketing. It inhibits our
approaches to diversity, equity, accessibility, and inclusion. This
is a passion of mine, and it is perhaps the key issue for museums
in the early twenty-first century.*

* We spoke shortly before the killing of George Floyd and the ensuing
protests about racial inequities in the United States.

Adam Levine

The field imbibed an approach to audience segmentation that results in a tokenism that is not true inclusion. Our approach has been to say, "This is the show for this audience." This "portfolio approach" to audiences requires engagement of a certain demographic periodically, rather than sustainably and recurrently. Instead of measuring the demographics of visitation, perhaps we should measure the demographics of repeat visitation. One of the constructs I try to use in management is, "Can you get someone to come for a third visit in eighteen months?" That third visit is when you turn someone from being a non-visitor to a visitor.

Are you concerned about the long-term viability of museums? How about new threats of climate change and pandemics, things that are no longer just looming in a distant future?
How does any institution reorient its operating model to be resilient? The two short answers are: adequate liquidity and diverse revenue streams. You can't know what those black-swan events will be. We now seem to have them once a decade. You need to have enough resources not only to survive, but to buy against the market. When everyone is running one way, sometimes you need to go to the other direction.

Museums need to think desperately about their revenue models. We have retail businesses. We sell things in shops and cafés. And maybe it was you who once said this: "The best retailers in the world can't do retail, so what makes museums think they can do retail?" When you look deeply, these functions almost never pay.

In my view, museums haven't leveraged their intellectual capital, though some have tried. Tate, for example, has Tate Enterprises. Some museums have business incubators. Every now and then you hear about an IP-protected product from a museum. But just to make up an example, if I told you that a business in Toledo, Ohio, has five billion dollars' worth of assets and an army of degreed people walking around, you wouldn't guess it was a museum.

Thirty years from now, I believe museums will think of the value of their works of art as part of their asset base. The conversation about how the liquidity trapped in artworks can be used has been a very un-nuanced one. As someone who cares about history, I am deeply afraid of bad precedent. But there

are no industries where sacred cows shouldn't be looked at. If a reasonable conversation was to be had, you could find all sorts of compelling opportunities for museums to use their fundamental assets to support their purpose without endangering the public trust. It is a difficult thing to do, but not impossible.

In the end, though, you are a traditionalist: you believe in the aesthetic experience. You believe in the concept of quality. What does it mean to you? What will quality mean in the future, and how can museums tap into it?
Sergio Marchionne, former CEO of FIAT Chrysler, gave a talk to several museum administrators. I was fortunate to be in the room. The director of a major US art museum raised his hand and asked, "I think we can learn a lot from FIAT Chrysler and the way you segment the market. You sell FIATs and you sell Ferraris. What are the lessons for us about accommodating everyone in every walk of life?" Sergio stared at him for a moment and said, "But you are Ferrari. Everyone wants a Ferrari."

The way quality has been interpreted in the museum is the problem, not quality itself. Quality is not just the Michelin-star dining experience. It is a great bagel and an excellent slice of pizza. Good is good. However, the parameters of good are different depending on the materials that you are considering. Quality is the best of everything, from anywhere. It is agnostic of geography and chronology. It doesn't matter whether you went to art school. It doesn't matter if art school existed. It doesn't matter if you are from third-millennial Shang Dynasty China, from sixteenth-century Benin, or from twenty-first-century Toledo. If it's good, it's good.

What saves quality from becoming a colonialist paradigm is understanding the aesthetics of different cultures on their own terms. And what saves this from being a totally subjective exercise is enumerating some trans-historical, trans-societal criteria for quality that are specific enough to capture a society's aesthetic impulse, but also broad enough that the way they are implemented in each society is different. We can and should tell a global art history, where inclusion is not a function of tokenism, but of the worthiness of the objects. We must reprogram ourselves to check our unconscious biases if we are to succeed.

Adam Levine

I believe we can do this. Museums have an opportunity to rethink quality as the truly inclusive concept that it is.

Now, maybe that's your one-phrase definition of the museum.
Only one institution can do this: the museum. That is an amazing superpower. We tell people what is good by putting it on our walls. And people trust us. So how do you use that superpower? In this frame, quality is the most egalitarian concept there is. The aesthetics differ from society to society. But there is no society that doesn't have an aesthetic impulse. There has never been a society that didn't have someone who made an object and didn't say at some point, "I just have to do this a little more."

We live in a time of aesthetic pluralism. Anything can be art. We take it for granted that all cultures in all places deserve attention and respect. Can a museum live up to it all?
I think it still can. But it gets harder and harder. The Toledo Museum has this notion of quality baked into its DNA. While it is an incredibly large institution—thirty-seven acres and a museum building a quarter of the size of the Met—we have only thirty thousand objects. Therefore, this museum accords incredible aesthetic merit to each individual object. We have a kind of spotlight approach: you choose exemplars and you juxtapose them.

However, if you are trying to capture the entirety of human aesthetics, that is going to be a tall order.

Put your mind in a time machine. You will be seventy-three years old in 2060. Imagine we are taking a walk together in a museum that year, say, in Shanghai. Maybe with your grandkids. What will be the most surprising thing about that experience?
You will find museums in major metropolitan areas that will be much more deeply connected to their communities. In this case, the visitation will be much more reflective of Shanghai than of other places. You will equally find that people visiting museums outside metropolitan areas will have a larger share of tourists. And yes, I am going on record that travel will resume once we have a vaccine. We will still see trends in interconnectivity and globalization continue, at least in major markets. And of course,

we will be floating, or immersed in some other inconceivable science-fiction, fantasy-made-reality...

For you, much of those next forty years may be spent at the helm of art institutions. What will keep you energized?
I am interested in accelerating changes in museums in ways that are beneficial. The most effective way to do this is by being at the helm of institutions. Resilience is about being flexibly sustain-able—that is what the museum of the future is about. We aspire to permanence. That is why we built all these Roman temples. We are trying to be here forever. So how do we ensure the health of these institutions?

The key to sustainability is relevance. Inclusion is a proximate concern, and that is why we are talking about quality. There is a midrange concern, which is around the financial model. What will keep me excited is those two areas of focus—trying to create sustainable models for museums, with strong finances and strong community engagement. There is a lifetime's work to be done.

Adam Levine

MAMI KATAOKA
Director, Mori Art Museum
Tokyo, Japan

ART WILL REVEAL THE STRUCTURE OF THIS WORLD

The Mori Tower's observation deck, high above the bustling streets of Roppongi Hills, is a must-see stop on any visit to Tokyo. The upper floors of the fifty-four-story tower operate as an ingenious museum-financing scheme, devised by the development's mastermind, Minoru Mori. Visitors and revenues flow to the Mori Art Museum, which is situated adjacent to the observation deck. The Mori was the last international museum I visited before the coronavirus bought travel to a standstill. The night I was there, the museum was supposed to host its annual gala, the first since its long-serving chief curator, Mami Kataoka, had been appointed director. The event was canceled at the last minute. I first met Kataoka, previously the founding chief curator of Tokyo Opera City Art Gallery, when we participated in an Art Basel Conversation in Hong Kong about contemporary art biennials. As artistic director of the Gwangju and Sydney Biennials, along with many other groundbreaking exhibitions, Kataoka had a reputation for her fearlessly original curation. Today, she is putting the Mori Art Museum in the service of constant reinvention and collective dreaming about our future.

ANDRÁS SZÁNTÓ *The morning I came to see you in late February, you were dealing with the cancellation of the museum's gala, due to Covid. What a time to take over a directorship.*

MAMI KATAOKA It has been a strange time to become director. But it's been quite interesting to be in this position after working at the Mori Art Museum for eighteen years. As director, I wanted to go back to the fundamental questions. *Do we really need this museum? Where are we going?* Covid-19 brought to me—to all of us—a great opportunity to think together. I formed a new digital team from curators and colleagues from marketing and PR and education, so it instantly became an interdepartmental team, which is quite rare. Those changes were made possible by Covid.

What was the path that led you to museums and to this job?
I didn't come upon it in a conventional way. I encountered contemporary art while in college, in 1985–86, when I spent time in New York and got to see the museums and galleries. I came back, worked in a gallery, got married, moved to Tokyo. In the 1980s and '90s, a number of regional governments and corporations in Japan were building cultural facilities. I got an offer to work in a consultancy for urban development. One of the projects was a new gallery and concert hall in the urban complex called Tokyo Opera City. In 1992, I was put in charge of developing a museum/art gallery there, which was to open in 1999.

I was thinking of a *Kunsthalle* type of space. There was no contemporary art museum in Tokyo at the time. The Museum of Contemporary Art Tokyo (MOT) opened in 1995. So I proposed a contemporary art center with international-quality exhibitions. When the time came to appoint a curator, I said to one of the board members, "Do you think I can try?" I wanted to realize my vision and plan. Otherwise, I felt as if I had been holding a balloon for a long time, and if I let go, it would fly away and disappear. And they said, "If you're doing it, that would be great." Looking back, it was an unusual appointment to get, without any museum experience.

David Elliott, the founding director of the Mori Art Museum, was an advisor to the Tokyo Opera City Art Gallery. He asked me if I wanted to join his team when he was appointed a new position. By then I had worked on the Tokyo Opera City project

for ten years. The Mori had a unique model, with a budget to make international-quality exhibitions. Unlike at many other private museums, Mr. Mori didn't start with his own collection, but from an urban-planning approach. As a developer, he believed that something creative like contemporary art can give energy to a city. I thought it would be interesting and meaningful to make this case study successful.

Can you describe the role the Mori Art Museum plays in the Japanese art landscape?
It is a corporate museum, a privately run museum. In many public museums in Japan, decisions come from a collective, and director is often a symbolic, honorary position. The Mori has a strong international connection established by Elliott, who was the first foreign museum director in Japanese museum history. Everything has been bilingual; therefore the museum is quite visible outside Japan. At the same time, it is in the midst of a popular tourist destination. While many contemporary museums target people who seek out contemporary art, our museum is open to tourists and the general public. Our unique ticket system is combined with the viewing deck, which was Mr. Mori's business model: to use income from the observation deck to support the museum.

What is a "museum" for you?
That is an interesting question. ICOM tried to renew a definition in 2019, in Kyoto, but they didn't reach a mutual agreement. It's extremely hard to find a simple paragraph to which everyone agrees.

In Japan, museums started out as a means of becoming modernized or Westernized in the early twentieth century. Museums started without extensive collections. After the Second World War, in the 1950s, key national and private museums of modern art were opened. Later, in the "museum boom" of the 1970s and '80s, many regional governments decided to launch museums. There was a national consensus that people need enrichment, happiness, not just material comfort. An incredible number of museums were built, mostly with limited collections. By the 1990s and 2000s, since the bubble economy burst, a lot of them were struggling.

Mami Kataoka

Now, after Covid, the museum is increasingly important as a place where we can encounter diversity, engage with different political, social, and historical values. It can be a free zone, a mutual space where all opinions and value systems can be present. And to me, it has to be a place of equilibrium. We can have discussion and conflict, but on the whole the museum has to be a free and open place.

That ICOM debate forms the backdrop to this book. This expanded model is, in some ways, what the current generation of directors is building.
I agree with what ICOM was trying to achieve—about how museums could contribute to society, and the importance of sustainability. This is still new for some museums, at least in Japan. It will soon become unavoidable to be part of this discussion about sustainability, including both social and environmental sustainability.

Japan is full of museums. Some are traditional, some experimental. Some are empty. But any museum lover who comes to Japan tries to make a pilgrimage to Naoshima Island, to see what a museum experience can be. What role can Japan play in innovating museums?
We can look at Naoshima as a museum or as a whole island experience. In 2000, Fram Kitagawa started the Echigo-Tsumari Art Triennial in the Niigata Prefecture by putting together a group of small villages and towns to host a rural art festival. This was one of the first models of integrating contemporary art into regional communities. Soichiro Fukutake, who established Naoshima and the whole Setouchi Inland Sea art complex, built his first museum there in 1992, not because he wanted to exhibit his collection, but to save those islands from becoming a dumping ground for industrial waste. He wanted to change the future of the islands. Now some fifteen islands, including Naoshima, feature contemporary art, forming something between museums and regional festivals. And it is helpful for regional governors to understand that contemporary art can play a role in revitalizing a region. Art, artists, and the young audience they attract can fill the void left in society by declining towns and villages. This is an

inevitable discussion about how museums and regional festivals may coexist and find their respective visions.

I found Naoshima and the neighboring islands deeply inspirational. Does the world have an accurate image of contemporary art in Asia and in Japan?
In Japan, modern and contemporary art evolved in tandem with the country's modernization. At the time, this simply meant following the West. That included the perspective that we should look only to the West and ignore our friends in Asia. Asian modern art was largely ignored for a long time. In 1979, when the Fukuoka Art Museum in Kyushu decided to focus on Asia, that was the beginning of our engagement.

The turning point was probably in the late 1990s and the 2000s, when everybody started to travel around the world with discount tickets. A number of biennials launched in Asia, starting in 1995 in Gwangju. Artists and curators started to create a new regional community. Exhibitions like *Cities on the Move*, by Hans Ulrich Obrist and Hou Hanru, forged new links, as did *Contemporary Art in Asia: Traditions/Tensions* at the Asia Society in New York. By the late 1990s, Asian art had become increasingly visible in the international art scene. In 1999, Harald Szeemann showed twenty Chinese artists in the Venice Biennale; that was another symbolic wave. Japan was part of how Asia was being seen in a different light. As contemporary art and its infrastructure—museums, biennials, art fairs—evolve throughout the world, there are more opportunities to encounter art produced in Asia than there were twenty years ago, and correspondingly more potential to learn from each other.

Thinking about how far museums have come in the past fifty years, what would surprise us the most about them in the future?
I have often said that a museum is a microcosm of the world—where we can encounter the world through artists, their lives, their practices and perspectives. We can learn from what they do and how they do it. Particularly in this strange pandemic time with very limited travel, those experiences represent the whole world. The museum has to be a place where we can learn about the past and experience the present—and by doing that, we can

Mami Kataoka

find a vision for the future. To that end, it would be important for museums to archive how they are overcoming the current health crisis and how they are adapting, so future museum professionals can learn from this experience.

Where do you see programming and exhibitions evolving? Can museums tell stories in new ways?
Because of social distancing and limitations on the number of visitors, the live experience of the museum might become more precious, potentially with higher ticket prices. The museum might become a place where you detach yourself even more from everyday life: a place for contemplating, for meditation, to quietly think about your own existence. At the same time, the physical museum space itself may not be the only place for experience. The museum can pop up in different places, including the digital realm and somewhere beyond the museum walls. It can be a concept, an idea, which doesn't have to be attached to a specific site. We have to rethink the categorization between museums, festivals, biennials, and the digital world.

In technology, they call this "platform-agnostic"—the same thing incarnating in different arenas, not just one.
We are talking a lot about international traveling exhibitions. Due to the limitations from Covid, maybe exhibitions can be shared via discussions with colleagues in different parts of the world; maybe physical artifacts do not have to travel. How important is the physical presence of the artist? At this year's Yokohama Triennale, everything was installed remotely. People are coming up with different approaches to exhibition-making.

I am asking the curators at the Mori Art Museum what we need to be doing in the next couple of years to reflect on what is happening. For me, the inspiration will always come from the artists. But I am also interested in exhibition history: how models of exhibition-making may shift, and how certain types of exhibitions became accepted at certain times, as part of larger social, political, and cultural upheavals. Therefore, the museum could be platform-agnostic, and ideas about exhibition-making could come from diverse perspectives.

Looking beyond the art world, from which fields can museums borrow as they evolve?

Everything. The problem of modern society is that we have divided all these learning processes into different subjects. Art has to be what pulls that fragmentation back together— Renaissance-style. I tell my students to look at contemporary art through mathematics, history, social studies, physics, music, and all these subjects, as art is embedded in everything. I teach a small graduate class in Kyoto, and I invite artists and curators from around the world to offer them multiple perspectives. And the speakers can invite specialists from completely different fields. One of the artists, Susan Norrie, invited a volcano expert— that was extremely exciting. Art will reveal the structure of this world—geographically, sociologically, and conceptually. It is so important to look outside of the art realm.

Much art discourse has become a hall of mirrors, looking inward and reflecting the art world's internal concerns and conversations.

Even curating has become very similar everywhere. Students now learn how to be a curator at school. But it is far more important to travel around the world and understand how people live their lives in different contexts than to study curation through theory and models.

You have made public statements about how a museum can help to build a better future. The exhibition I saw at the Mori Art Museum in January, Future and the Arts: AI, Robotics, Cities, Life—How Humanity Will Live Tomorrow, *was a peek into the future and the role of artists in it. Can the museum help us imagine a better future?*

I am not a big fan of innovation or newness for its own sake. The future, which is a continuation of the past and the present, is more about long-term engagement. It is about the sustainability of our society and of this world. So if the museum can maintain its nature where we can talk about what needs to be inherited and what needs to be changed, then we can make very big contributions to a better future.

Mami Kataoka

The future is many things—technology, economics, demograph-ics, architecture. How can a museum engage with all these fields meaningfully?

I would choose the word "doubt." New technologies often have utopian ideas about the future. Economics and demographics tend to be numerical and holistic. But one role of the museum is to have a meaningful discussion with these fields and challenge them. Artists always offer a critical view, reflecting emotional and intuitive value and individual stories. They can reveal things that people are not looking at, things that are uncomfortable. Art shines a light on people and places that don't get enough light. Bringing those parts of society and the world into the discourse with technology, economics, and so on would be very meaningful to achieving a better equilibrium in the future.

Artists spoke up against nuclear proliferation, for example. Now there is so much happening in the world that artists need to exam-ine and scrutinize. Can the museum operate more deliberately as a kind of think tank?

The contemporary art museum should always function as a think tank. I want the museum to present multiple perspectives at the same time, to never be defined by a single point of view. I want the Mori Art Museum to have a sharply critical outlook on society. We should talk about the future, but also look back on human history and on the history of exhibition-making. We have to be a broader platform, not just for art specialists, but always open to anyone who wants to come into the museum. I would like to embrace these two different poles, like yin and yang, to be always fluid and ambiguous.

This could be an answer to your question about the definition of the museum: arguably it is probably better to remain ambig-uous and open. In the Western modernist tradition, you like to define, divide, and clarify. I think in this part of the world we still like the ambiguity of having multiple ideas coexist at the same time. I see more possibilities in that direction. It is an extremely complex task to achieve a state of equilibrium among conflicting positions, but that is what makes me excited.

One of these divisions is the separation of art and science—the "two cultures," as C. P. Snow called them. Artists rarely understand technology, let alone science. Can the museum facilitate a closer dialogue between the two, to imagine a better future?

Art and science share similar roots. Hiroshi Sugimoto, for example, uses photography as a medium, and his interests extend to science, history, and politics, and reflect the ideas of Benjamin Franklin and mathematical models from the nineteenth century in his artworks—simply everything. Scientists, mathematicians, and artists are all deeply connected to fantasies and creativity about the unknown. If we dig deep into the foundations of each respective field, we will find where they are connected. It is harder to find that connection on a superficial level.

When we say "better" future, that is a normative term, an ideological term—it implies a theory about what is a better life. Can a museum offer such normative guidance?

One of the most complex challenges we are facing is how to live together in equality together but with differences. As we have been discussing, the contemporary art museum has a huge potential to be a place where people can encounter diverse ideas without making a judgment about who is right or wrong. It has to be a place where value systems coexist. It is important for people to understand that there are different systems, cultures, beliefs, hundreds of ways of thinking, in different parts of the world. Experiences through contemporary art have made me realize that everything is relative. And the contemporary art museum must be a place for learning about our enormous unknowns in this world.

If there was one thing you could do to express these ideas of hybridity and multiple possibilities in the museum of the future, what would that be?

I always think the museum is the world, like walking on the surface of this planet. It would be great if once you entered the museum, the space would be infinite and you would just start walking in the exhibition space and keep walking forever. And you would encounter all the beautiful people and different ideas from different times and spaces.

Mami Kataoka

I suppose virtual reality could give you that experience.
If we accumulated all the exhibition experiences and contexts over the course of time, it would be an infinite world at the end of your life.

After eighteen years at the Mori Art Museum, your directorship began with a pregnant pause. What are your greatest hopes for the future now?
I am interested in how this museum will develop and reinvent itself during my time as director. I don't have to stay so long. I would like to give a golden spoon, the most beautiful museum, to the next director. The museum doesn't have to be "the best" in terms of the hierarchy, but it has to be the best in its own way. This is not a competition. This is not about being a champion. It is more about how you fight within yourself.

MARC-OLIVIER WAHLER
Director, Musée d'Art et d'Histoire (MAH)
Geneva, Switzerland

BROUGHT TO YOU BY MANY TRANSFIGURATION OFFICERS

My conversations with Marc-Olivier Wahler started in 2012, in Paris, where he was running the Palais de Tokyo, Europe's largest contemporary art center. We intersected over the years in New York, Basel, Miami, Budapest, Buenos Aires, and especially in East Lansing, Michigan, where he oversaw the MSU Broad, Michigan State University's contemporary art museum, housed in a radically futuristic structure designed by Zaha Hadid. Wahler has explored the possibilities of the art museum with all the fearlessness and dexterity of the avid skateboarder that he is. He now brings this curiosity back to his home country of Switzerland, as the director of Geneva's grand municipal museum and its one million objects.

ANDRÁS SZÁNTÓ *The institution that you have led for less than a year has an unusual history and a vast range of collections. What attracted you to this museum?*

MARC-OLIVIER WAHLER For me, what is interesting is the collection—almost a million objects. It is an encyclopedic museum, with objects spanning from fifty thousand years ago to today, including archaeology, musical instruments, applied arts, fine arts, arms and armor, horology—everything that has to do with creative minds and every type of person who wants to create something. Also, the institution is going to reopen as a refurbished and expanded museum in ten years. Which means I have to think about what the museum will be a decade from now.

I come from contemporary art, where history matters. In this kind of institution, you are not only dealing with the past and the present, but you have to project history into the future. These three elements are combined into one. That is the fantastic challenge of running an institution nowadays.

What got you involved in museums in the first place? What from your previous experiences running very different museums informs your thinking about this new challenge?

In the 1990s, I created an art center in my hometown, Centre d'Art Neuchâtel (CAN). Whether at CAN, or at the Swiss Institute in New York, or at the Palais de Tokyo in Paris, or later at the Broad Museum at Michigan State University, I was always thinking about the same question: Why would people come into this building to see art? Why would they come and see things they may not understand?

In Neuchâtel, I thought, *Well, maybe if people enter directly through a restaurant café, and at the end there is a door leading into an art center, then they may be enticed.* If you link art or an exhibition to a cultural experience you already know, maybe that can be an entry point.

At the Palais de Tokyo, people would come for many different reasons. They might come for a hotel room that we offered, or because we had a Michelin-star restaurant, or because they could skateboard in the courtyard. The *Guardian* newspaper selected the Palais de Tokyo as the number-one pick-up place in Paris. And why not? Maybe the best museums are the ones where you

can fall in love. It doesn't need to have a direct link to an exhibition or to art. Maybe you fall in love and then see the best exhibition of your life.

That would be very Parisian, certainly. But it is interesting that you pursued this agenda in Paris, with all those monumental institutions around you.
At the Palais de Tokyo, there was a hairdresser, a hotel, and a few restaurants. I tried to multiply the type of experiences that would be available in an art center. And when it came to expanding the Palais de Tokyo—because we had all these huge spaces underneath—I proposed a concept that may have been too radical. The idea was to have different experiences, always driven by artists, including a new kind of spa, a butcher shop, some weird shops, and galleries. Why not a swimming pool? Anything would be good as long as the creative process could be visible through these experiences. We tried to rewrite the rules.

I notice you are using the term "art center" and not "museum" when talking about these institutions. Is this a conscious choice?
A "museum" involves more than a collection. But maybe "museum" is too authoritative. An "art center" might be less so. The museum builds on exclusion: specific knowledge that not everyone has, authoritarian architecture like a vault, a bank, or a jail. So what can we do to soften these authoritarian edges?

The goal is not to become Disneyland. The rule of a museum, in my view, is that you have to be totally radical. You have to stay close to what the artists want—to things that we may not understand, and that may have multiple interpretations. You need to have this entry point. I am constantly searching for the right tools. And of course, the tools we have today will not all be relevant tomorrow. So, we need to invent tools that still will be relevant a decade or more from now.

Where in the history do you see some of these tools being applied well? Do any current institutions offer glimpses?
I think the Beaubourg (Centre Pompidou, Paris), when it opened in 1977, with Pontus Hultén in charge, proposed a useful model. For me, that was the perfect museum for the time it opened.

It lasted two or three years, and then it was over. They thought there was no limit to creativity. They took risks. They worked with young architects, young artists. They did the right retro-spectives—Duchamp, Malevich—and the right group shows: *Paris–New York, Paris-Berlin*. There was no hierarchy among the arts. You could enter from multiple points. You had a post office inside the building and these activities around the museum.

For a moment there was this dream where all art could gather without hierarchy. Yet soon thereafter, the hierarchy was imposed. Now there is a floor for library books, two floors for fine art; music was moved somewhere else. They restarted the old order. And it was over.

The museum reverted to type. Powerful forces push against such a radical vision. Museums are complicated engines. It's hard to take them apart. They are purposefully built for conservation and continuity. How can you resist falling back into old habits and patterns?
It's a constant battle. Everything makes you want to go in that direction. It's about categories. It is easy to bring things back into categories, because you know where things are, you know how to categorize it, you know the rules, the habits. The bigger the institution, the more difficult it is to run it, and the slower it becomes. Then, if you want to drive this institution, you might think it is better to use the existing tools. However, the danger is that you will end up with just a regular big institution—slow and not so useful.

You and I have often talked about how the earlier history of cultural institutions may offer some clues as to what the experience of the museum might look like in the future. Can you talk about historical examples that have informed your thinking?
Our Geneva museum opened in 1910. When I look at pictures of old exhibitions, I find that it was a golden era. Because everything was all mixed together. In the early twentieth century, the difference between an object with usage value and an object whose destination was aesthetic pleasure—the boundary between these two kinds of objects was not so strong. Nowadays, the use-value of an object has all but disappeared in the museum. This is

Marc-Olivier Wahler

especially true for ethnographic museums, where the cult aspect of a mask, for example, has vanished, to the benefit of its visual and aesthetic aspect. A big challenge for us in this museum— where two-thirds of the objects have usage value—is how to display them. Some of the answer might be found in the way in which such objects were displayed before.

It's not hard to conjure the current "international style" of museum display. A white-cube gallery. Floating walls. Architecture with abundant glass and marble. Perfectly directed lighting. Pristine glass vitrines that transform each object into a relic, isolated in its own space, and so on. Is this a period style? What of it should remain as we move forward?

Everything should remain—as a witness of its time. A white cube is a witness of its own time. In twenty, thirty years, we will look back and say, "Oh, they thought the white cube was the answer to how to look at art." Now, suddenly, we have an interest again in the period rooms. In fact, there is no right or wrong way to show objects. It always corresponds to the zeitgeist.

Speaking of the zeitgeist, a trending term today is "immersive experience." If the white cube was attempting to suck all signal interference from the gallery space, except for the glorified art object, then now we appear to be leaning toward spaces that are themselves full of information and sensory energy. What do you make of that?

It's linked to the development of art. Minimal art is about delegating meaning and interpretation to something other than the object. The "insignificant object" means that your attention can only glide from the object to the floor, to the walls, to the ceiling, and maybe to the other visitors in the room. It highlights the unique experience of visiting an exhibition. A participatory, relational aesthetics comes from that type of experience.

Nowadays we are captivated more and more by immersive environments. We see big slides of Van Gogh works projected into huge spaces. People want to be fully immersed in these environments. They need to be immersed into something. It all says something about the way art is always reinterpreted, and of course, about our society at this moment.

So with all this in mind, when thinking about the museum of the future, what key words come to mind?

First, *museums* instead of *museum*. There should be as many kinds of museums as possible. There should not be one model.

Second, the museum as we know it today will not necessarily work tomorrow. We will still have the big museum, the encyclopedic museum, which represents a classic way of showing art. But I think the museum should evolve to a point where it will not necessarily look like a museum anymore.

What do I mean? With artists, when we talk about a new work in the public space, my motto is, "If it looks like art, it's not good enough." If you immediately know that you are facing an artwork, you lose that tension of needing to figure out whether it is an ordinary object or an artwork. You lose that suspense, where interpretation can fall to one direction or another. That moment is rich, because you have all these possibilities.

To me, the museum is similar. We need to look further than what is familiar. This means a museum where you may enter space for any reason, not just to see an exhibition. Think about a guy who wants to skateboard, and suddenly, as if by chance, he is in a Steven Parrino exhibition. There will be a collision of thoughts in this guy's mind. It's not something he predicted. But he has to deal with it. This can happen in a video game, but not in reality.

One of the most powerful exhibitions I have seen consisted of a door connected to a small bridge. It was a piece created by Christoph Büchel in the early 1990s. I thought, *Okay, it's a bridge to a door—boring*. But when you walked across the bridge, suddenly you were inside an old-age home. I forgot that the museum shared a wall with this type of organization. It was a total surprise. The tension created by the collision of two different ways to look at things was thrilling.

In a museum, that type of tension is lost. From the moment you step in, you are conditioned to see art. You are in a space that triggers you to see things a certain way. To see pigments on a canvas as art, you need a process, a way of seeing that helps you to see this canvas transfigured into an artwork.

"Transfiguration" is exactly the word I was going to use. Arthur Danto talked about art in terms of the transfiguration of the com-

Marc-Olivier Wahler

monplace object. What sort of a transfiguration exactly does the museum do?

I want to keep things elastic. That is my obsession. It always starts with Duchamp. Duchamp realized that it was not so difficult to go from the ordinary object to art, from point A to point B. But then he spent the rest of his life trying to go in reverse, from point B to point A. That was the drama of his life—saying that he was not an artist, that he was an engineer or a chess player.

I try to take that same approach to museums. Museums are tools to transfigure anything that goes through that engine. But can we imagine a museum that allows for more flexibility, where things are not so dependent on an authoritarian process?

When we agreed to talk about the future of the museum, you said you would like to explore "the post-museum." I guess that would be a kind of museum that generates the sense of suspense and surprise you are talking about. What would such a post-museum look like?

It should feel like software more than hardware.

What do you mean by that?

If you look at the history of the computer, you have hardware, and then software has to be built to function on this hardware. Eventually, more and more, the software gained autonomy, to a point where it could graft onto different platforms without losing its identity.

If a museum is only hardware with a software to which it is totally dedicated, then it will be too stiff. It cannot evolve. A post-museum would have to be a museum that is built intentionally as software that can graft onto different platforms. It would not relate only to one building. It is no longer about the hardware. It is the software.

An exhibition should be able to happen anywhere: in a museum, on a fridge, in the kitchen, on a beach, in the street. A museum likewise should be able to exist and function anywhere and everywhere. It should not relate to only one specific place where the architecture confines you to one specific type of experience.

Can you name any experiments that offer a taste of that open-endedness?
I don't know if it exists yet. There is no example I know.

I am building a museum called the Museum of Horizon, which is in a tower in the heart of Portugal, a watchtower for fires. No one can go there. It is for mental images. Like the horizon— you know it is there, but it really doesn't exist. We will work with the idea that an artwork can exist only if it is a mental image. Of course, you need triggers. It's like magic. There are things you see and things you don't see, and the result is something you need to trust. You have to believe so it can work.

Back to the hypothetical post-museum—can you describe certain roles that people might play in such an institution? Let's start with the curator. What exactly is the role of the curator in the post-museum?
The curator is like a magician. He has to convince you that what he is going to do—he will make things appear, disappear, and reappear—will only work if you believe in what he is doing. He or she is the one that has to talk to you and make you believe that you will see things differently.

Something like a "chief transfiguration officer" ... a "CTO" ...
Exactly. I like it!

What is the role of the director in the post-museum?
The director looks at the gap between what the museum should do and what the museum *can* do. The biggest problem right now is that the artists have a certain speed of doing things, and the museum has another speed. The bigger the gap, the less effective the museum. The director makes sure this gap is as narrow as possible.

Does the post-museum have a public in the sense that we understand?
There is no museum without a public, just as there is no artwork without spectator, as Duchamp said. The spectator is doing half of the job. So in the museum the visitor should also do half of the job. But what do the spectators actually do? Maybe they can do

something else besides walk around in front of artworks, and still have the experience of the museum.

One thing is sure: the physical connection to the world of art will remain, even if it is only a mental image.

What role will technology play in the post-museum?
It would just be a tool. It will help us in this transfiguration. What if you have a perfect hologram of a sculpture, for example? But the question will always remain: how do you transfigure this into a relevant experience?

A lot of this is fairly abstract. What are some concrete steps that could aid movement in this direction?
For me, the goal is to understand "What is a museum? What is an artist? What is a visitor? What is a collection? What is an exhibition?" All these things that constitute a museum have to be studied and tested. Here in Geneva, for the next ten years we will continue to do shows. And we will also open a new branch where we will test things out.

So, imagine one day you walk into this museum of the future, this un-museum, this post-museum. As you said, we don't know what it will look like. But maybe we can talk about what it would feel like. How would you know that you are having this post-museum experience?
Well, it would be the experience of art—of a good artwork. That might be easy to say, but it is extremely difficult to accomplish.

You can see the best artwork, but if you just had a bad meal, you won't feel it. It is the whole ecosystem, a whole process that matters—that entire sequence that led you to this great artwork, from the moment you entered the building, or even before, from the moment you thought about going there.

For me, the museum should be part of all these experiences, well before you enter the building. I don't think that one object can enlighten you because of its fabulous properties. No, it's the whole thing. We can see in this larger frame something fantastic. And this fantastic thing has been brought to you by many transfiguration officers.

Acknowledgements

It should come as no surprise that many of the museum leaders in this book attribute their love of art to childhood experiences of visiting exhibitions. The same is true for me. I am grateful to my parents for taking me to museums early and often. Like several of the directors, I found my way to the art world circuitously. I am indebted to my early contacts in Budapest and to my mentors along the way, and none more so than the late Arthur C. Danto. There are too many friends, colleagues, clients, and collaborators to acknowledge here by name, but they know who they are, and I thank them for helping me learn over the years about art and its institutions. For bringing this book to fruition under a pressing deadline, I thank the indefatigable Lena Kiessler and her colleagues at Hatje Cantz, my agent Rob McQuilkin, Neil Holt for his astute design, and the incomparable Myles McDonnell for his subtle copyediting. This book could not have been realized without Laura Noguera's enthusiasm and support and the assistance of Caroline Callender. And while it is customary for an author to thank his family for putting up with it all, I owe a special debt of gratitude to my wife and constant muse and companion, Alanna Stang, and to my children, Lex and Hugo, for allowing me to soak up the hours of our pandemic lockdown and summer with this crazy project. In the end, this book is about the ideas of the museum leaders who agreed to participate in it. I thank them for their candor and thoughtfulness, and for being such splendid conversation partners, especially at such a challenging time.

Images Captions and Credits

P.19 Aerial view of Hong Kong with the M+ Museum building. Image courtesy of West Kowloon Cultural District Authority.

30 Museo de Arte Moderno de Buenos Aires, exterior façade. Photography by Guido Limardo.

41 Pérez Art Museum Miami, hanging gardens, designed by Patrick Blanc, 2014. Photography by Daniel Azoulay Photography.

51 Musée de la Fondation Zinsou, exterior façade. Photography by Jean-Dominique Burton.

62 Brooklyn Museum, exterior façade. Photography by Jonathan Dorado. Image courtesy of the Brooklyn Museum

73 Museu de Arte de São Paulo, installation view of *Acervo em Transformação*, 2020. Photography by Eduardo Ortega.

84 Tel Aviv Museum of Art, exterior façade. Photography by Elad Sarig.

94 The curved veil signing the entrance of the National Gallery Singapore between the two monuments. Photography by Fernando Javier Urquijo. Image courtesy of studioMilou Singapore.

105 Zeitz Museum of Contemporary Art Africa, exterior façade. Photography by Heatherwick Studio. Image courtesy of Hufton + Crow Photography.

116 Museo de Arte Moderno de Medellín, open-air cinema at the square. Image courtesy of the Museo de Arte Moderno de Medellín.

126 UCCA Dune, aerial view. Image courtesy of OPEN Architecture.

138 Adelaide Biennial of Australian Art: *Monster Theatres featuring Bay of Sick*, by Mikala Dwyer, 2020. Photography by Saul Steed. Courtesy of the Art Gallery of South Australia.

149 de Young Museum, exterior façade. Photography by Gary Sexton. Image courtesy of the Fine Arts Museums of San Francisco.

160 Event Tour & Art with Dar Bellarj Foundation (single mothers of the Marrakesh medina), 2019. Photography by Ayoub El Bardii. Image courtesy of the Museum of Contemporary African Art Al Maaden.

171 View of Garage Museum of Contemporary Art, Garage Screen summer cinema, Garage Square and the Hexagon, 2018. Photography by Ivan Eroofeev. Image Courtesy of Garage Museum of Contemporary Art.

181 Schloss Pillnitz Wasserpalais, exterior façade. Photography by Klemens Renner. Image courtesy of Staatliche Kunstsammlungen Dresden.

192 Serpentine Pavilion, designed by Junya Ishigami, at the Serpentine Galleries, 2019. Photography by Norbert Tukaj. Image credit: Junya Ishigami + Associates.

203 Palais de Lomé, front building façade and the Ocean Alleyway, 2020. Image credit: Studio Erick Saillet.

214 The Met Fifth Avenue, Great Hall. Photography by Brett Beyer. Image courtesy of the Metropolitan Museum.

225 Josh Kline's *Skittles*, part of the High Line Art group exhibition *Archeo,* 2014. Photography by Timothy Schenck. Image courtesy of the High Line.

234 Peabody Essex Museum, East India Marine Hall with new wing. Photography by Aislinn Weidele/Ennead Architects. Image courtesy of Peabody Essex Museum.

245 Aerial rendering of Lucas Museum of Narrative Art, in Los Angeles. Designed by Ma Yansong of MAD Architects. Image courtesy of Lucas Museum of Narrative Art.

256 *Wunderkammer*, 2020. AR artwork by Olafur Eliasson presented by Acute Art. Image courtesy of Acute Art.

266 Australian Centre for the Moving Image, exterior façade, 2020. Photography by Charlie Kinross.

277 The Life Room at the Royal Academy Schools, 2010. Photography by Marcus Leith. Image courtesy of Royal Academy of the Arts.

288 Warner Glass Pavilion interior at the Toledo Museum of Art. Photography by floto+warner studio. Image courtesy of the Toledo Museum of Art.

298 Landscape of Tokyo with Mori Art Museum Tower. Image courtesy of Mori Building Co., Ltd.

309 Illuminated mapping of the inner courtyard of the Musée d'Art et d'Histoire. Image courtesy of Musée d'Art et d'Histoire.

Author
András Szántó

Managing Editor
Lena Kiessler

Assistant Editor
Laura Noguera

Project Assistant
Caroline Callender

Copyeditor
Myles McDonnell

Graphic Design
Neil Holt

Typeface
Arnhem

Production
Vinzenz Geppert

Printing and binding
GRASPO CZ, A.S.

© 2020 Hatje Cantz Verlag, Berlin,
and the author

Published by
Hatje Cantz Verlag GmbH
Mommsenstraße 27
10629 Berlin
www.hatjecantz.de
A Ganske Publishing Group Company

ISBN 978-3-7757-4827-8 (Print)

ISBN 978-3-7757-4828-5 (e-Book)

Printed in the Czech Republic